GREAT SCOTTISH JOURNEYS

TWELVE ROUTES TO THE HEART OF SCOTLAND

KEITH FERGUS

BLACK & WHITE PUBLISHING

For Helen, Kyla and Cameron, who have visited many of the locations in this book with me, and Bill Campbell, who introduced me to the amazing landscapes of Scotland.

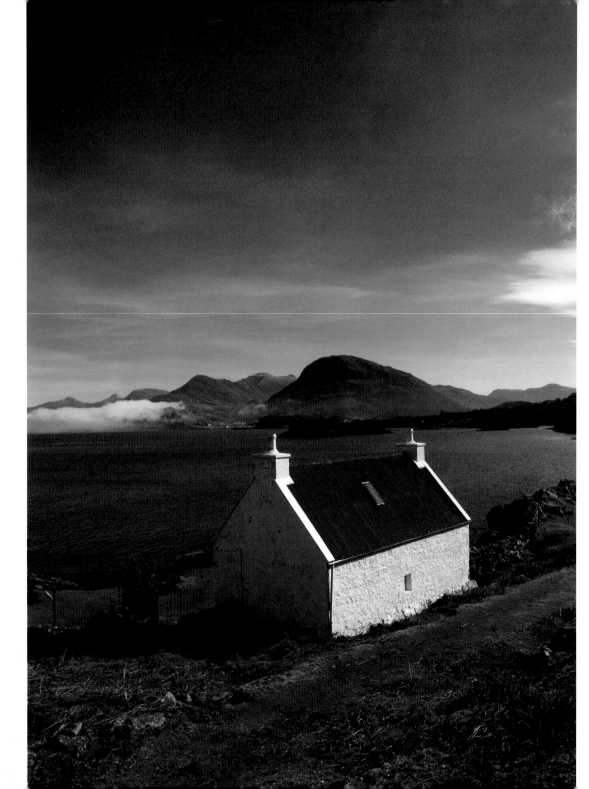

THE Scots MAGAZINE

GREAT SCOTTISH JOURNEYS

First published 2017
by Black & White Publishing Ltd
Nautical House, 104 Commercial Street,
Edinburgh, EH6 6NF

1 3 5 7 9 10 8 6 4 2 17 18 19 20

ISBN: 978 1 78530 142 1

Copyright © Keith Fergus 2017

Layout by Richard Budd Design
Printed and bound by Opolgraf, Poland

Contents

Introduction		viii
1.	Turnberry to Portpatrick – A Coastal Classic	1
2.	Arran – All Around Its Coast	23
3.	Musselburgh to Dunbar – Exquisite East Lothian	43
4.	Lower Largo to St Andrews – Fife's Historic East Neuk	65
5.	Tarbet to Lochgilphead – The Spectacular A83	85
6.	Crinan Canal – The Most Beautiful Shortcut in Scotland	107
7.	The West Highland Way – A Walker's Paradise	125
8.	The Road to the Isles – Fort William to Mallaig	149
9.	Loch Lomond to Inverness – Lochs, Glens and Mountains	167
10.	Inverness to Applecross – Way Out West	187
11.	Kinlochewe to Durness – The North Coast 500	205
12.	Invergarry to the Storr – An Iconic Landscape	225

Introduction

Scotland is renowned the world over for its outstanding scenery, with millions of people visiting every year to revel in its urban, rural, mountain and coastal settings. Much of this remarkable topography is accessible to all, whether this be by road, by rail, by boat or even on foot, adding to the appeal for visitors and residents alike.

From the mighty mountains of the Northwest Highlands, to the exquisite sandy beaches of Arisaig, the gentle delights of the Crinan Canal, or the wonderful rolling landscape of Galloway, you are never far from spectacular locations. Which is why there is a plethora of Great Scottish Journeys to enjoy, allowing the traveller to experience everything this beautiful country has to offer.

The purpose of this book is to let the reader see what is out there, and to provide some inspiration to explore the A-roads, the back roads, the paths, the towpaths, our mountains, lochs and coast. There is much to see, do and learn along the way.

For instance the Crinan Canal, which runs for 14km (9 miles) between Ardrishaig and Crinan, in Argyll & Bute, is often referred to as the most beautiful shortcut in Scotland. It is a truly exceptional journey, one that can be taken on foot, bike or by boat. Or for a trip from the Lowlands into the Highlands, where Scotland's remarkable geology divides the land, then a week walking the West Highland Way is special. This spectacular 154km (96 mile) long distance route runs between Milngavie, a few miles from Glasgow, and Fort William, seen by many as the outdoor capital of Scotland.

Scotland's road network comes to the fore on many of the journeys included in this book. The North Coast 500 for example, which has been called Scotland's Route 66, takes in many

of the quiet roads skirting the coastal fringes of the Highlands, Sutherland and Caithness. The scenery is never less than dramatic and the rocks that help form this unique landscape are some of the oldest in the world.

A trip along the East Neuk of Fife, or an excursion over the Road to the Isles to Mallaig, bestows a stunning variety of scenery and a chance to sample some of the best seafood in the world. The beguiling coastlines of Ayrshire, Galloway and East Lothian are also visited in the book while, heading inland, Loch Lomond, Glencoe, Lochaber, Loch Fyne and the Arrochar Alps highlight the diversity of the Scottish countryside.

A sense of adventure is also delivered. A Great Scottish Journey could mean taking the ferry across the beautiful Firth of Clyde to reach the dazzling Isle of Arran, or driving beneath the spiky mountains of Kintail onto Skye.

From here, a passage across the Misty Isle, past the serrated spectacle of the Cuillin, to the unique and striking topography of the Trotternish Ridge, is simply breathtaking.

The images in this book have been taken over a number of years, with every trip to every location having imparted vivid memories that I have been lucky enough to capture on camera. Each Great Scottish Journey reminds me what an exceptional country Scotland is and how fortunate we are to be able to rejoice in its incredible beauty.

Keith Fergus

CHAPTER ONE

A Coastal Classic
Turnberry *to* Portpatrick

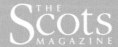

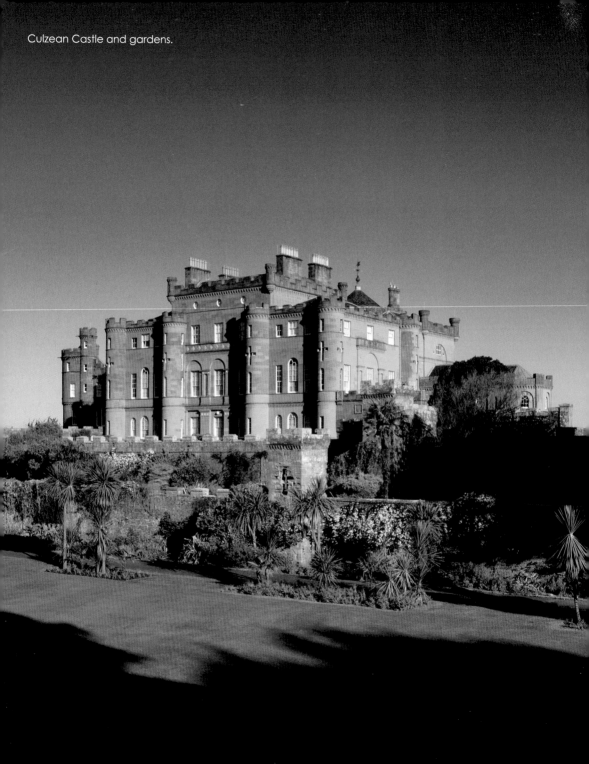

Culzean Castle and gardens.

Turnberry *to* Portpatrick

The 71km (44 miles) from Turnberry to Portpatrick run along one of the finest stretches of coastal road in Scotland.

The A77 hugs the shoreline for much of the journey, one that takes in a section of both Ayrshire and Galloway, and passes through a number of towns and villages, including Girvan, Lendalfoot, Ballantrae and Stranraer.

The journey is bookended by the magnificent Turnberry Lighthouse and the gorgeous village of Portpatrick, a beautiful place to relax and watch the world come and go.

In between, a string of superb sandy beaches offer invigorating walks while the scenery, much of it rugged, draws the eye to Ailsa Craig and the Kintyre Peninsula.

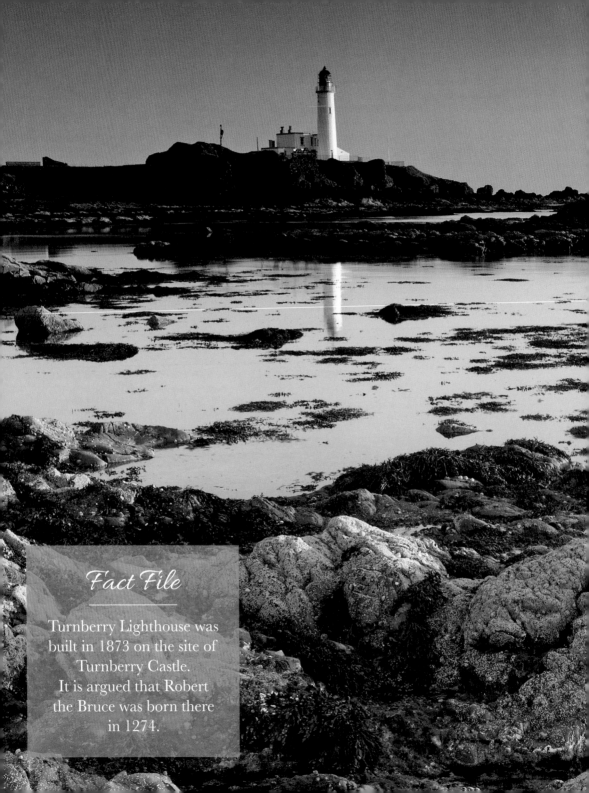

Fact File

Turnberry Lighthouse was
built in 1873 on the site of
Turnberry Castle.
It is argued that Robert
the Bruce was born there
in 1274.

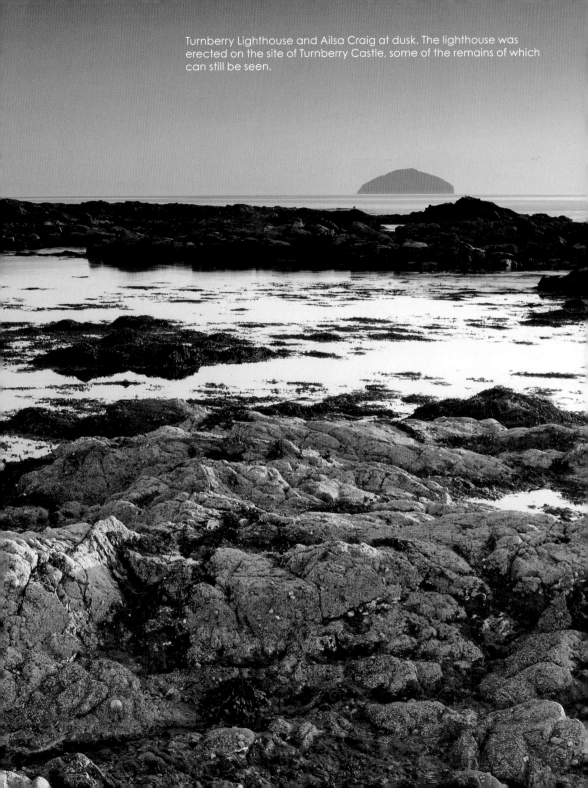
Turnberry Lighthouse and Ailsa Craig at dusk. The lighthouse was erected on the site of Turnberry Castle, some of the remains of which can still be seen.

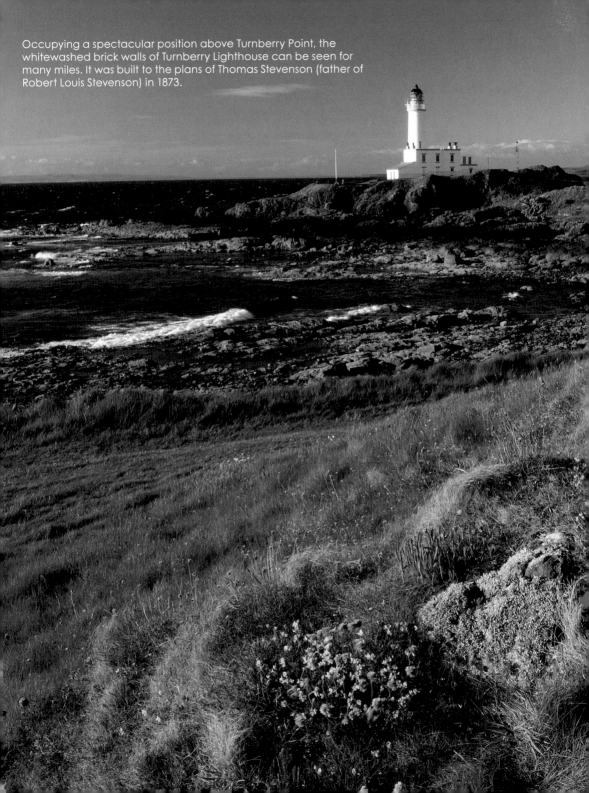

Occupying a spectacular position above Turnberry Point, the whitewashed brick walls of Turnberry Lighthouse can be seen for many miles. It was built to the plans of Thomas Stevenson (father of Robert Louis Stevenson) in 1873.

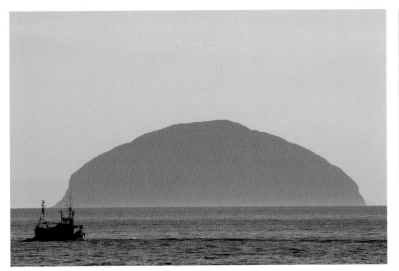

A fishing trawler leaves Girvan, in full view of Ailsa Craig. The island lies some 16km (10 miles) off the Ayrshire Coast, rises sharply to 340m (1115ft) in height and has a diameter of around 1km (0.6 miles). The island is renowned worldwide for its quality of granite, used in the production of curling stones.

The long ridge of Byne Hill overlooks Girvan.

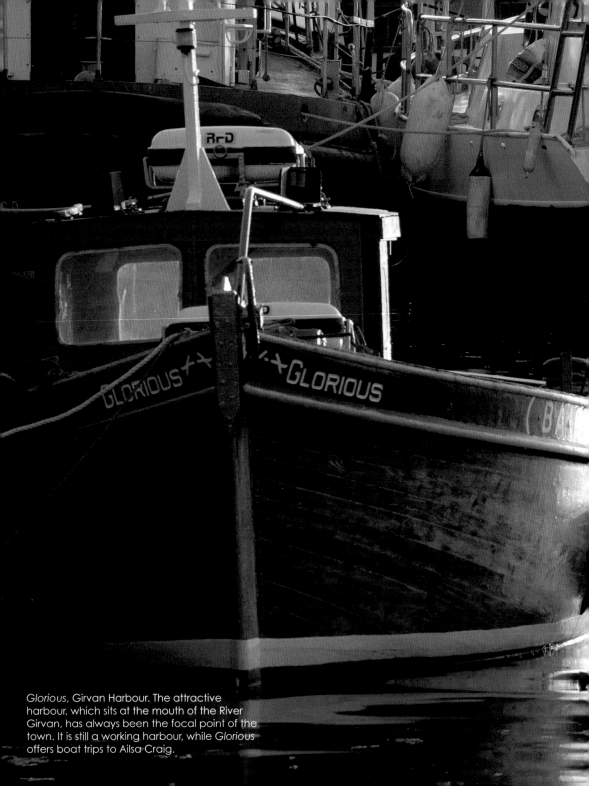

Glorious, Girvan Harbour. The attractive harbour, which sits at the mouth of the River Girvan, has always been the focal point of the town. It is still a working harbour, while *Glorious* offers boat trips to Ailsa Craig.

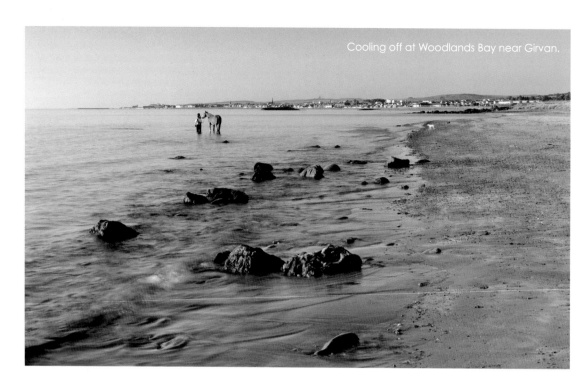

Cooling off at Woodlands Bay near Girvan.

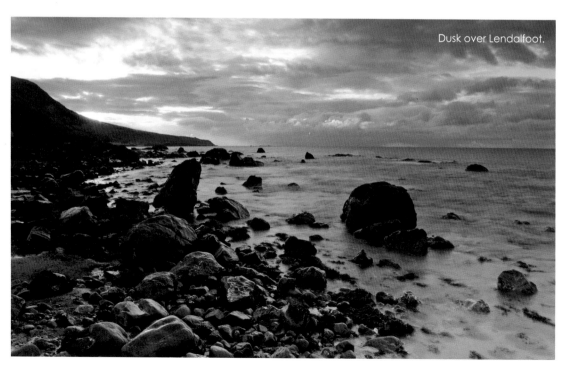

Dusk over Lendalfoot.

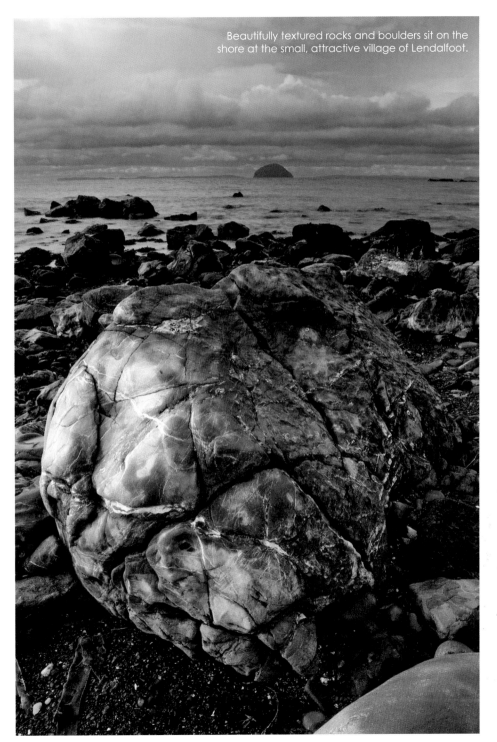

Beautifully textured rocks and boulders sit on the shore at the small, attractive village of Lendalfoot.

The historic Kennedy Mausoleum stands in Ballantrae. It was built by Lady Bargany after her husband Gilbert Kennedy (who was Laird of Bargany) was killed by the 5th Earl of Cassillis, John Kennedy. Gilbert was buried at Ayr, but when Lady Bargany died in 1605, both their bodies were taken to Ballantrae and laid to rest in the Kennedy Mausoleum.

The small but perfectly formed Glenapp Church is one of the smallest churches in Scotland and is known locally as 'The Glen Kirk'.

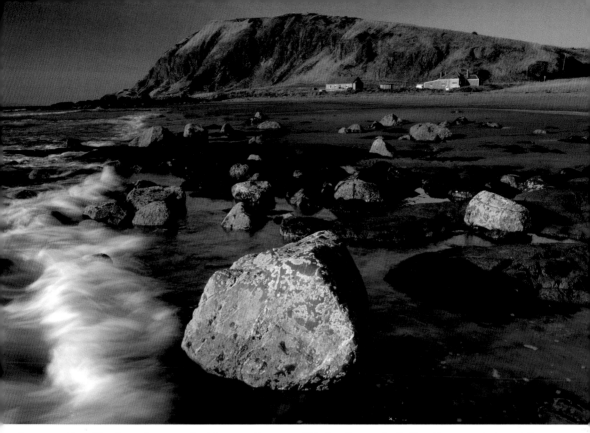

Bennane Head is where the cannibal Sawney Bean and his family reputedly lived in a cave. According to the legend, the family managed to keep their whereabouts secret for many years, until King James VI and an army of 400 men tracked them down to Bennane Head. Sawney Bean and his family were all executed without trial in Edinburgh.

Pinbain Hill and a distant Byne Hill from the A77 above Lendalfoot.

The A77 snaking its way along the Ayrshire Coast.

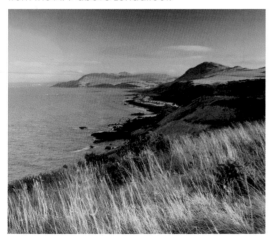

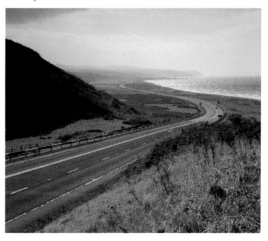

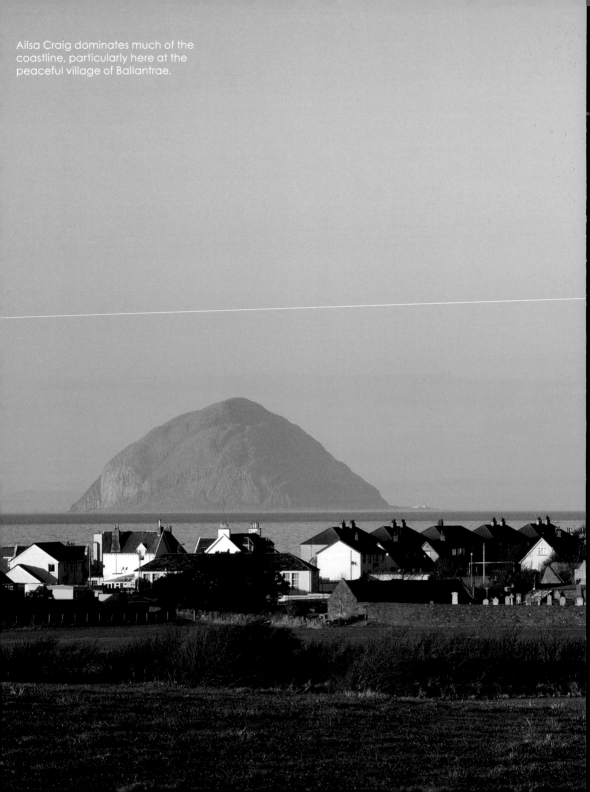

Ailsa Craig dominates much of the coastline, particularly here at the peaceful village of Ballantrae.

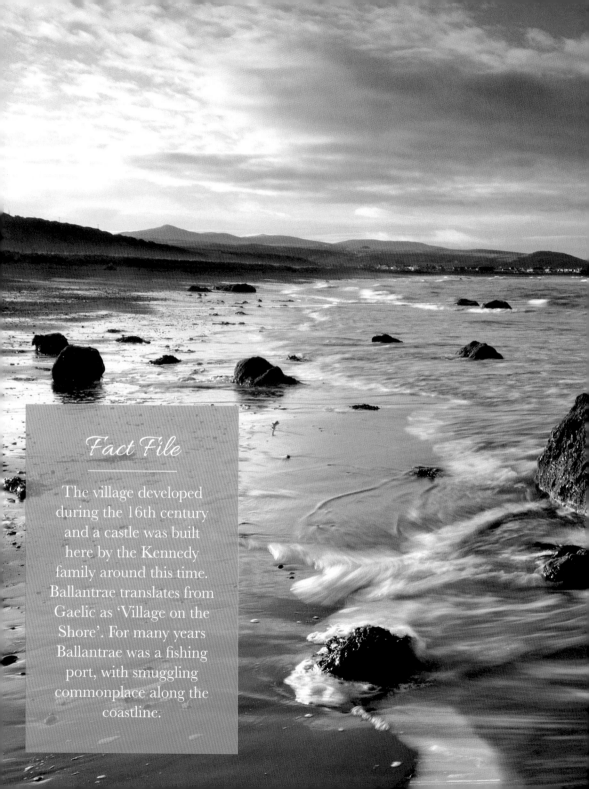

Fact File

The village developed
during the 16th century
and a castle was built
here by the Kennedy
family around this time.
Ballantrae translates from
Gaelic as 'Village on the
Shore'. For many years
Ballantrae was a fishing
port, with smuggling
commonplace along the
coastline.

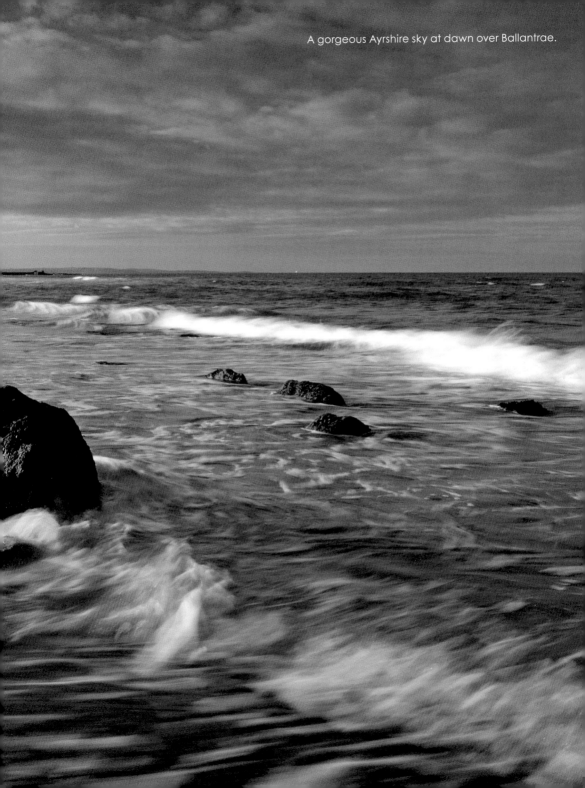

A gorgeous Ayrshire sky at dawn over Ballantrae.

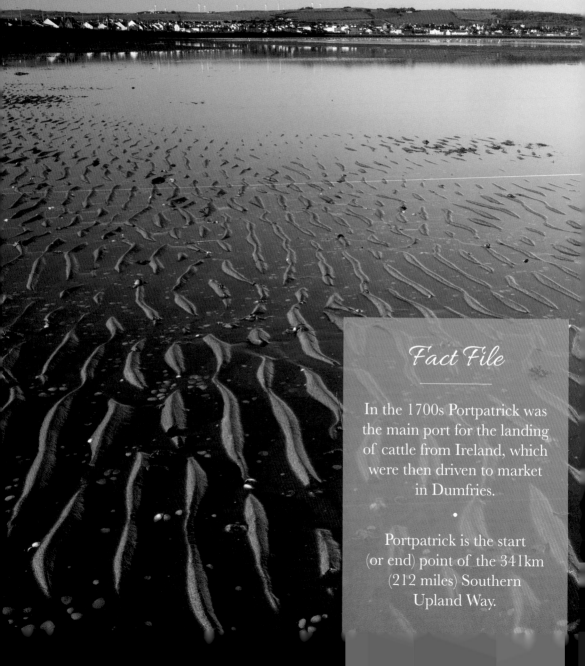

Stranraer, the largest settlement in this part of south-west Scotland, sits on the shores of Loch Ryan and is the gateway to the Rhinns of Galloway. The town's origins date back around 500 years but it really developed when a harbour was built in the 1700s. For 150 years, from the 1860s, Stranraer was the main ferry port for Northern Ireland, until the service was moved to nearby Cairnryan in 2011.

Fact File

In the 1700s Portpatrick was the main port for the landing of cattle from Ireland, which were then driven to market in Dumfries.

•

Portpatrick is the start (or end) point of the 341km (212 miles) Southern Upland Way.

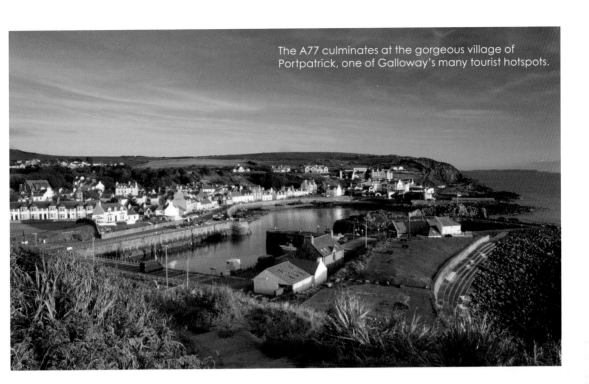

The A77 culminates at the gorgeous village of Portpatrick, one of Galloway's many tourist hotspots.

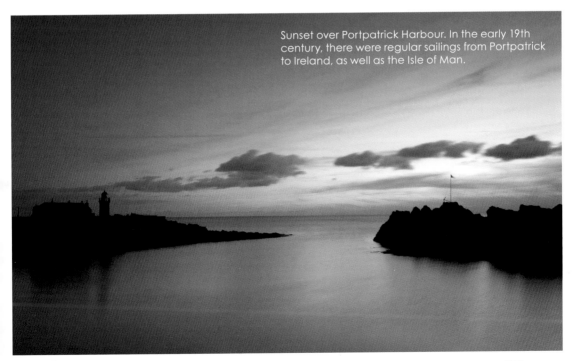

Sunset over Portpatrick Harbour. In the early 19th century, there were regular sailings from Portpatrick to Ireland, as well as the Isle of Man.

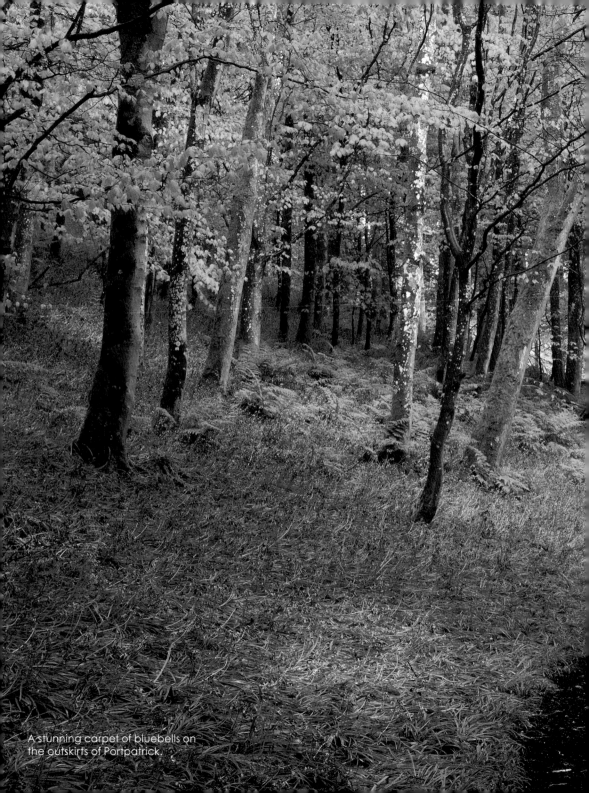

A stunning carpet of bluebells on
the outskirts of Portpatrick.

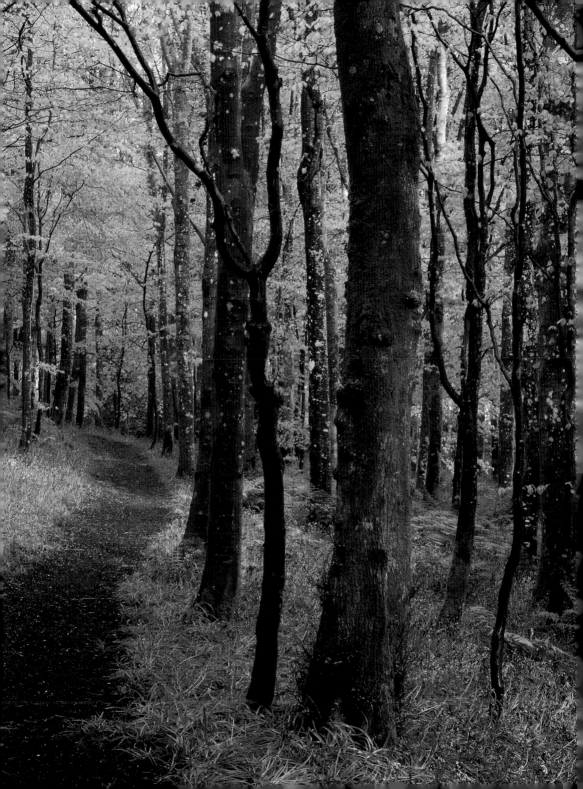

CHAPTER TWO

All Around Its Coast

Arran

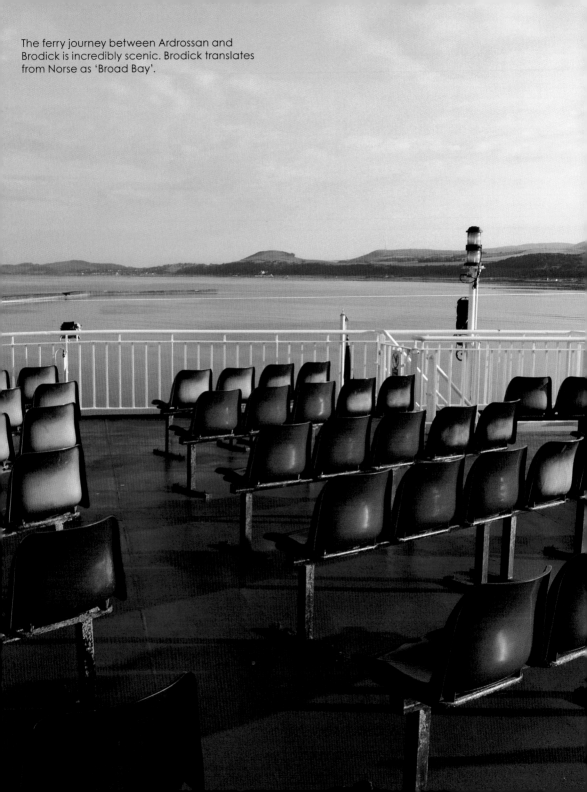

The ferry journey between Ardrossan and Brodick is incredibly scenic. Brodick translates from Norse as 'Broad Bay'.

All Around Arran

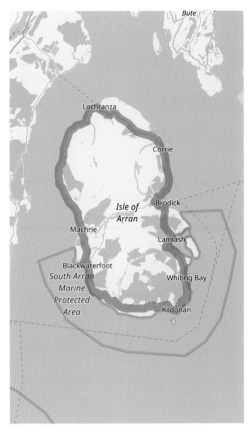

A trip across the Firth of Clyde to the magnificent Isle of Arran is one of our finest ferry crossings. Upon reaching Brodick, a spectacular journey continues along the A841 as it circumnavigates Arran's beautiful coastal landscape for 89km (55 miles).

If travelling anticlockwise (although clockwise is just as alluring), the route heads beneath the mighty slopes of Goat Fell and Caisteal Abhail, and through gorgeous little settlements such as Corrie and Sannox, to reach Lochranza.

The road then continues along Arran's west coast to Blackwaterfoot, bestowing stunning views of the Kintyre Peninsula.

Heading east, taking a short diversion through Kildonan is highly recommended. The A841 runs north through Whiting Bay, then Lamlash and then back to Brodick, resulting in the culmination of a stunning circular trip.

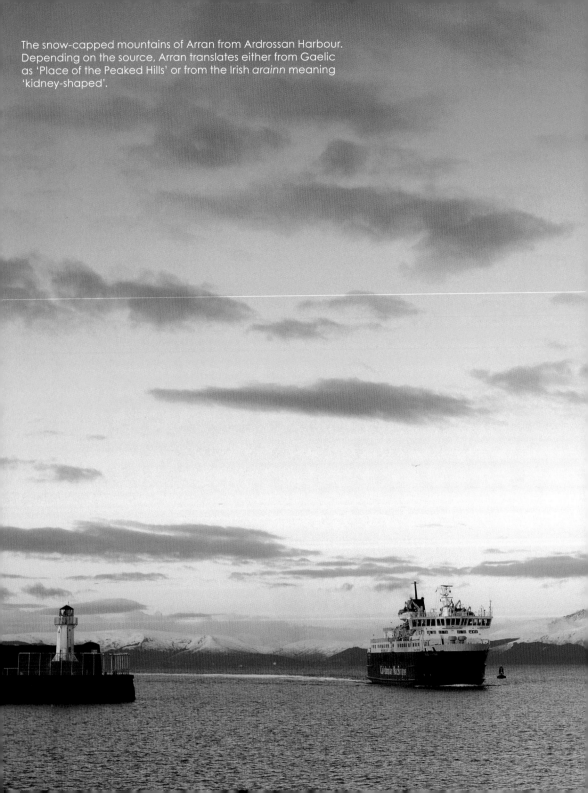

The snow-capped mountains of Arran from Ardrossan Harbour. Depending on the source, Arran translates either from Gaelic as 'Place of the Peaked Hills' or from the Irish *arainn* meaning 'kidney-shaped'.

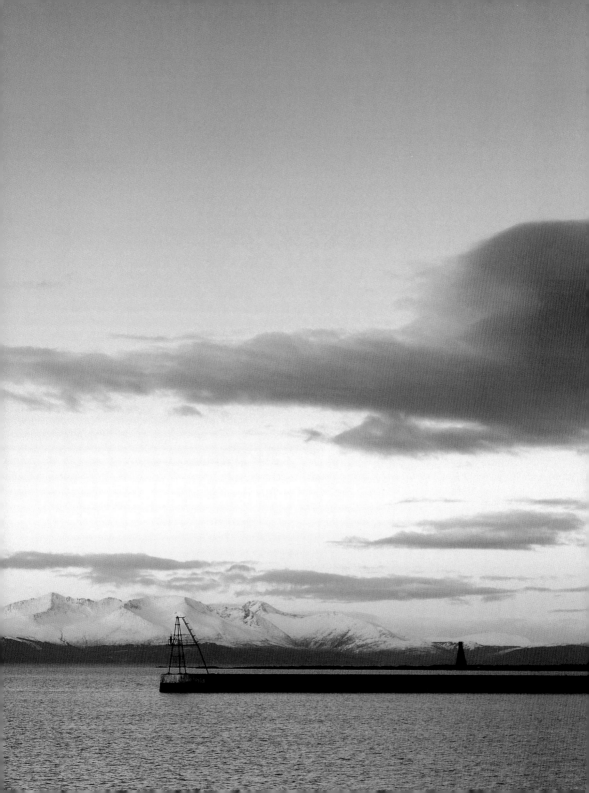

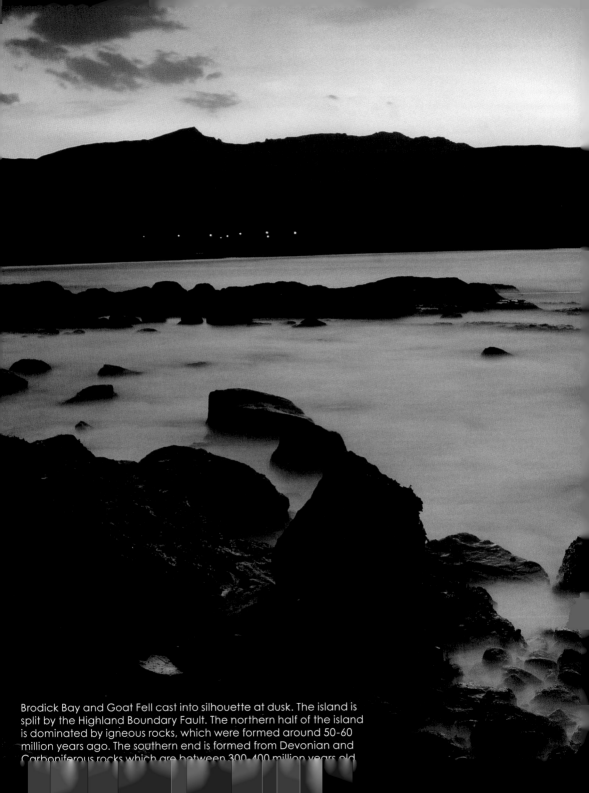

Brodick Bay and Goat Fell cast into silhouette at dusk. The island is split by the Highland Boundary Fault. The northern half of the island is dominated by igneous rocks, which were formed around 50-60 million years ago. The southern end is formed from Devonian and Carboniferous rocks which are between 300-400 million years old.

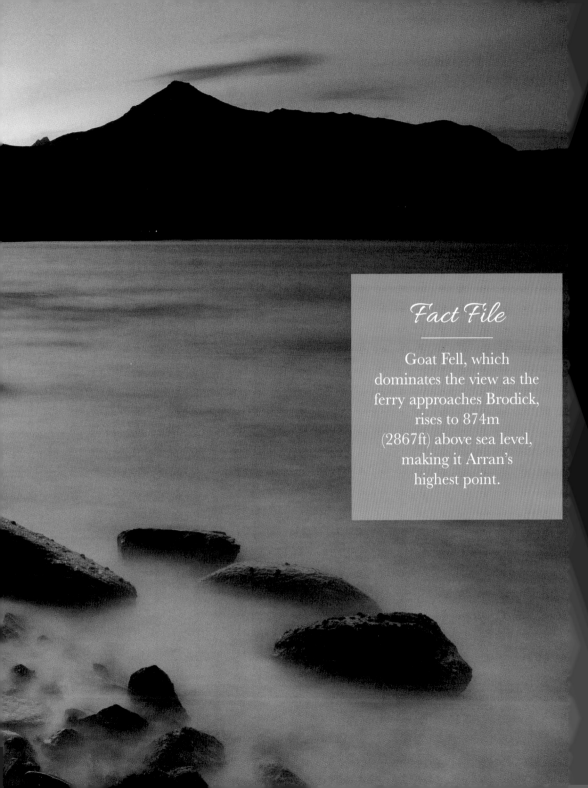

Fact File

Goat Fell, which
dominates the view as the
ferry approaches Brodick,
rises to 874m
(2867ft) above sea level,
making it Arran's
highest point.

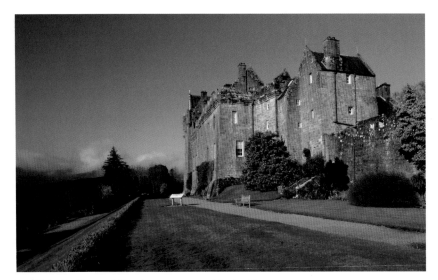

Brodick Castle and Gardens are cared for by the
National Trust for Scotland.

Early morning light picks out the vibrant colours along the shore at Pirate's
Cove, near Corrie. A number of erratic boulders rest on the beach here, having
been carried down from the mountains by glaciers around 15,000 years ago.

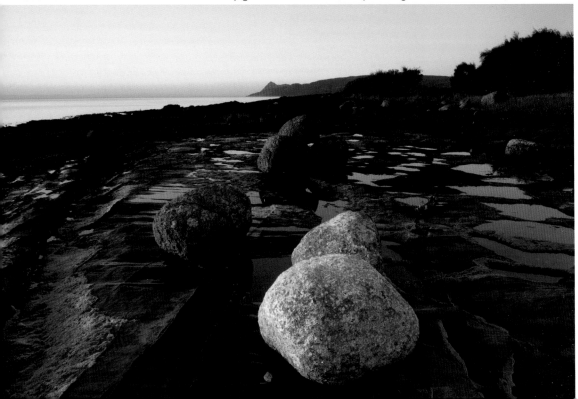

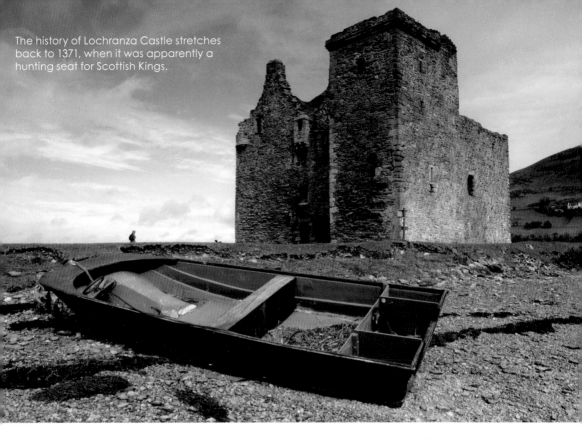

The history of Lochranza Castle stretches back to 1371, when it was apparently a hunting seat for Scottish Kings.

The enormous Black Cave is one of the many geological marvels along Arran's coastline.

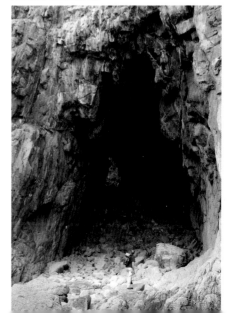

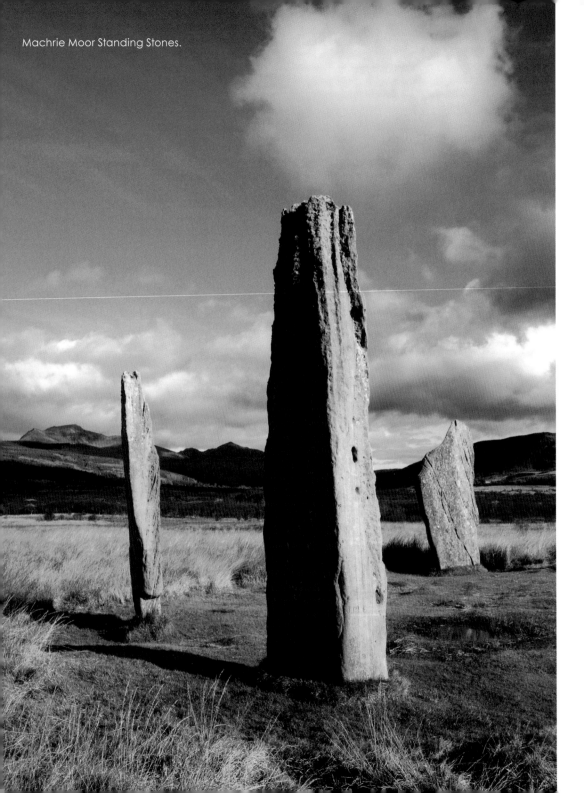
Machrie Moor Standing Stones.

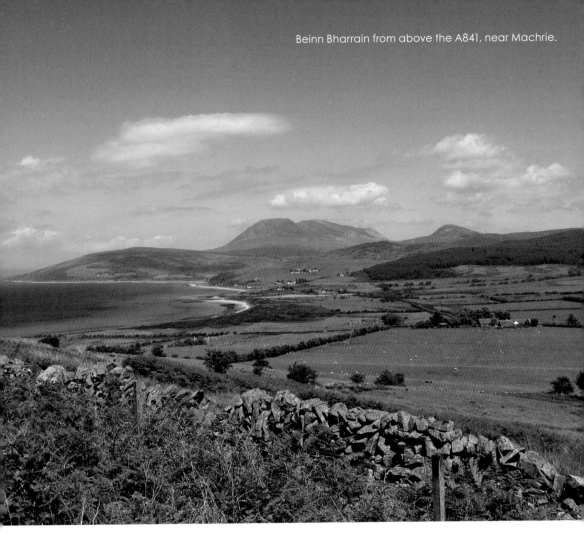

Beinn Bharrain from above the A841, near Machrie.

Fact File

Machrie Moor Standing Stones date from around 3500 BC and are thought to be a burial site for an important clan member. During excavations Neolithic pottery has also been found.

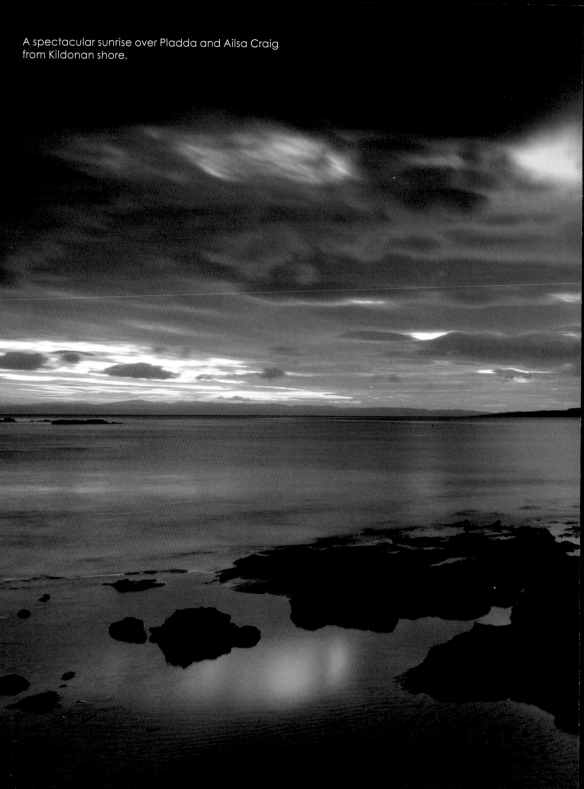

A spectacular sunrise over Pladda and Ailsa Craig from Kildonan shore.

Pladda and its 18th century lighthouse, built in 1790 and automated in 1990.

Fact File

The island of Pladda, off the coast of Kildonan, rises to only 27m (89ft) above sea level and, incredibly, has its own source of fresh water.

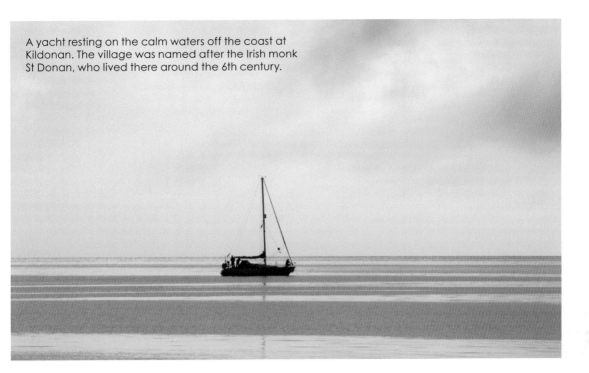

A yacht resting on the calm waters off the coast at Kildonan. The village was named after the Irish monk St Donan, who lived there around the 6th century.

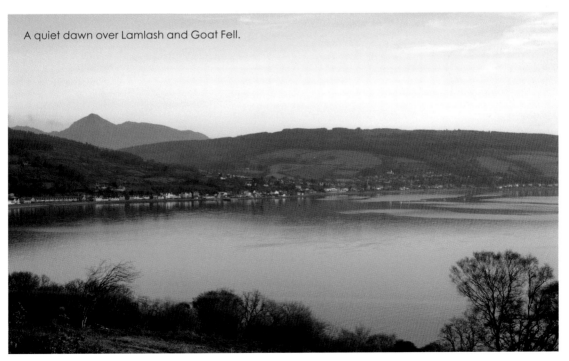

A quiet dawn over Lamlash and Goat Fell.

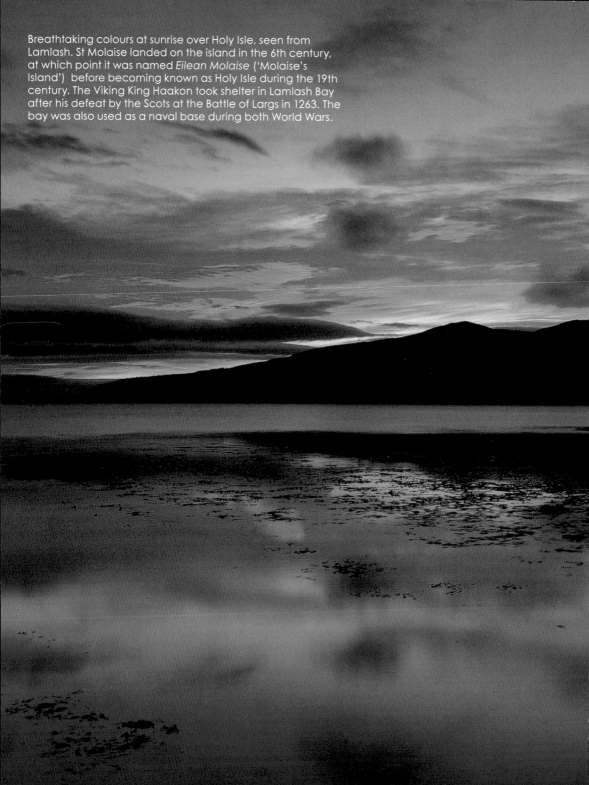

Breathtaking colours at sunrise over Holy Isle, seen from Lamlash. St Molaise landed on the island in the 6th century, at which point it was named *Eilean Molaise* ('Molaise's Island') before becoming known as Holy Isle during the 19th century. The Viking King Haakon took shelter in Lamlash Bay after his defeat by the Scots at the Battle of Largs in 1263. The bay was also used as a naval base during both World Wars.

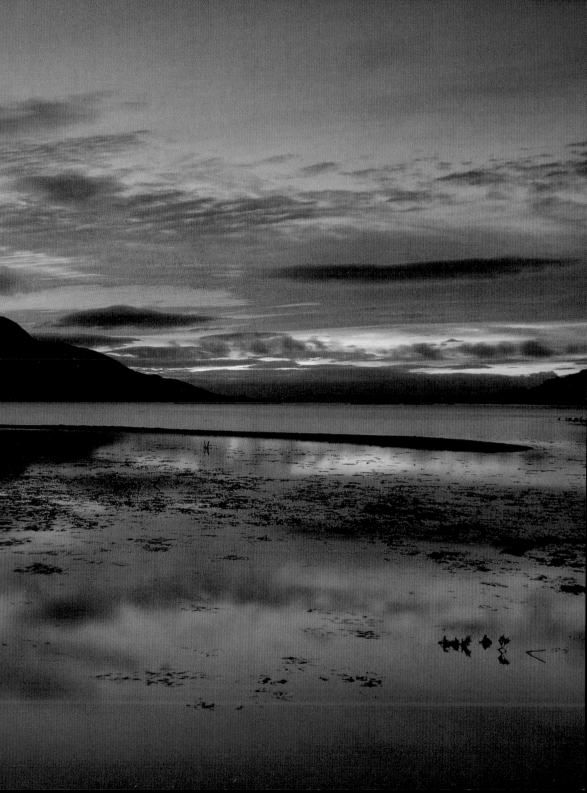

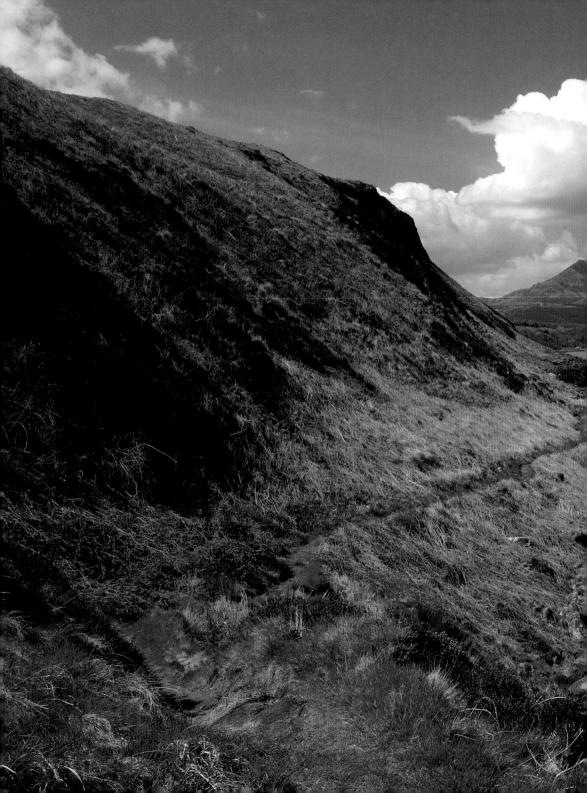

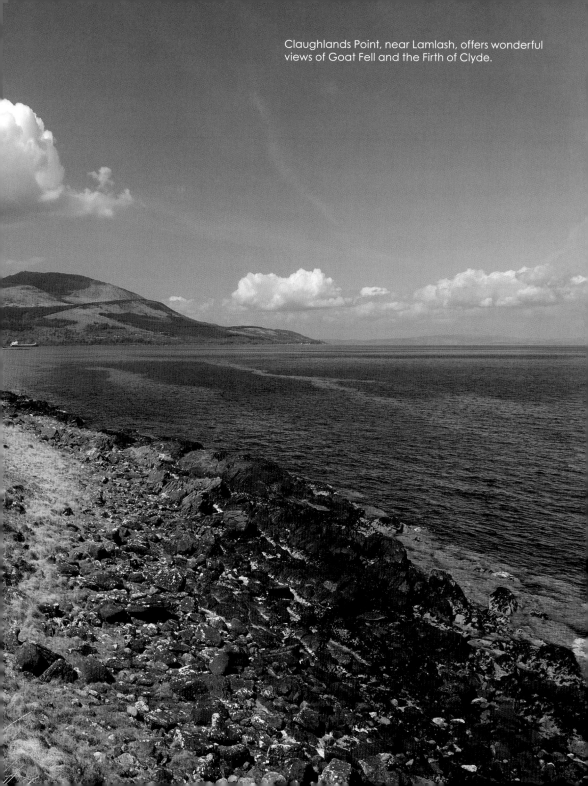

Claughlands Point, near Lamlash, offers wonderful views of Goat Fell and the Firth of Clyde.

CHAPTER THREE

Exquisite East Lothian

Musselburgh to Dunbar

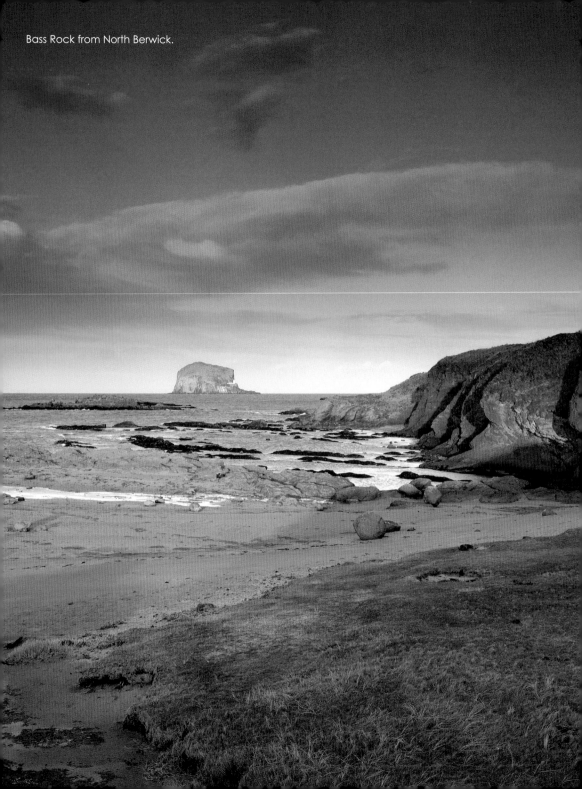

Bass Rock from North Berwick.

Musselburgh *to* Dunbar

Scotland's east coast is sometimes overlooked by tourists rushing to its dramatic west coast cousin.

Yet long stretches, particularly the gorgeous East Lothian coastline, are as scenically inspiring as anywhere along Scotland's renowned western seaboard.

Between the vibrant settlements of Musselburgh and Dunbar are a string of stunning sandy beaches, impressive craggy cliffs, and a number of striking topographic features such as Fidra, Bass Rock and North Berwick Law.

The section of the journey through Aberlady, Gullane and North Berwick is known as Scotland's 'Golf Course Road', due to the proliferation of championship links courses.

By following the B1348 then the A198 and A199, a wonderful sense of space can be enjoyed, under big skies and beautiful light.

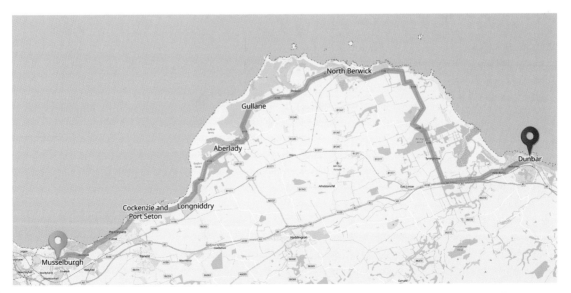

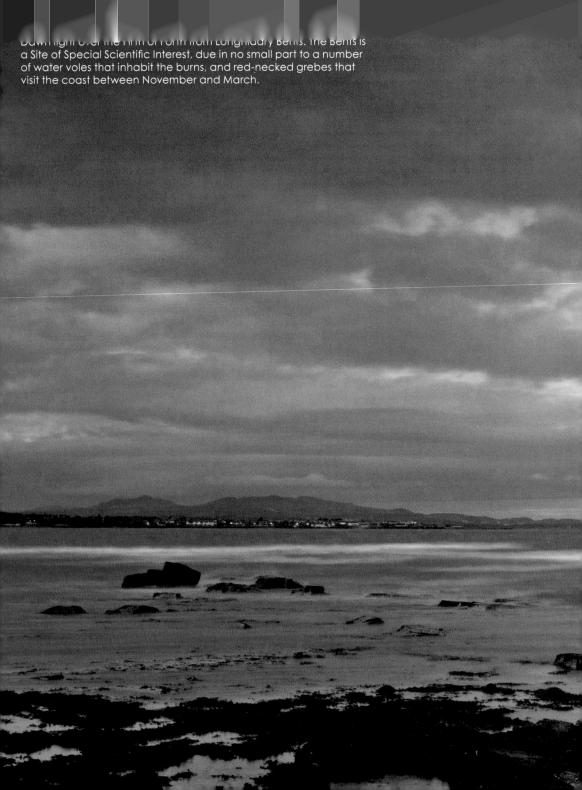

Dawn light over the Firth of Forth from Longniddry Bents. The Bents is a Site of Special Scientific Interest, due in no small part to a number of water voles that inhabit the burns, and red-necked grebes that visit the coast between November and March.

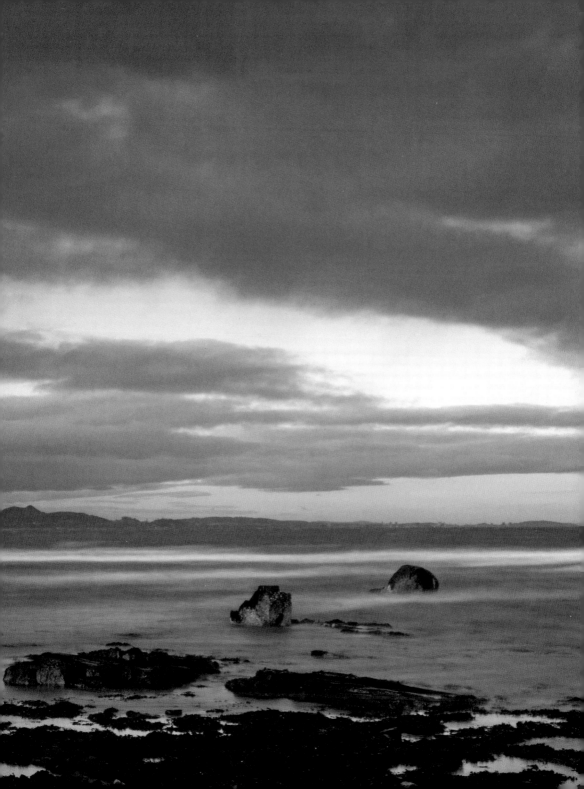

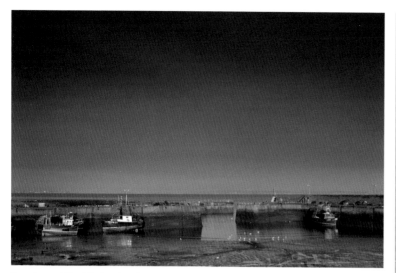

Trawlers at Port Seton harbour.

The Edinburgh skyline from Musselburgh, one of Scotland's oldest towns and the largest in East Lothian. Musselburgh prospered in the 17th century due to industries such as fishing (Musselburgh translates simply as 'Mussel Town'), wool and coal mining.

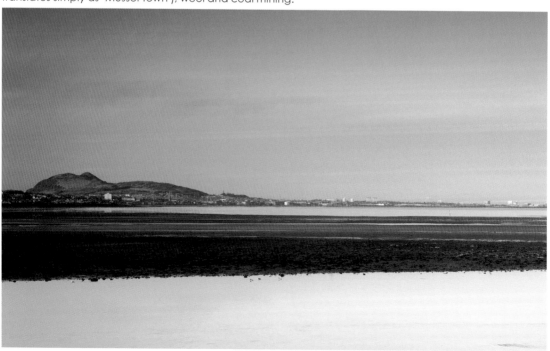

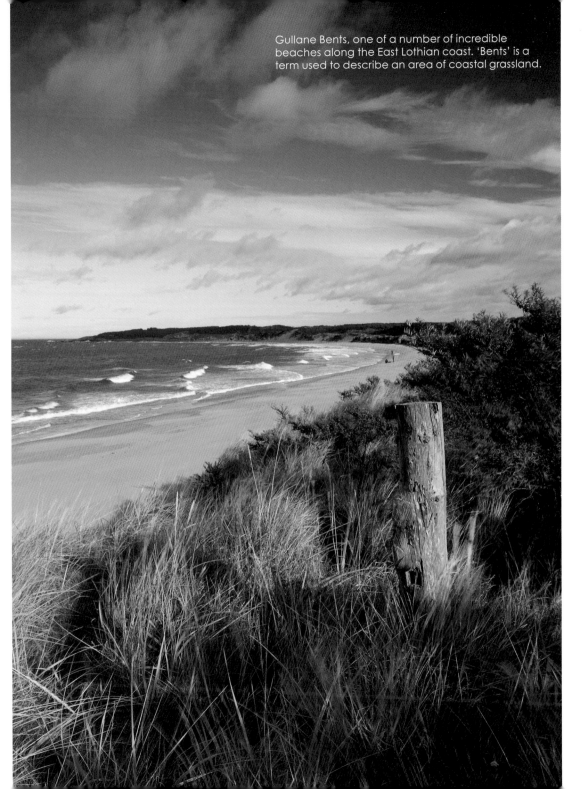

Gullane Bents, one of a number of incredible beaches along the East Lothian coast. 'Bents' is a term used to describe an area of coastal grassland.

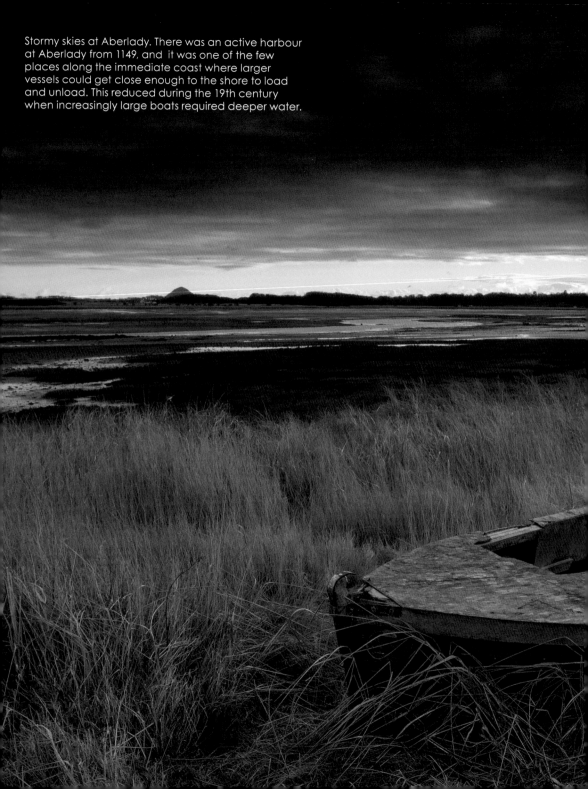

Stormy skies at Aberlady. There was an active harbour at Aberlady from 1149, and it was one of the few places along the immediate coast where larger vessels could get close enough to the shore to load and unload. This reduced during the 19th century when increasingly large boats required deeper water.

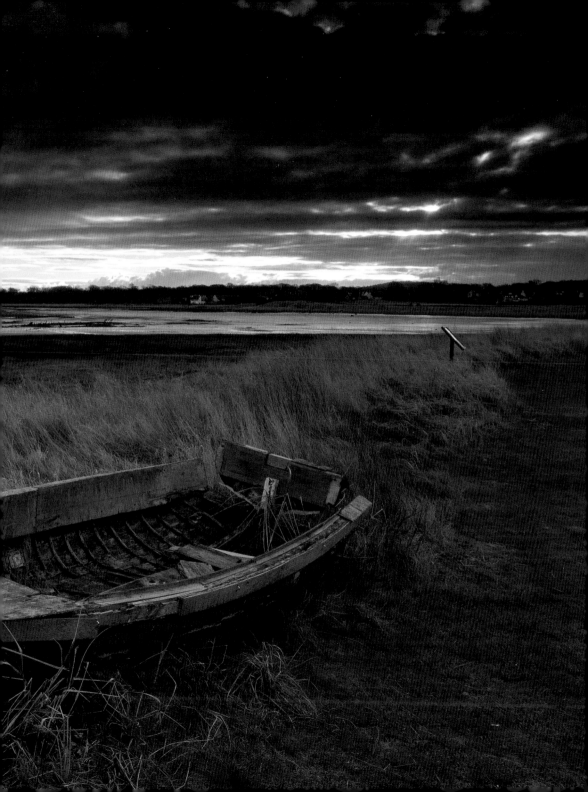

The incredible dune system between Aberlady and Gullane.

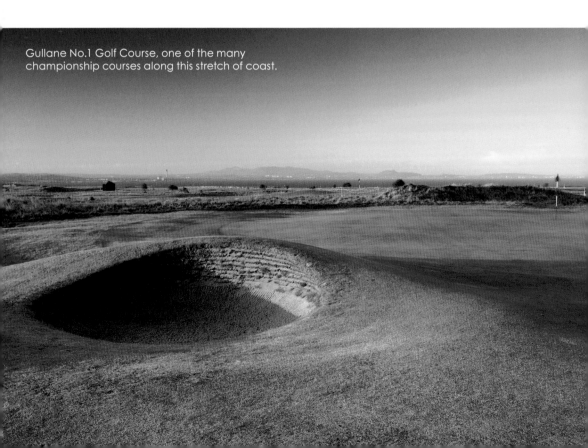

Gullane No.1 Golf Course, one of the many championship courses along this stretch of coast.

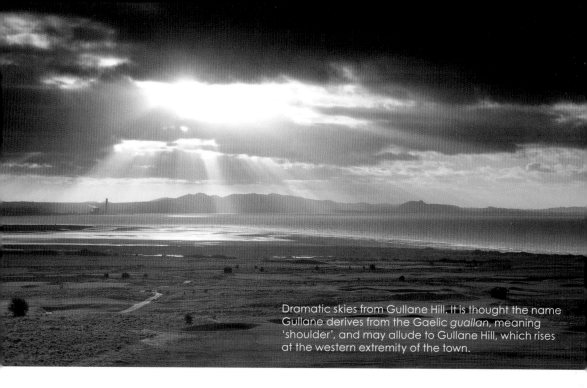

Dramatic skies from Gullane Hill. It is thought the name Gullane derives from the Gaelic *guallan*, meaning 'shoulder', and may allude to Gullane Hill, which rises at the western extremity of the town.

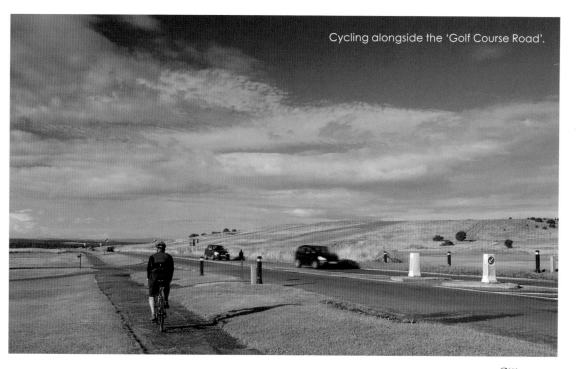

Cycling alongside the 'Golf Course Road'.

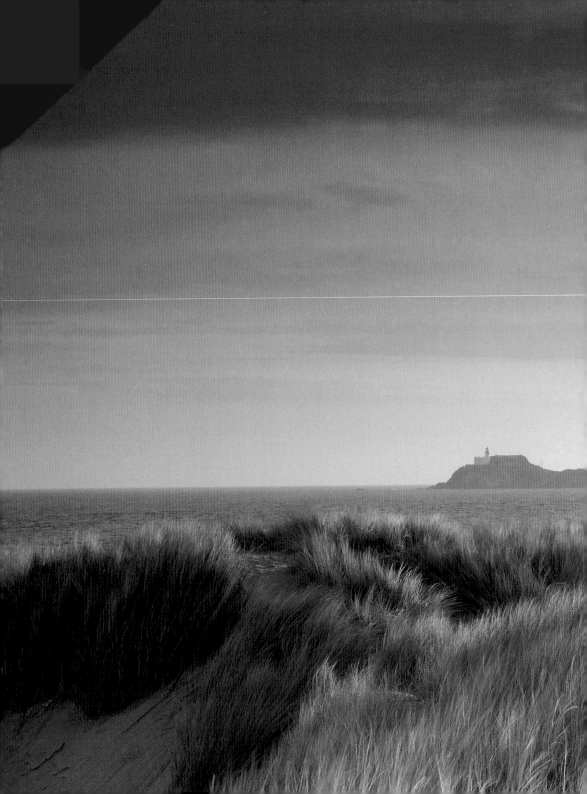

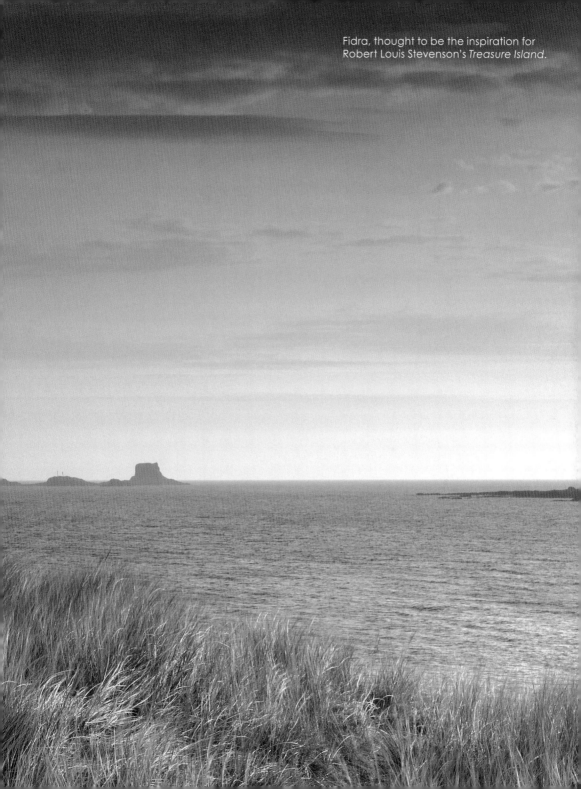

Fidra, thought to be the inspiration for Robert Louis Stevenson's *Treasure Island*.

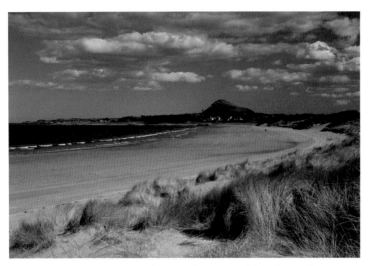

Looking towards North Berwick Law from Broad Sands. North Berwick's history stretches back to the 12th century, when it developed around its harbour. A ferry service used to leave North Berwick and cross the Firth of Forth to Earlsferry in Fife. It was a popular shortcut for pilgrims heading to St Andrews.

Late evening light over Bass Rock, seen from North Berwick.

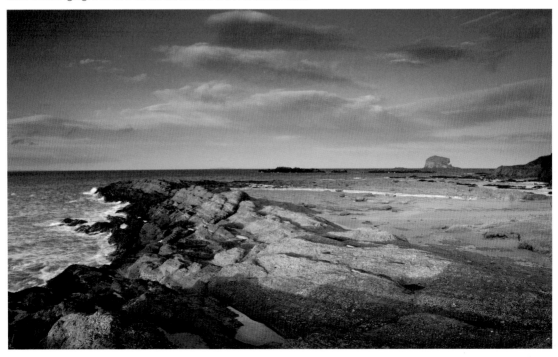

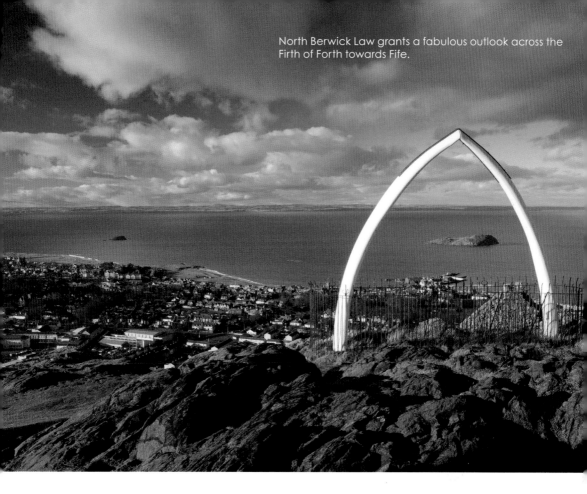

North Berwick Law grants a fabulous outlook across the Firth of Forth towards Fife.

Seacliff and Bass Rock.

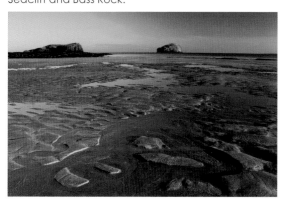

Ravensheugh Sands is one of Scotland's finest beaches.

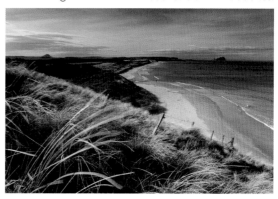

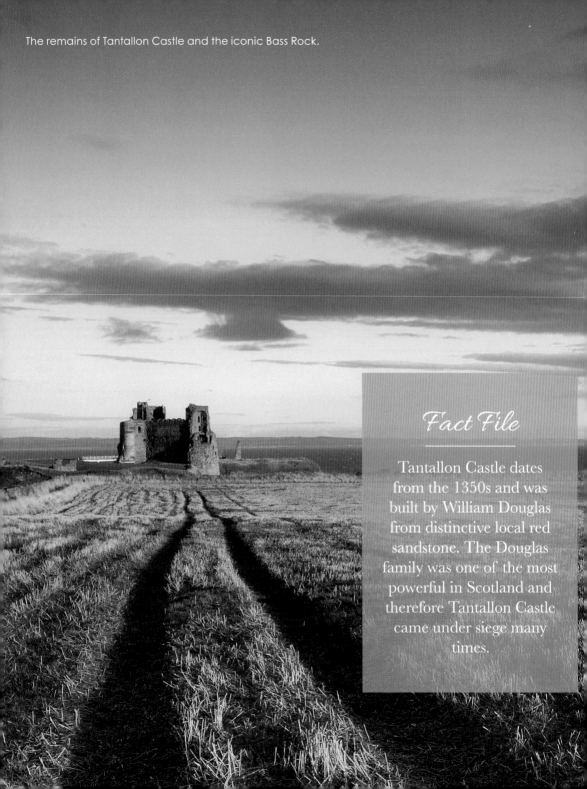

The remains of Tantallon Castle and the iconic Bass Rock.

Fact File

Tantallon Castle dates from the 1350s and was built by William Douglas from distinctive local red sandstone. The Douglas family was one of the most powerful in Scotland and therefore Tantallon Castle came under siege many times.

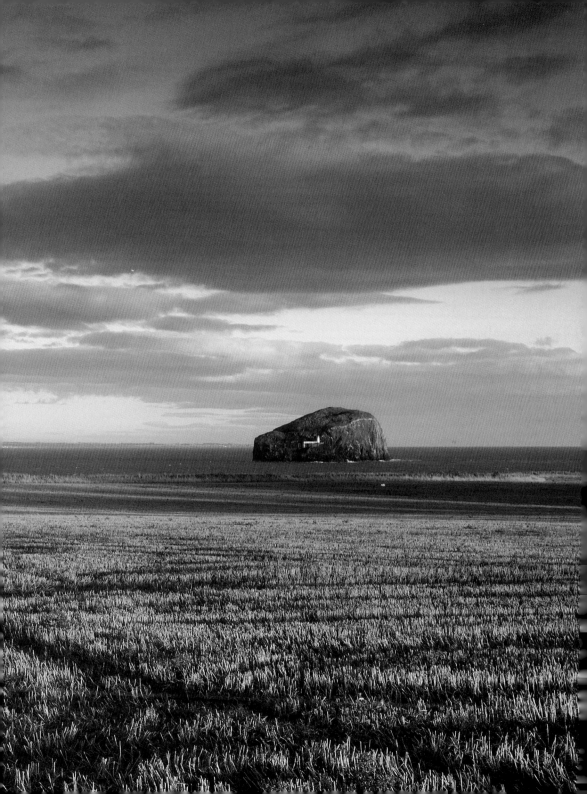

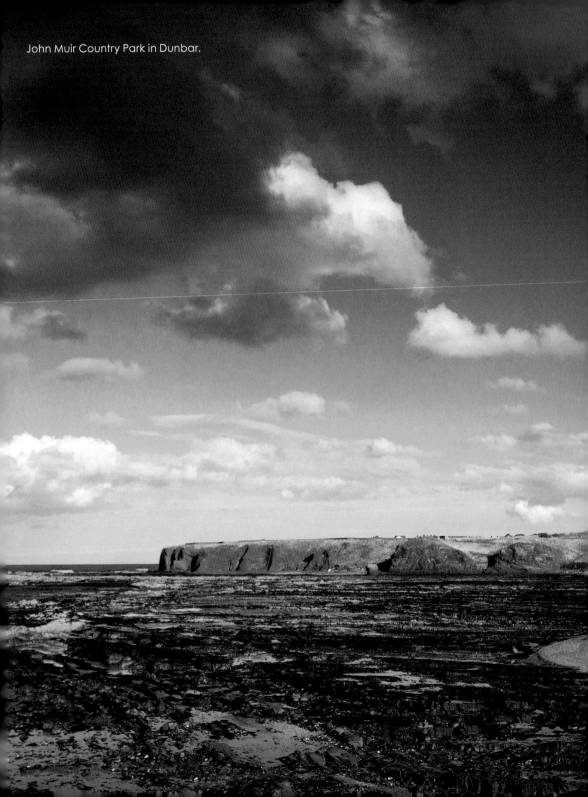
John Muir Country Park in Dunbar.

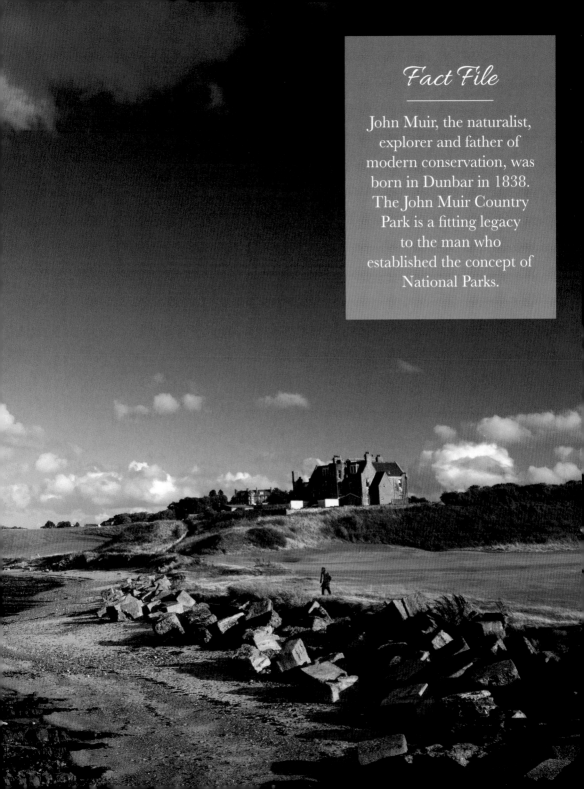

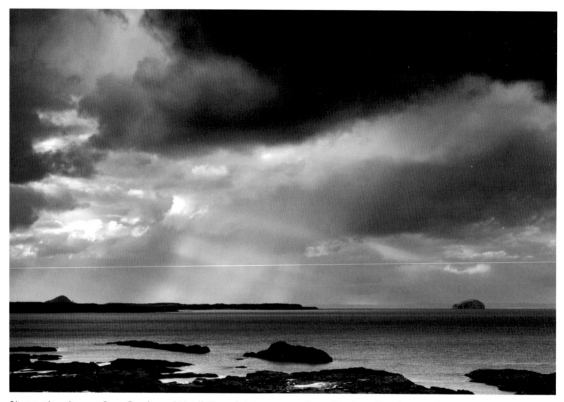

Storm clouds over Bass Rock and North Berwick Law, seen from Dunbar. The town's history extends back around 2000 years. At this time, a fort was built where the remains of Dunbar Castle stand today, and over the subsequent centuries the castle became one of the most important in Scotland.

Cromwell Harbour was opened in 1730 and established the town as a major fishing port.

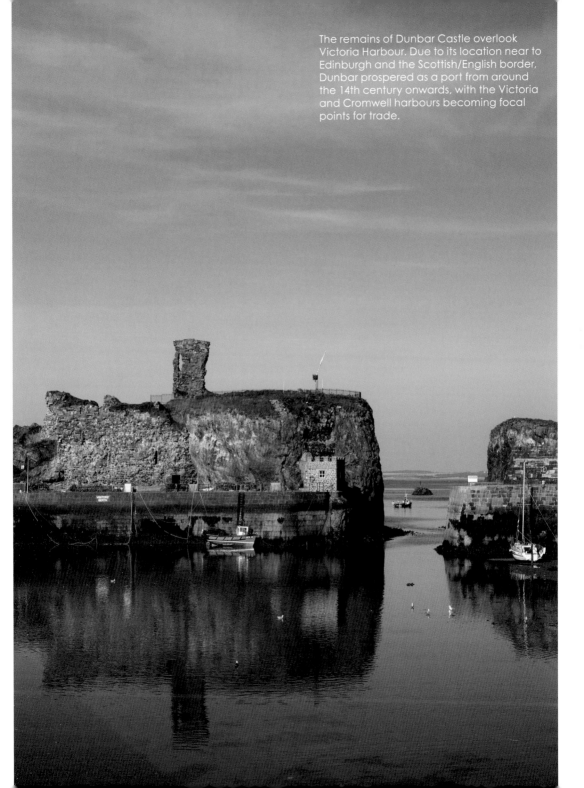

The remains of Dunbar Castle overlook Victoria Harbour. Due to its location near to Edinburgh and the Scottish/English border, Dunbar prospered as a port from around the 14th century onwards, with the Victoria and Cromwell harbours becoming focal points for trade.

CHAPTER FOUR

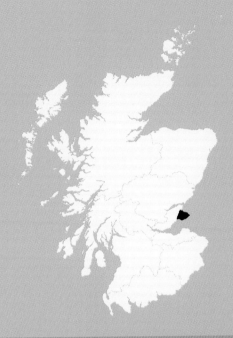

Fife's Historic East Neuk

Lower Largo
to St Andrews

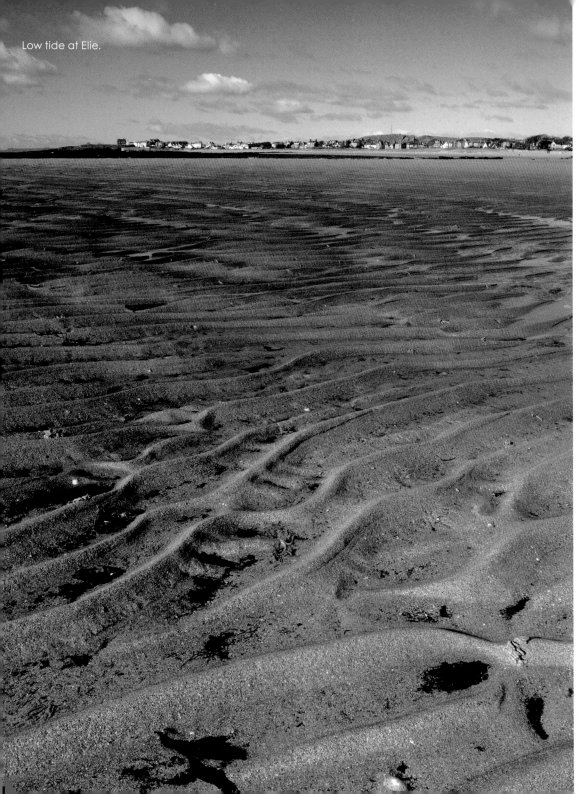

Low tide at Elie.

The East Neuk of Fife

With a fascinating history, a necklace of beautiful beaches, and breathtaking scenery, the sliver of coastline between Lower Largo and St Andrews is an exceptional part of Scotland.

Better known as the East Neuk of Fife, the landscape is punctuated by a number of celebrated links golf courses, including the Old Course at St Andrews. Golf and tourism play a major role in the Neuk's economy today, but it is fishing that has been foremost in the area's development over the centuries.

There are still some busy working harbours, particularly at Crail, Anstruther and Pittenweem, but not to the same extent as in the past. It is said that 50 years ago you could walk from one side of Anstruther's wide harbour to the other by stepping from fishing boat to fishing boat.

Elie's award-winning beach is a wonderful spot to relax, while the East Neuk is renowned for its delicious fish suppers.

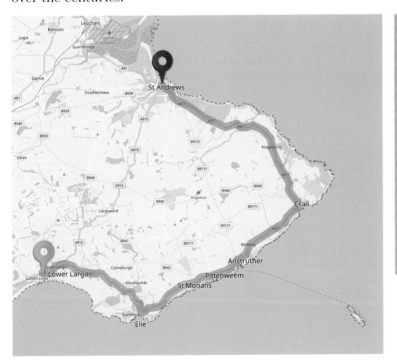

Fact File

Neuk is the old Scots word for 'corner', and the East Neuk is the name given to the landscape around Fife's Eastern peninsula.

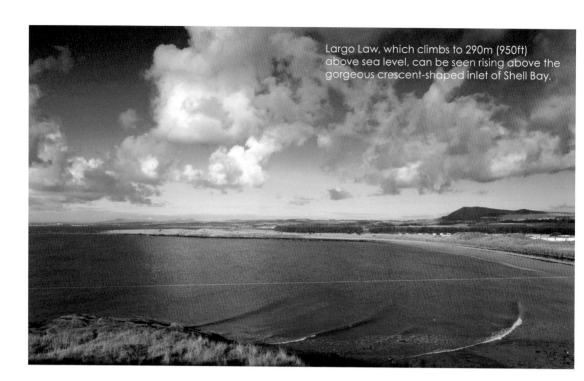

Largo Law, which climbs to 290m (950ft) above sea level, can be seen rising above the gorgeous crescent-shaped inlet of Shell Bay.

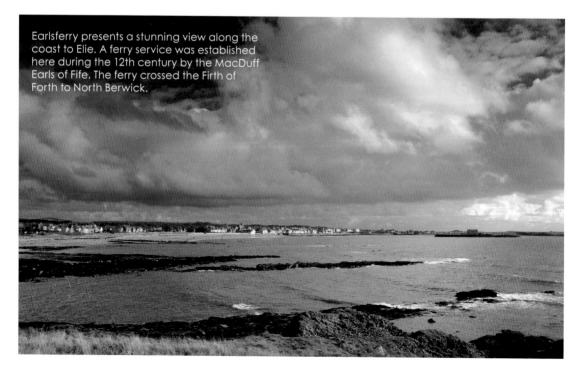

Earlsferry presents a stunning view along the coast to Elie. A ferry service was established here during the 12th century by the MacDuff Earls of Fife. The ferry crossed the Firth of Forth to North Berwick.

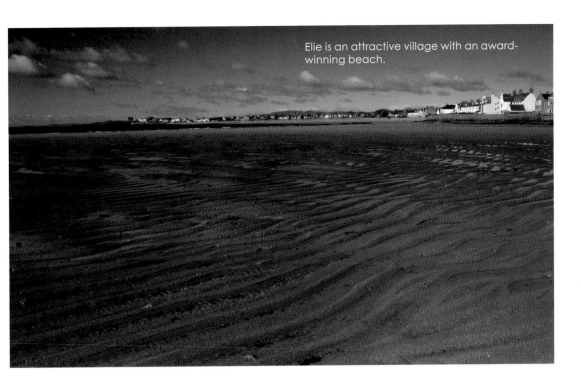

Elie is an attractive village with an award-winning beach.

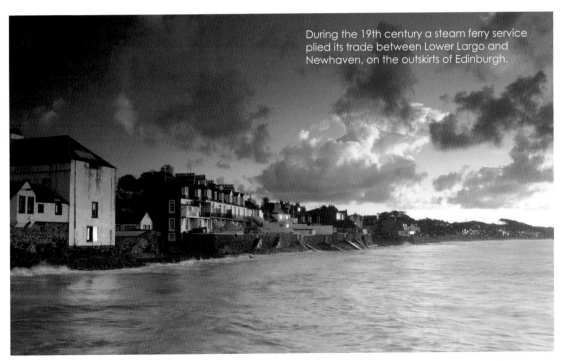

During the 19th century a steam ferry service plied its trade between Lower Largo and Newhaven, on the outskirts of Edinburgh.

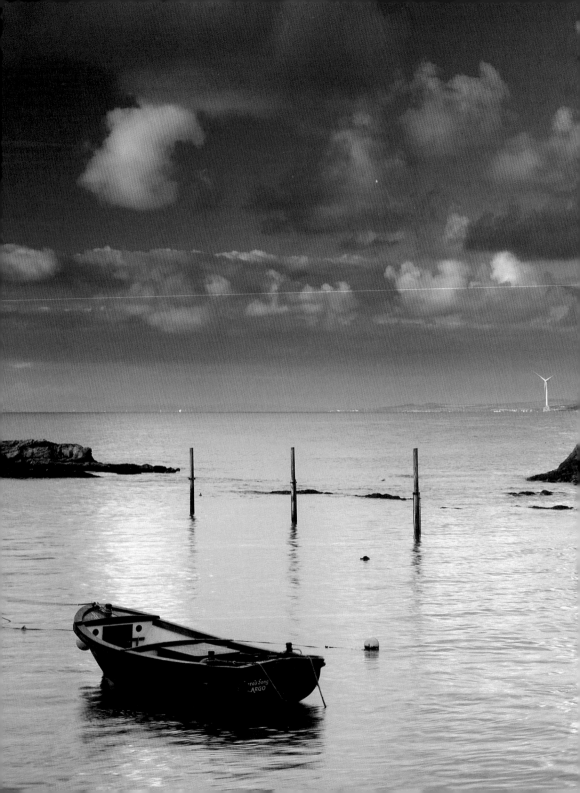

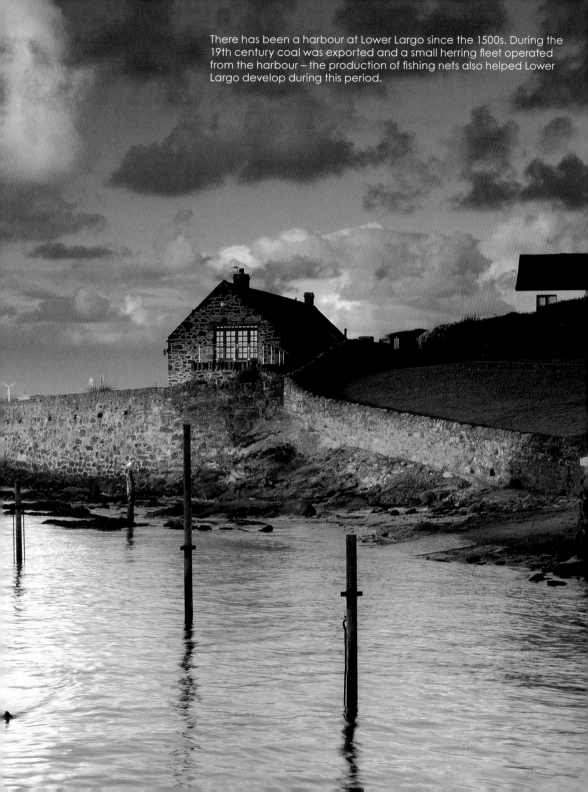

There has been a harbour at Lower Largo since the 1500s. During the 19th century coal was exported and a small herring fleet operated from the harbour – the production of fishing nets also helped Lower Largo develop during this period.

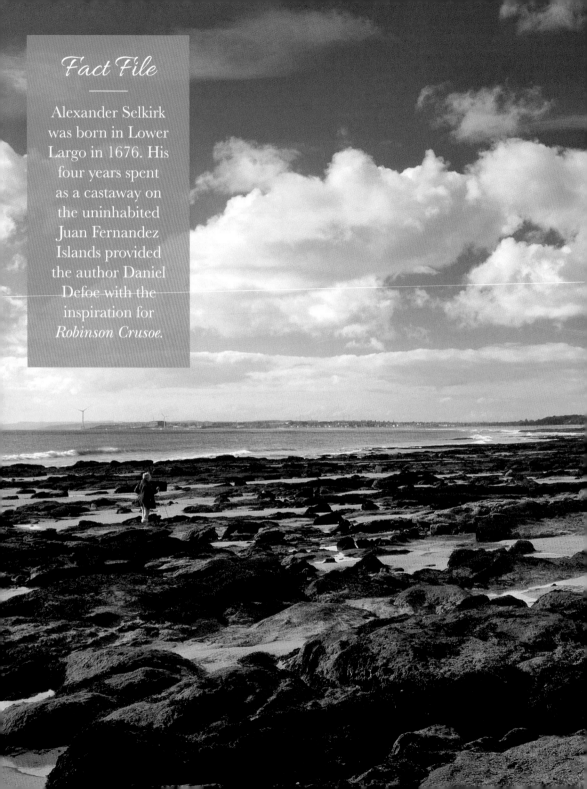

Fact File

Alexander Selkirk
was born in Lower
Largo in 1676. His
four years spent
as a castaway on
the uninhabited
Juan Fernandez
Islands provided
the author Daniel
Defoe with the
inspiration for
Robinson Crusoe.

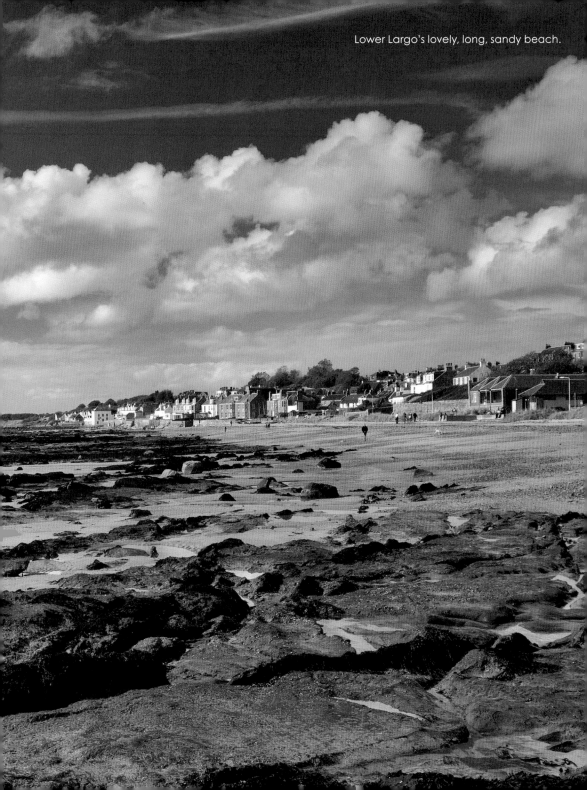

Lower Largo's lovely, long, sandy beach.

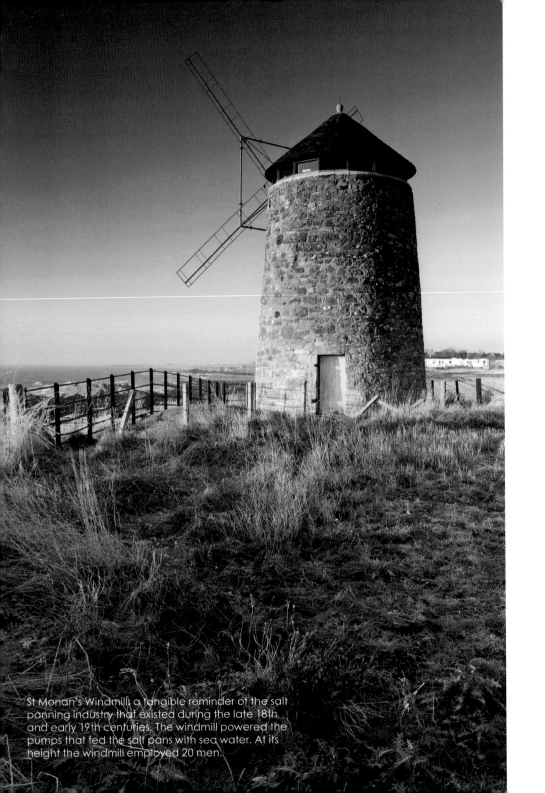

St Monan's Windmill; a tangible reminder of the salt panning industry that existed during the late 18th and early 19th centuries. The windmill powered the pumps that fed the salt pans with sea water. At its height the windmill employed 20 men.

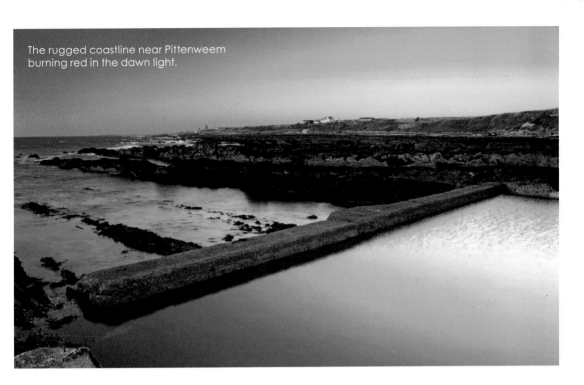

The rugged coastline near Pittenweem burning red in the dawn light.

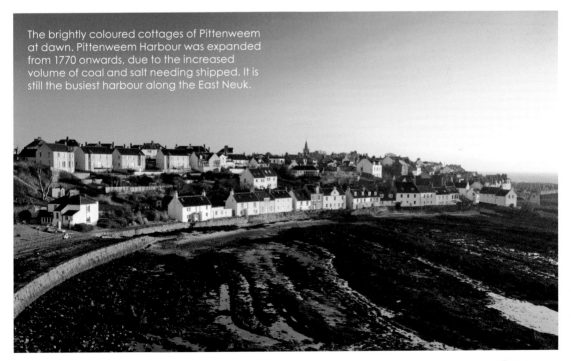

The brightly coloured cottages of Pittenweem at dawn. Pittenweem Harbour was expanded from 1770 onwards, due to the increased volume of coal and salt needing shipped. It is still the busiest harbour along the East Neuk.

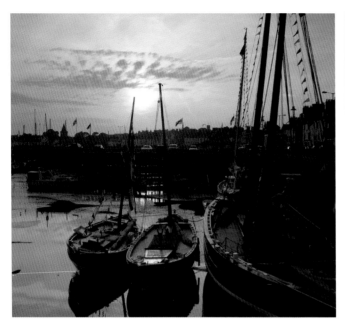

Anstruther Harbour at dusk. Anstruther's history is indelibly linked to the fishing industry.

Fact File

Anstruther is home to the superb Scottish Fisheries Museum, which details the history of Scottish fishing from earliest times to the present day.

•

Crail was granted Royal Burgh status by Robert the Bruce in 1310, along with the right to hold markets on a Sunday.

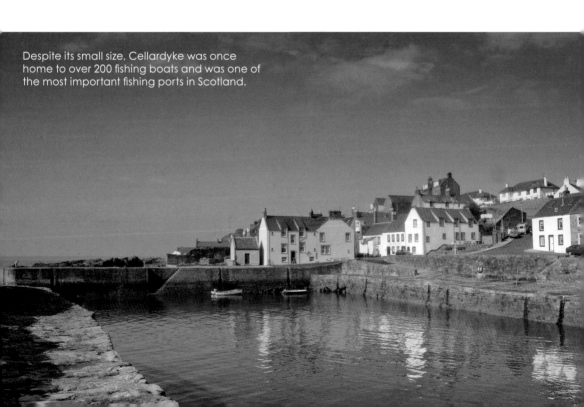

Despite its small size, Cellardyke was once home to over 200 fishing boats and was one of the most important fishing ports in Scotland.

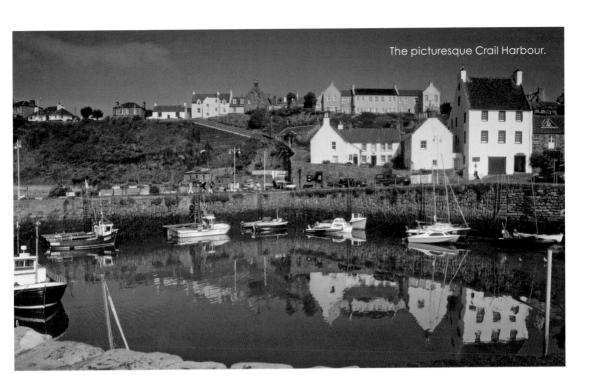
The picturesque Crail Harbour.

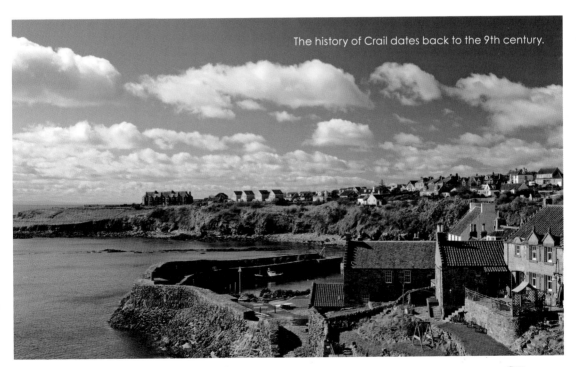
The history of Crail dates back to the 9th century.

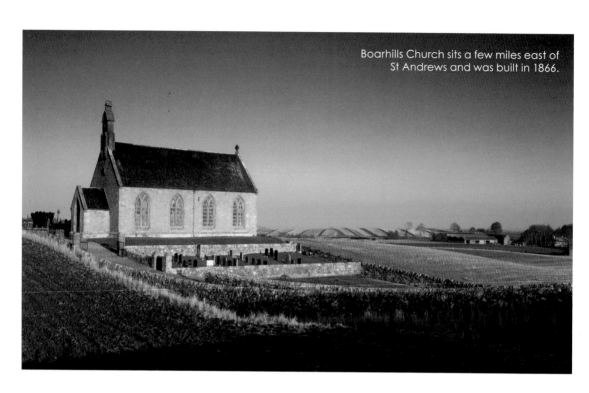

Boarhills Church sits a few miles east of St Andrews and was built in 1866.

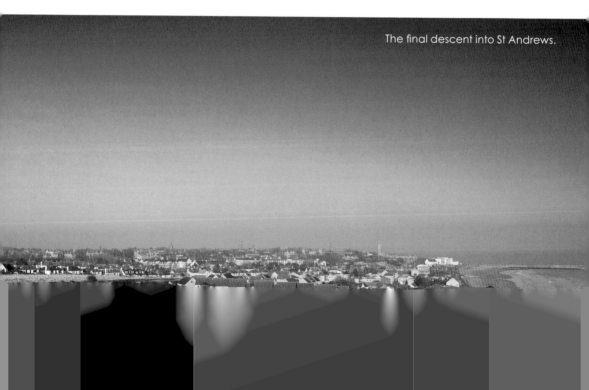

The final descent into St Andrews.

Work began on St Andrews Cathedral in 1160 but it was only dedicated in 1318, in the presence of King Robert the Bruce. The site had been used for worship since the 8th century, when the relics of Scotland's patron saint, St Andrew, were said to have been brought there. The cathedral went on to become the country's largest medieval church and the seat of Scotland's leading bishops and archbishops.

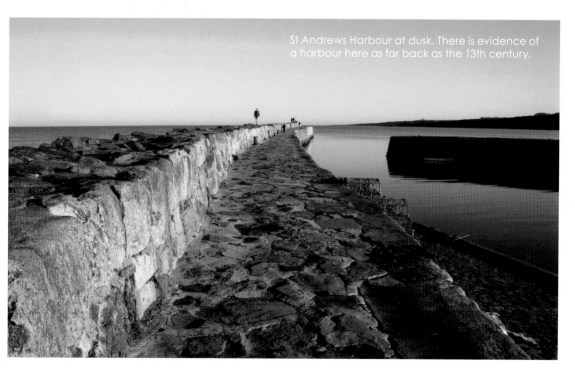

St Andrews Harbour at dusk. There is evidence of a harbour here as far back as the 13th century.

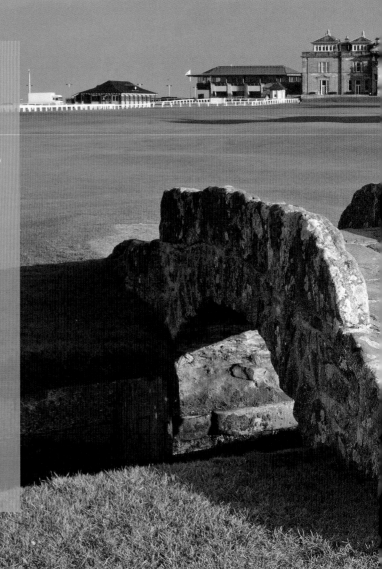

The Old Course, St Andrews, also known as The Home of Golf. The famous Swilken Bridge straddles the Swilken Burn on the Old Course's 18th hole.

Fact File

St Andrews hosts the Open Championship every five years. It is also home to St Andrews University, the oldest in Scotland and the third-oldest English-speaking university in the world.

•

More than 45,000 rounds are played annually on the Old Course and nearly 220,000 rounds over all St Andrews' seven courses. It is thought that golf has been played there since the 1400s.

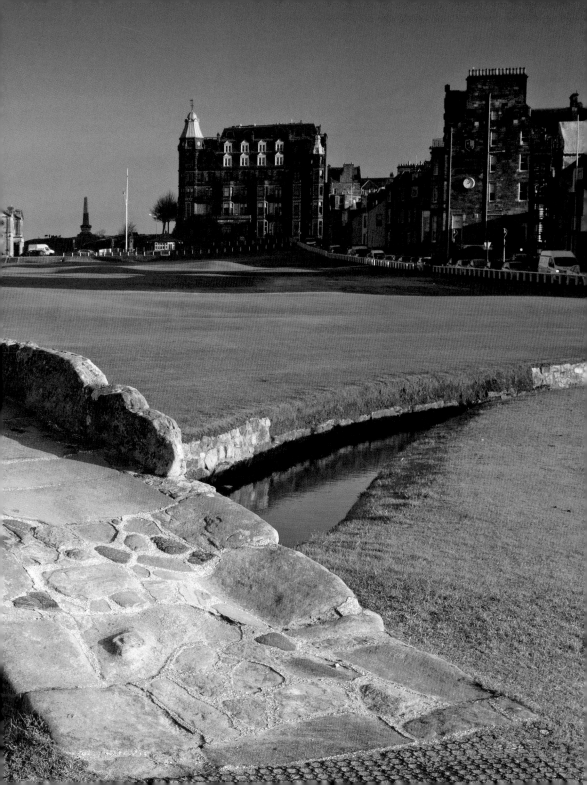

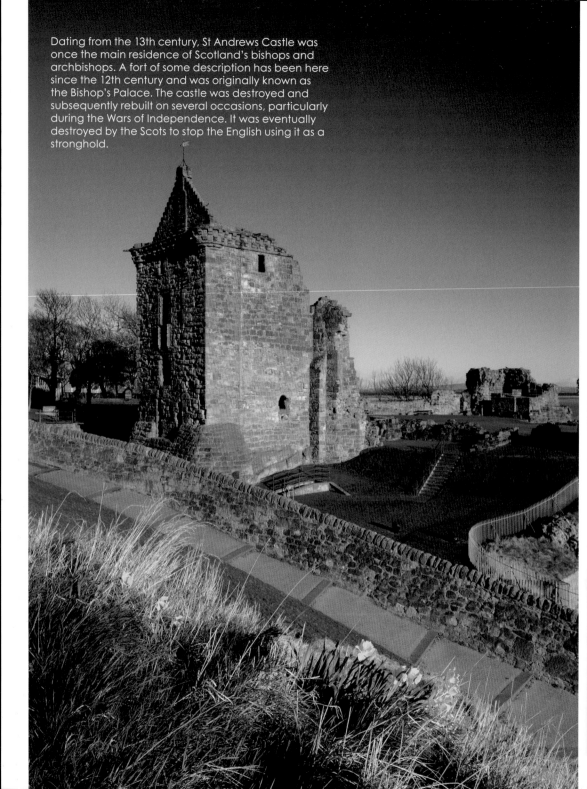

Dating from the 13th century, St Andrews Castle was once the main residence of Scotland's bishops and archbishops. A fort of some description has been here since the 12th century and was originally known as the Bishop's Palace. The castle was destroyed and subsequently rebuilt on several occasions, particularly during the Wars of Independence. It was eventually destroyed by the Scots to stop the English using it as a stronghold.

Jubilee Links, one of the many championship golf courses along the East Neuk.

Walking along West Sands, St Andrews.

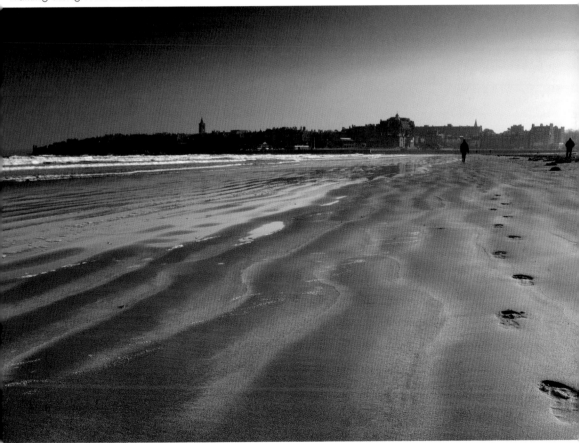

CHAPTER FIVE

The Spectacular A83

Tarbet *to* Lochgilphead

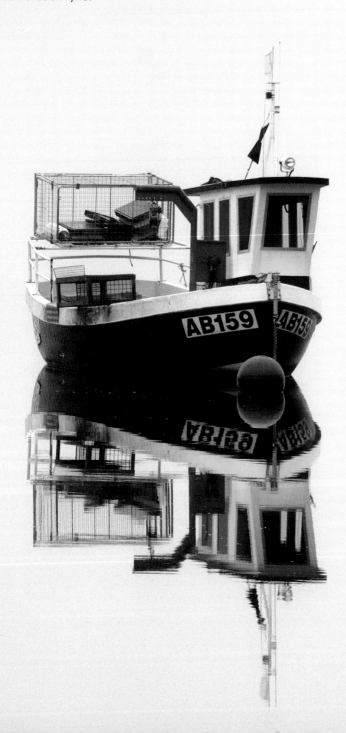

A fishing trawler perfectly reflected in the waters of Loch Fyne.

Tarbet *to* Lochgilphead

The A83, which branches off the A82 at Tarbet on Loch Lomondside, travels through a majestic landscape, one that can rival its longer, better-known thoroughfare.

Its 77km (48 mile) journey culminates at the attractive town of Lochgilphead, the administrative centre for Argyll & Bute, having run alongside a number of beautiful lochs, including Loch Long, Loch Fyne and Loch Gilp.

The A83 also climbs over the spectacular Rest And Be Thankful, which is flanked by a chain of jagged peaks, such as Beinn an Lochain and the iconic Ben Arthur, known to many as the Cobbler.

Inveraray, the beautiful gardens of Ardkinglas and Crarae, and the historic township of Auchindrain are just some of the attractions awaiting the ardent traveller.

Fact File

Tarbet means 'Place of Portage'. Famously, in 1263, the Vikings carried their longships over ground between Loch Long and Loch Lomond.

•

Loch Long translates as 'Loch of Ships', which may relate to the boats that once navigated their way inland from the sea.

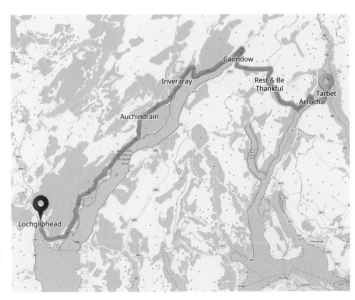

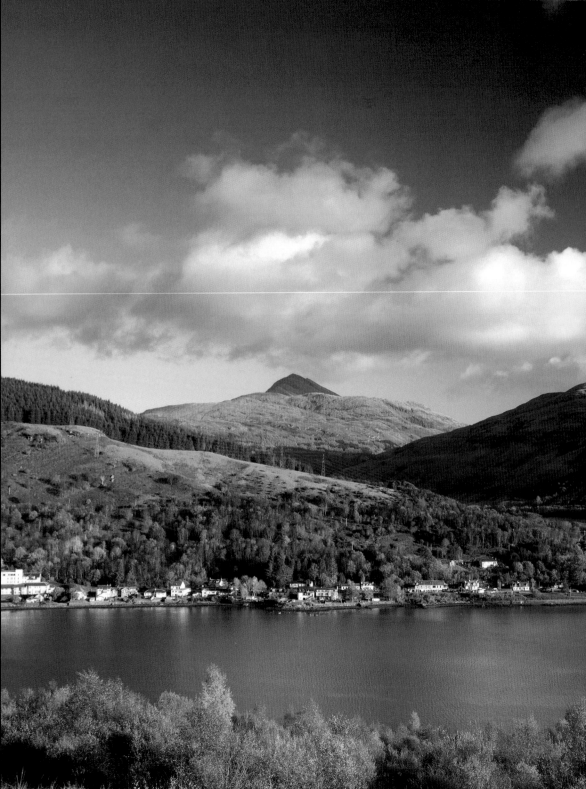

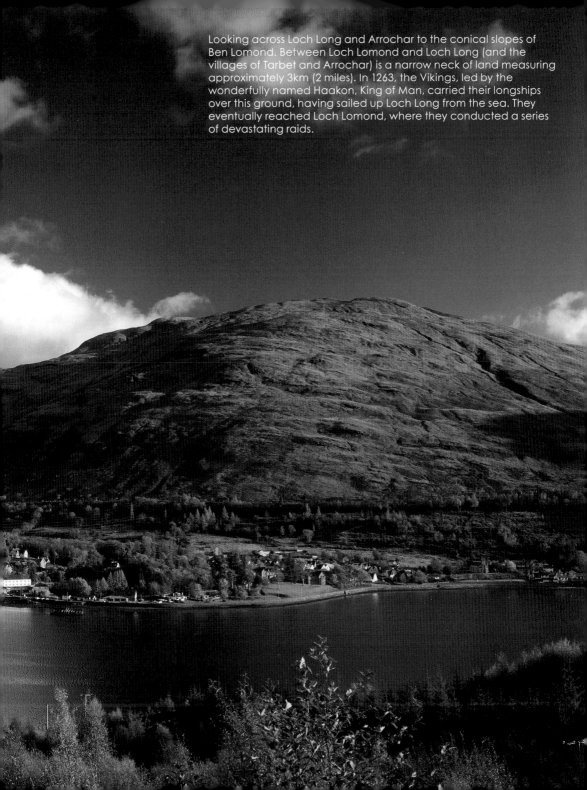

Looking across Loch Long and Arrochar to the conical slopes of Ben Lomond. Between Loch Lomond and Loch Long (and the villages of Tarbet and Arrochar) is a narrow neck of land measuring approximately 3km (2 miles). In 1263, the Vikings, led by the wonderfully named Haakon, King of Man, carried their longships over this ground, having sailed up Loch Long from the sea. They eventually reached Loch Lomond, where they conducted a series of devastating raids.

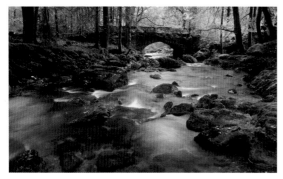

The River Croe at Ardgartan, which translates from Gaelic as 'The High Garden'. The River Croe begins its journey 7.5km (4.7 miles) to the northwest, near the top of the Rest And Be Thankful.

Fact File

The Rest And Be Thankful sits at 244m (803ft) above sea level. Its name refers to the inscribed stone that was placed there by soldiers when they completed the original military road in the 1700s. Drovers, travellers and cyclists have made the steep climb from either Loch Long or Butterbridge ever since. Thomas Pennant, Boswell and Johnson, and Dorothy and William Wordsworth are just some of those who have enjoyed the spectacle.

The spectacular vista along Glen Croe, seen from the summit of the Rest And Be Thankful.

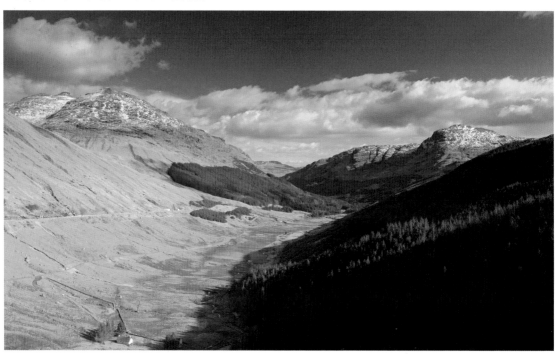

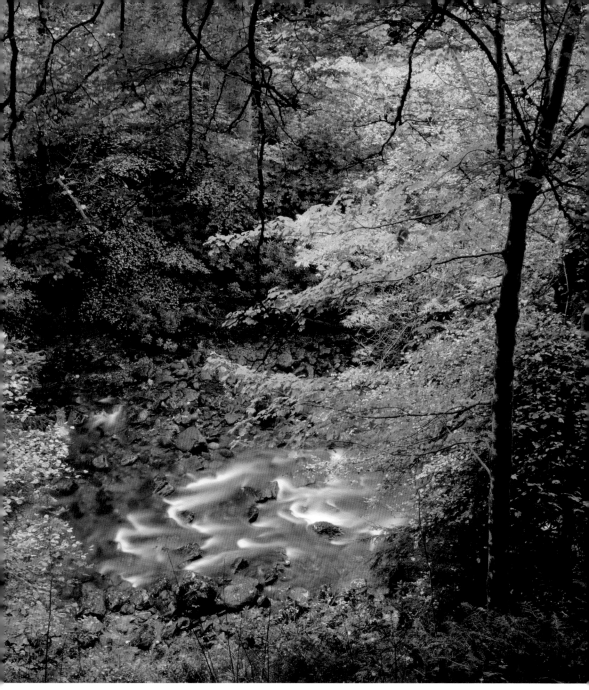

Gorgeous autumnal colours at Ardkinglas Woodland. It is thought that Sir Alexander Campbell laid out the estate during the 1700s, although there has been an orchard and culinary garden here since the 14th century. Exotic conifers from America and the Far East were then planted during the 19th century by the then-Laird, James Henry Callander. John and Michael Noble, of the Noble family that owned Ardkinglas, planted many of the rhododendrons in the early 1900s.

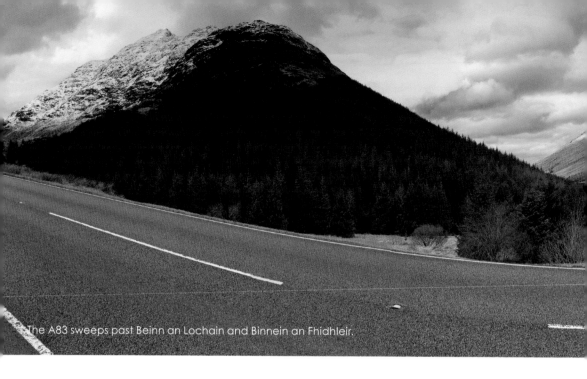

The A83 sweeps past Beinn an Lochain and Binnein an Fhidhleir.

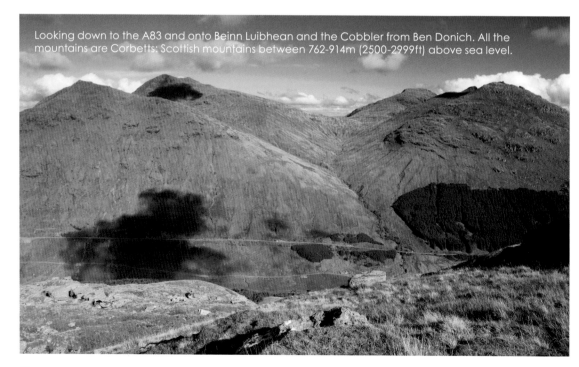

Looking down to the A83 and onto Beinn Luibhean and the Cobbler from Ben Donich. All the mountains are Corbetts: Scottish mountains between 762-914m (2500-2999ft) above sea level.

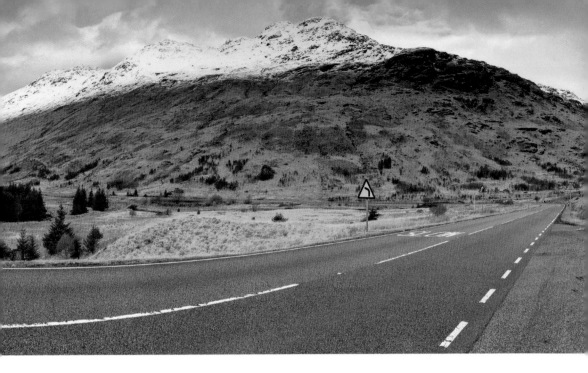

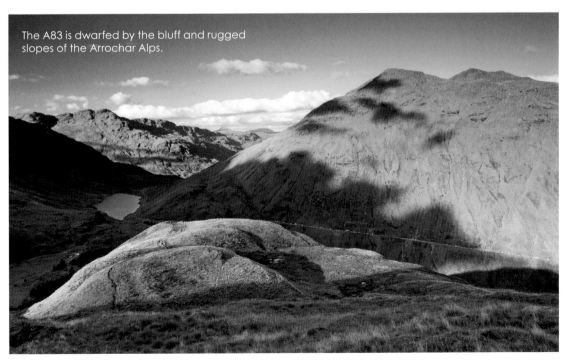

The A83 is dwarfed by the bluff and rugged slopes of the Arrochar Alps.

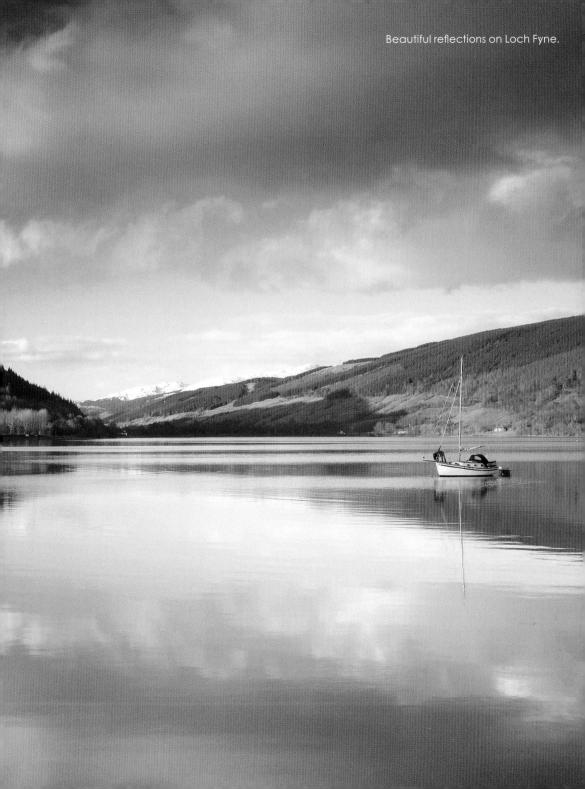

Beautiful reflections on Loch Fyne.

Fact File

The foundation stone of Inveraray Castle was laid in 1746, although it took a further 43 years for the building to be completed.

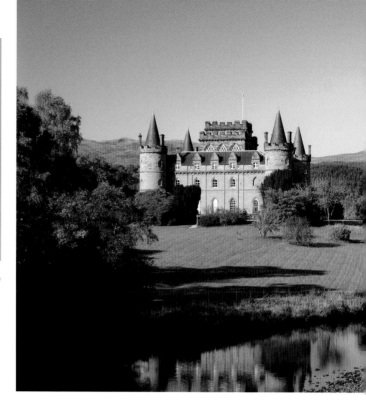

Inveraray Castle is the ancestral home of the Duke of Argyll. The castle's architects were Roger Morris and William Adam. Internally, Inveraray Castle is stunning and home to an amazing array of artefacts, including the magnificent armoury hall. The castle is open daily between April 1 and October 31.

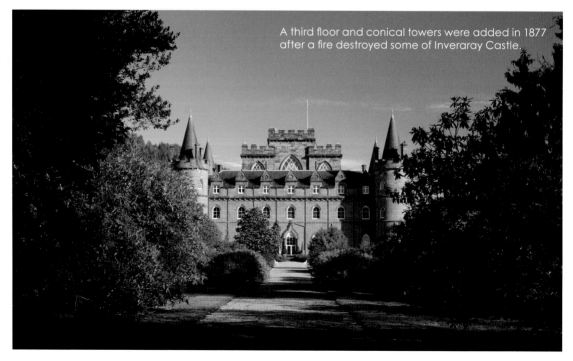

A third floor and conical towers were added in 1877 after a fire destroyed some of Inveraray Castle.

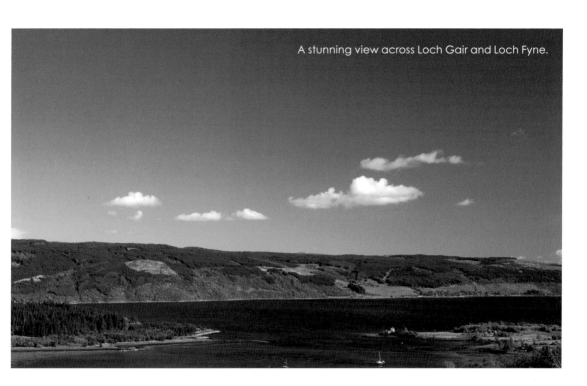

A stunning view across Loch Gair and Loch Fyne.

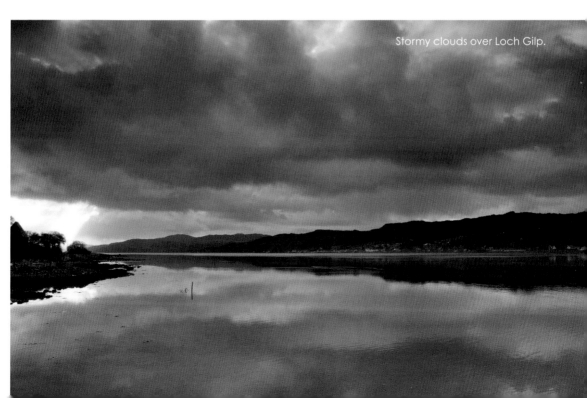

Stormy clouds over Loch Gilp.

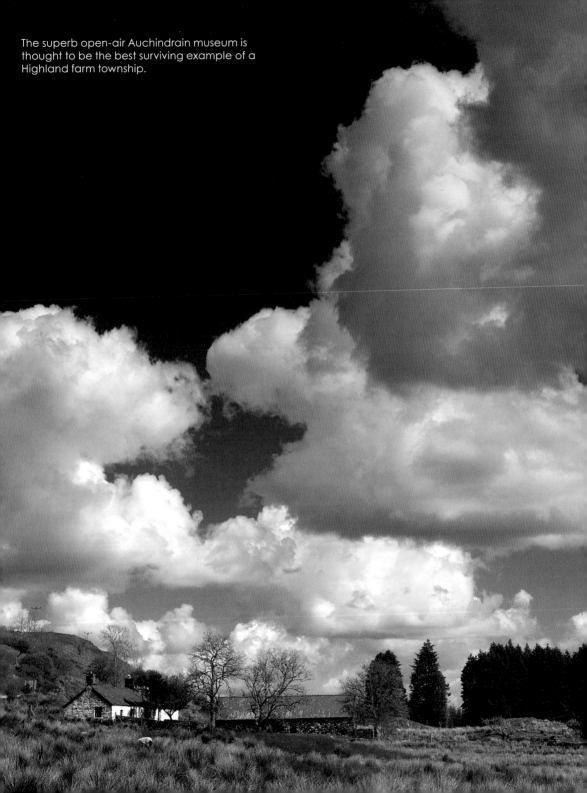

The superb open-air Auchindrain museum is thought to be the best surviving example of a Highland farm township.

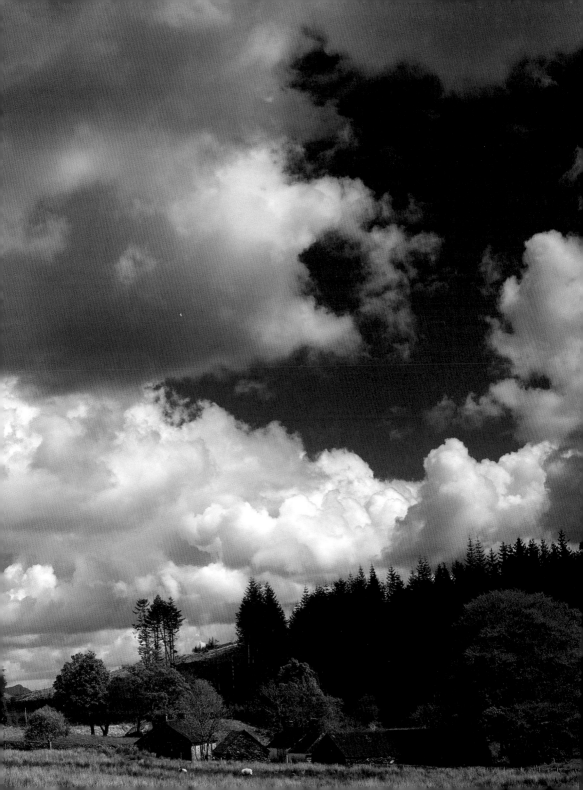

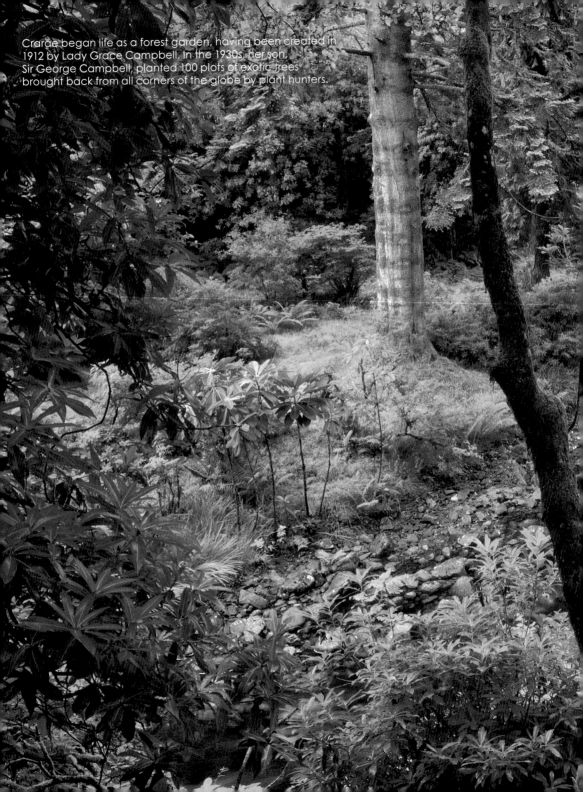

Crarae began life as a forest garden, having been created in 1912 by Lady Grace Campbell. In the 1930s, her son, Sir George Campbell, planted 100 plots of exotic trees brought back from all corners of the globe by plant hunters.

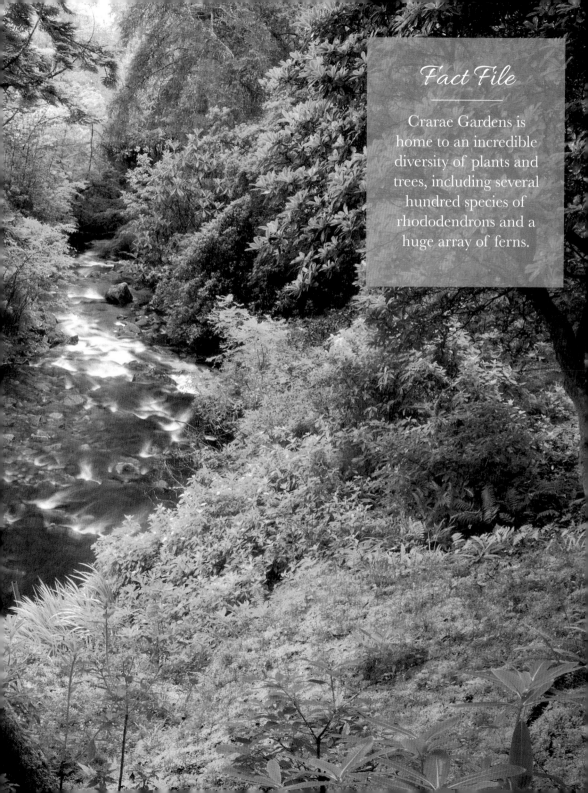

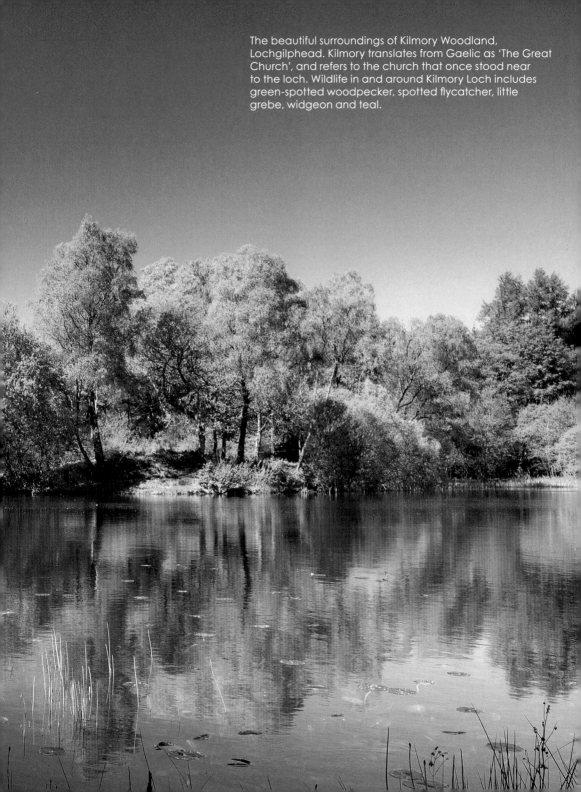

The beautiful surroundings of Kilmory Woodland, Lochgilphead. Kilmory translates from Gaelic as 'The Great Church', and refers to the church that once stood near to the loch. Wildlife in and around Kilmory Loch includes green-spotted woodpecker, spotted flycatcher, little grebe, widgeon and teal.

Lochgilphead was built as a planned town in 1790 and flourished during the early 1900s, because of its location next to the Crinan Canal. Over the course of the next 100 years, Lochgilphead became the administrative centre for Argyll & Bute, a position it still holds today.

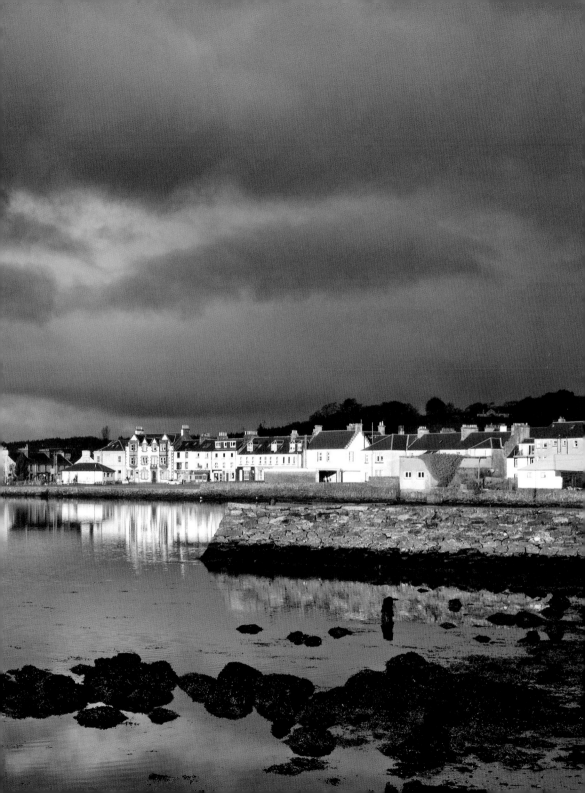

CHAPTER SIX

The Most Beautiful Shortcut in Scotland

Crinan Canal

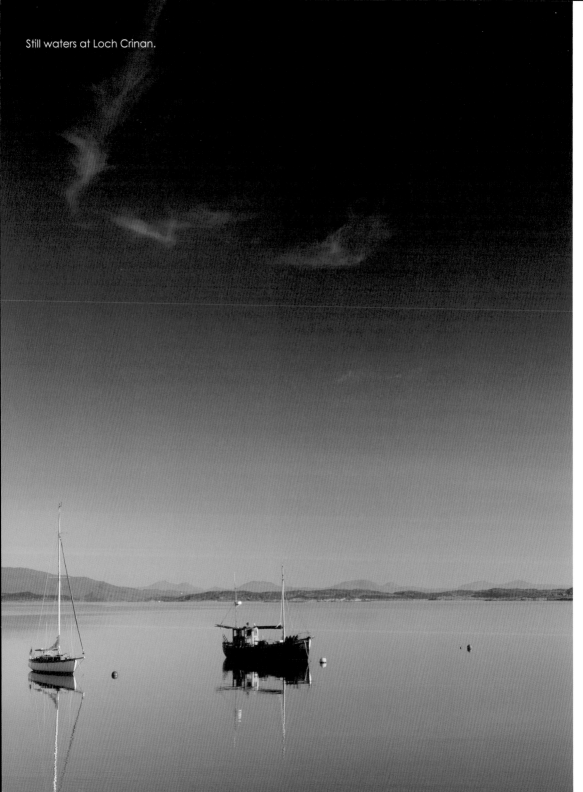

Still waters at Loch Crinan.

Crinan Canal

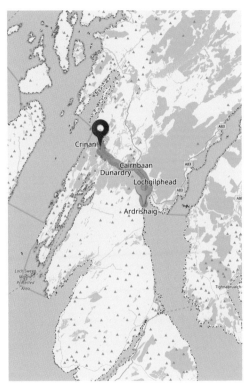

The Crinan Canal is frequently called the most beautiful shortcut in Scotland; the shortcut being between Loch Fyne at Ardrishaig and the Sound of Jura beyond Crinan.

In its early days, this granted an easier passage for transporting goods between the Clyde Estuary and the Inner Hebrides, without the need for a long diversion around the Kintyre peninsula.

Today the canal is used mainly for pleasure, with some 3000 boats passing through the 15 manually operated locks every year.

What's more, the 14km (9 mile) towpath grants an idyllic and relaxed walk or cycle through some of the finest scenery in Scotland.

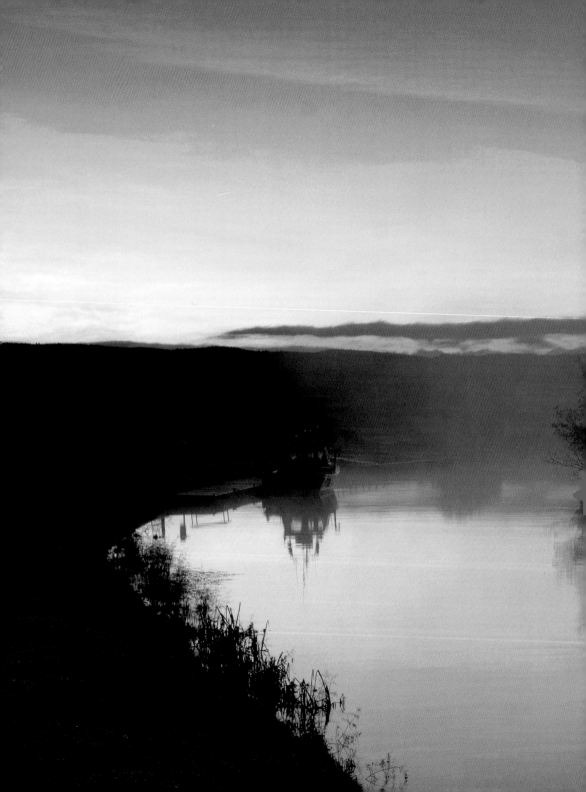

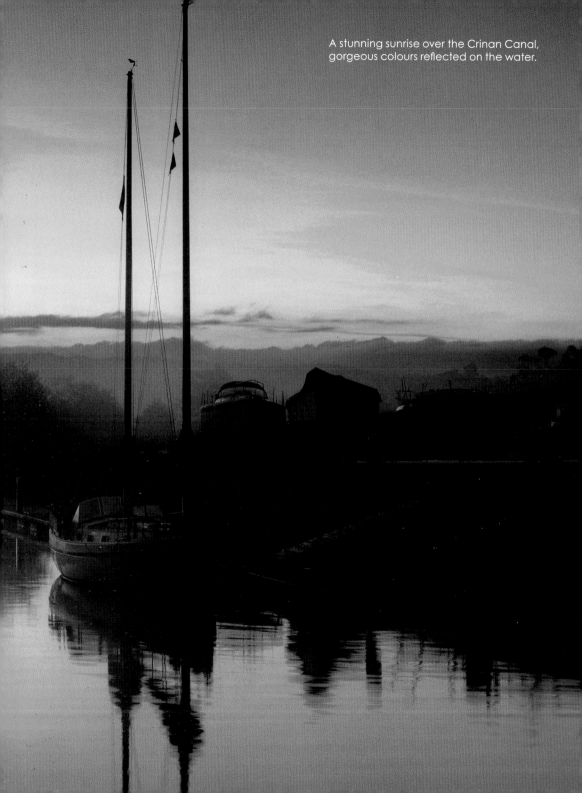

A stunning sunrise over the Crinan Canal, gorgeous colours reflected on the water.

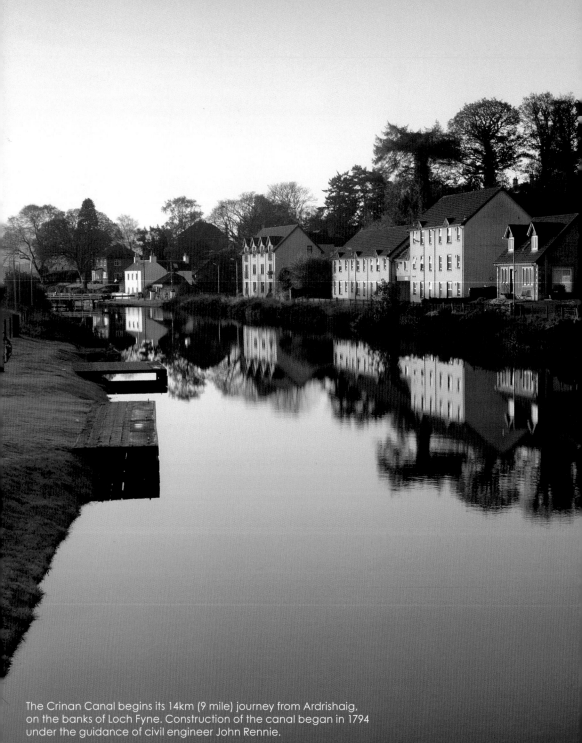

The Crinan Canal begins its 14km (9 mile) journey from Ardrishaig, on the banks of Loch Fyne. Construction of the canal began in 1794 under the guidance of civil engineer John Rennie.

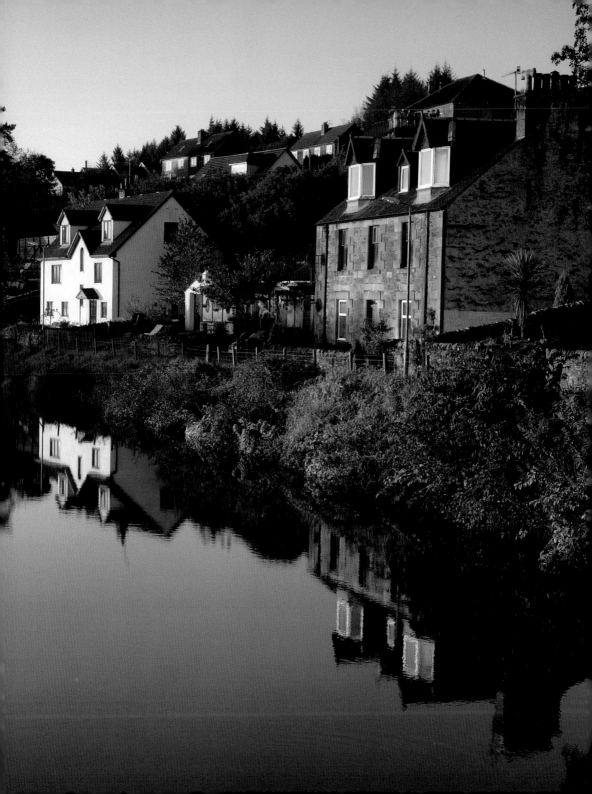

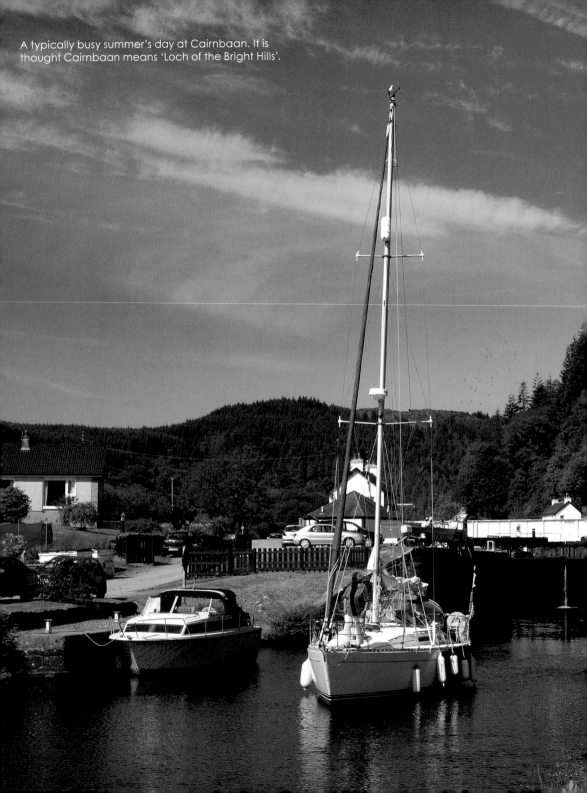

A typically busy summer's day at Cairnbaan. It is thought Cairnbaan means 'Loch of the Bright Hills'.

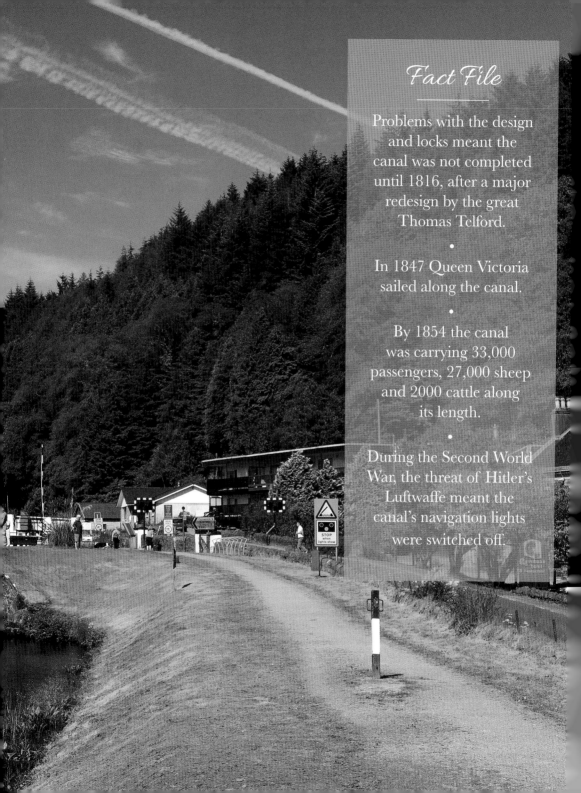

Fact File

Problems with the design and locks meant the canal was not completed until 1816, after a major redesign by the great Thomas Telford.

•

In 1847 Queen Victoria sailed along the canal.

•

By 1854 the canal was carrying 33,000 passengers, 27,000 sheep and 2000 cattle along its length.

•

During the Second World War, the threat of Hitler's Luftwaffe meant the canal's navigation lights were switched off.

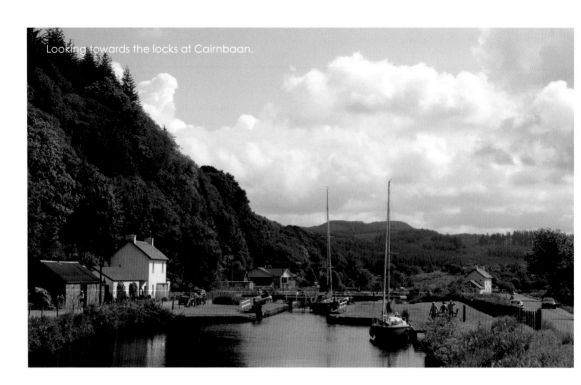

Looking towards the locks at Cairnbaan.

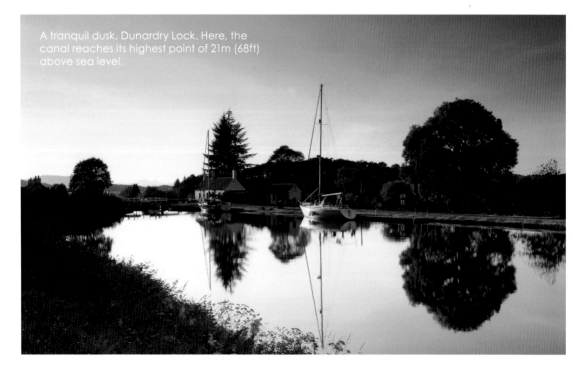

A tranquil dusk, Dunardry Lock. Here, the canal reaches its highest point of 21m (68ft) above sea level.

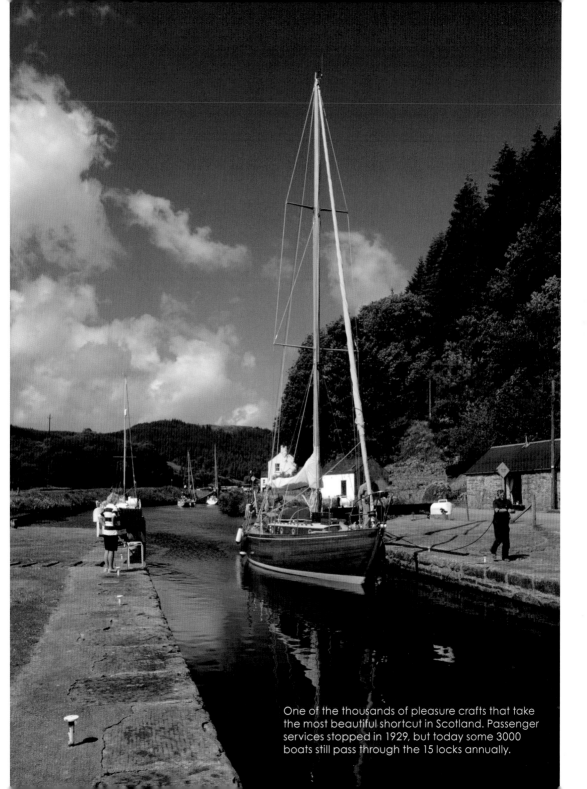

One of the thousands of pleasure crafts that take the most beautiful shortcut in Scotland. Passenger services stopped in 1929, but today some 3000 boats still pass through the 15 locks annually.

Mellow yellow: reflections on the canal.

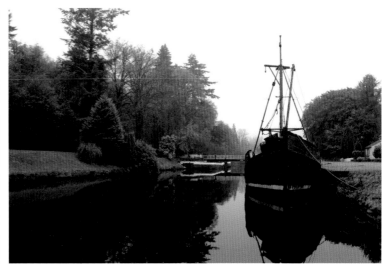

A misty morning cloaking the woodland beside Oakfield Lock.

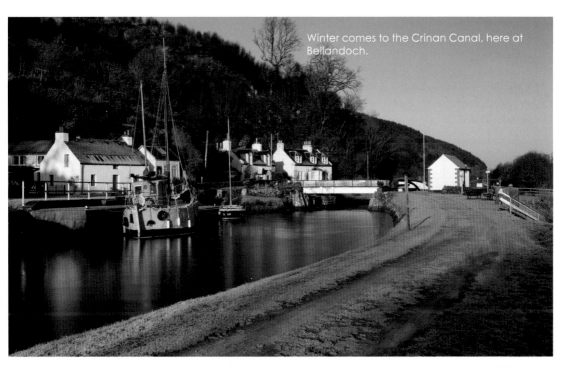

Winter comes to the Crinan Canal, here at Bellandoch.

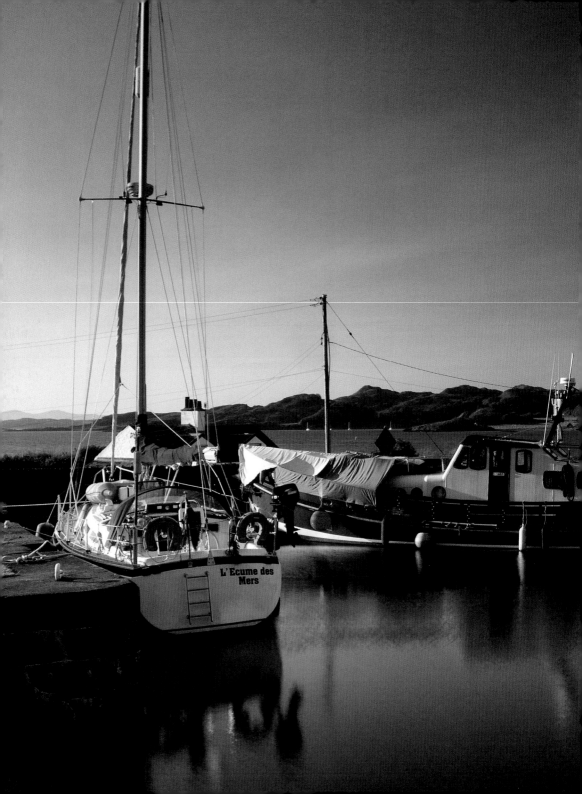

An idyllic summer evening at Crinan. During the 18th century, timber from Crinan was used for a range of industries, including as charcoal for iron smelting and bark for tanning – a tenant at nearby Kilmahumaig was a shoemaker.

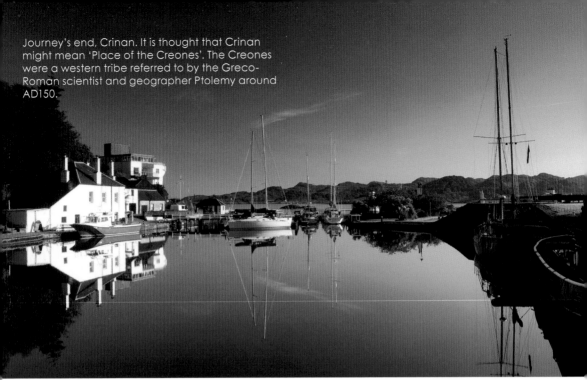

Journey's end, Crinan. It is thought that Crinan might mean 'Place of the Creones'. The Creones were a western tribe referred to by the Greco-Roman scientist and geographer Ptolemy around AD150.

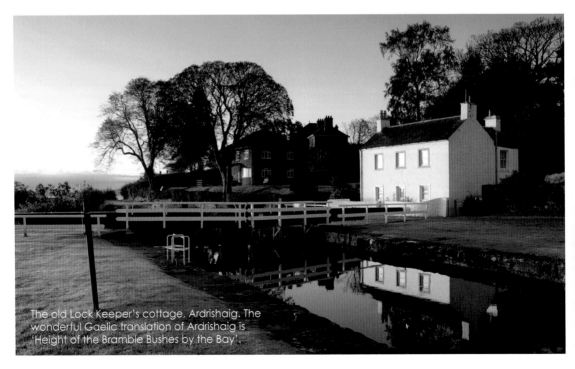

The old Lock Keeper's cottage, Ardrishaig. The wonderful Gaelic translation of Ardrishaig is 'Height of the Bramble Bushes by the Bay'.

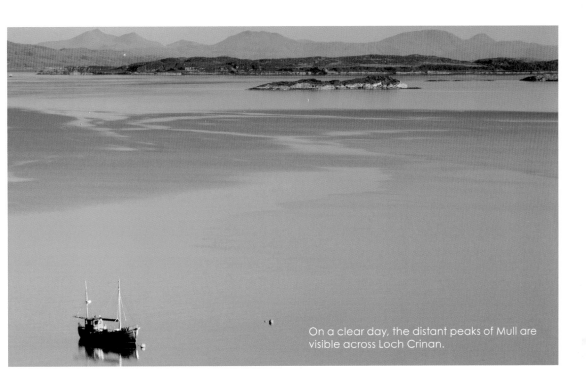

On a clear day, the distant peaks of Mull are visible across Loch Crinan.

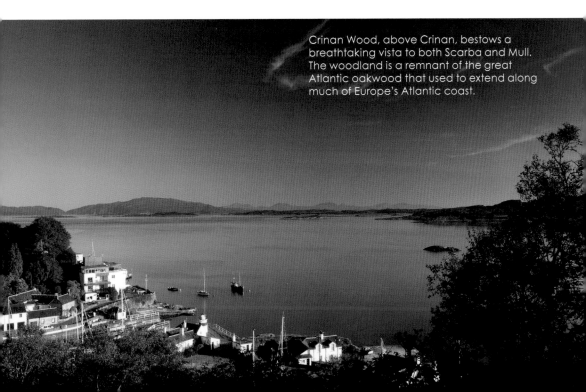

Crinan Wood, above Crinan, bestows a breathtaking vista to both Scarba and Mull. The woodland is a remnant of the great Atlantic oakwood that used to extend along much of Europe's Atlantic coast.

CHAPTER SEVEN

A Walker's Paradise

The West Highland Way

THE
Scots
MAGAZINE

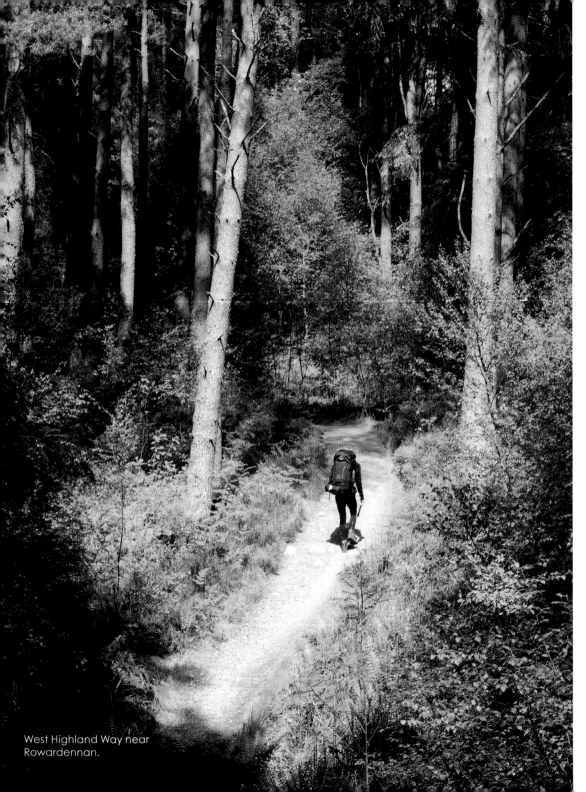

West Highland Way near
Rowardennan.

The West Highland Way

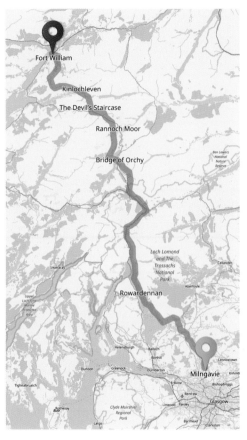

Established in 1980, the West Highland Way is still the most popular of Scotland's long distance trails and, for many, the most spectacular.

Every year it is thought that around 20,000 walkers complete the entire 154km (96 mile) route that links Milngavie, on the outskirts of Glasgow, with Fort William, which sits beneath Ben Nevis – Scotland's highest mountain.

In between, the West Highland Way passes through a dazzling array of scenery, from the Lowlands' gentle topography to the monumental landscape of the Southern and Central Highlands.

Loch Lomond, Rannoch Moor, the Devil's Staircase and Glen Nevis are just a few of the highlights, while a wonderful selection of flora and fauna and the camaraderie of other walkers help make the West Highland Way one of Scotland's finest walks.

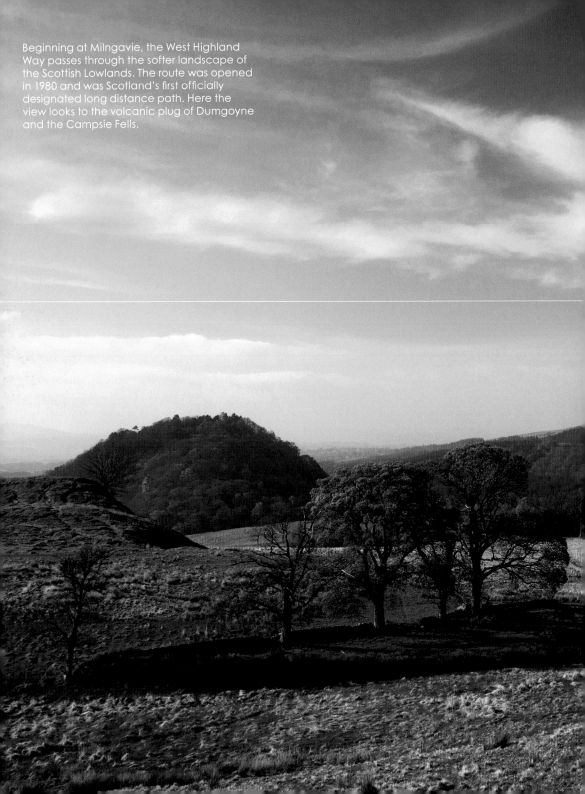

Beginning at Milngavie, the West Highland Way passes through the softer landscape of the Scottish Lowlands. The route was opened in 1980 and was Scotland's first officially designated long distance path. Here the view looks to the volcanic plug of Dumgoyne and the Campsie Fells.

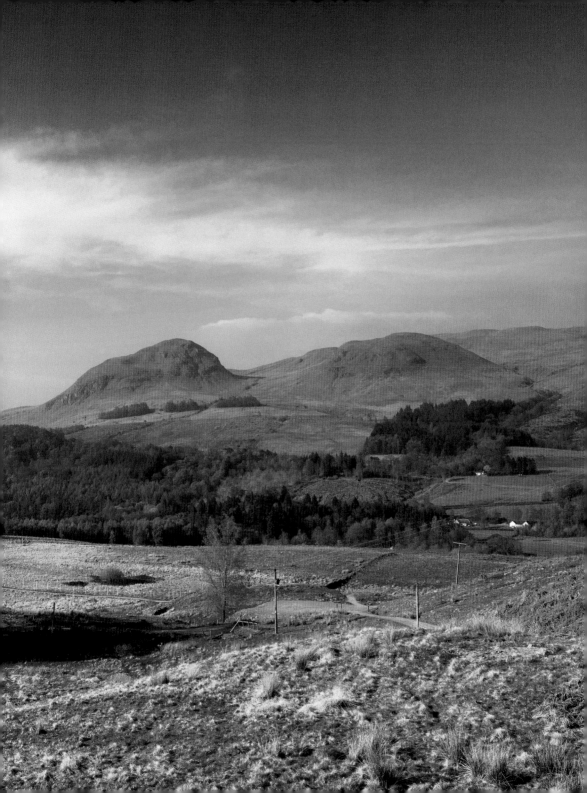

The topography changes as you cross Conic Hill and the Highland
Boundary Fault Line. Conic Hill rises to 361m (1184ft) above sea level.

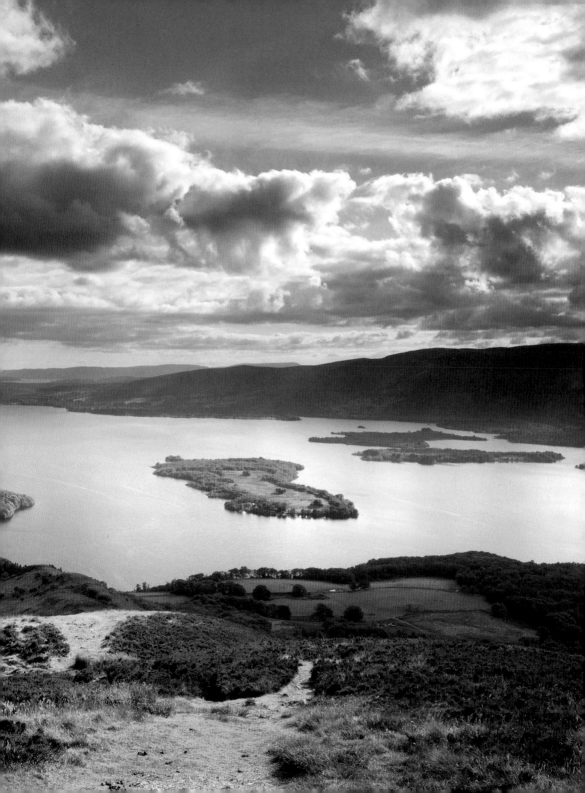

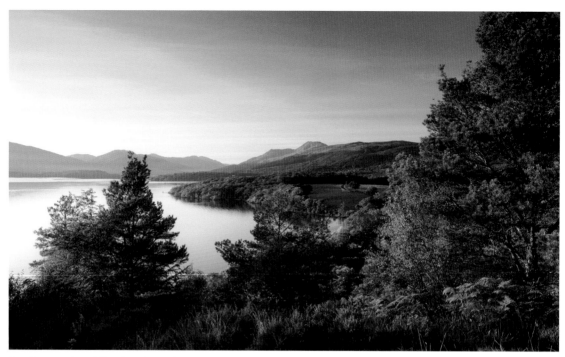

Ben Lomond and the Southern Highlands from Craigie Fort. At 974m (3196ft) in height, Ben Lomond is Scotland's southernmost Munro – a mountain that is over 914m (3000ft).

Loch Lomond from Balmaha. The derivation of Balmaha is unclear, but is thought to stem from the Gaelic *Bealach Mo-Cha*, meaning the 'Pass of Mo-Cha', referring to St Kentigerna, the daughter of an Irish prince. St Kentigerna emigrated from Ireland during the 8th century and settled on the island of Inchcailloch, which sits just off the shore at Balmaha.

Fact File

Over the course of the West Highland Way there is more than 3000m (10,000 ft) of ascent.

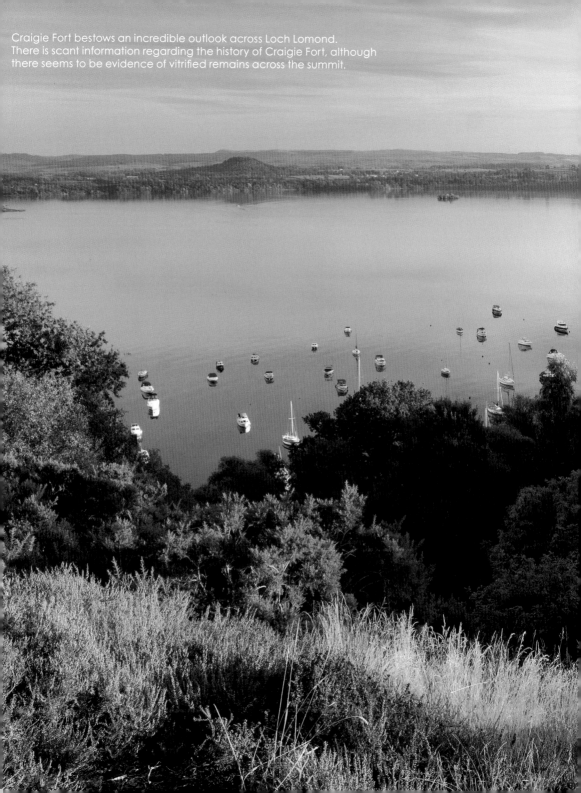

Craigie Fort bestows an incredible outlook across Loch Lomond. There is scant information regarding the history of Craigie Fort, although there seems to be evidence of vitrified remains across the summit.

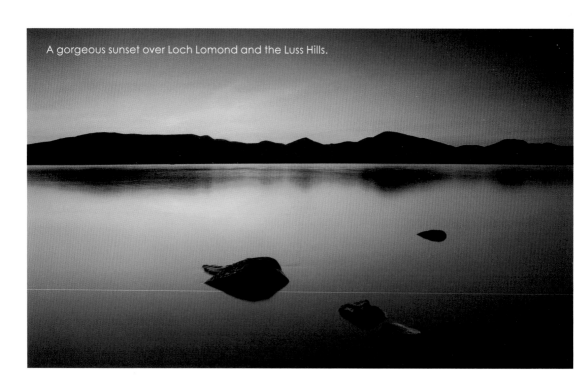

A gorgeous sunset over Loch Lomond and the Luss Hills.

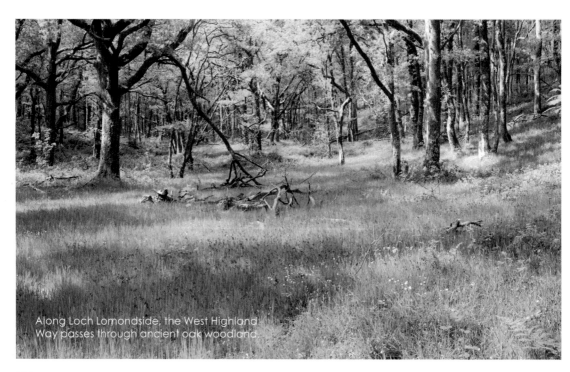

Along Loch Lomondside, the West Highland Way passes through ancient oak woodland.

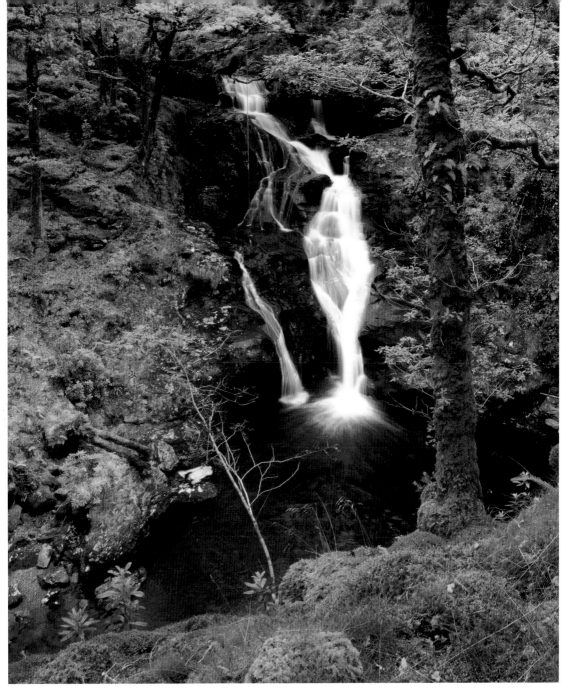

The dramatic Arklet Falls at Inversnaid, which translates from Gaelic as 'Mouth of the Needle Stream'. The Arklet water flows into Loch Lomond at Inversnaid and cascades down a couple of striking waterfalls. The setting was celebrated in Gerard Manley Hopkin's poem *Inversnaid*, written in 1881.

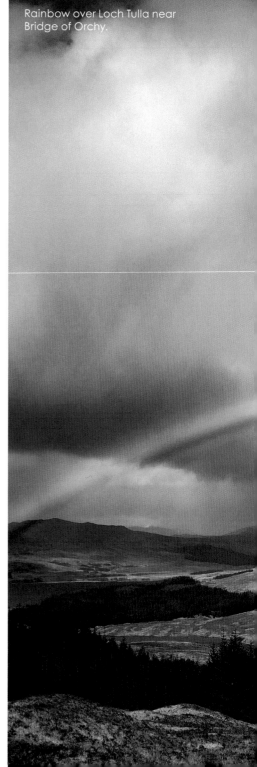
Rainbow over Loch Tulla near Bridge of Orchy.

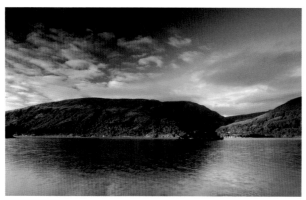

Dawn breaks over Loch Lomond at Rowardennan.

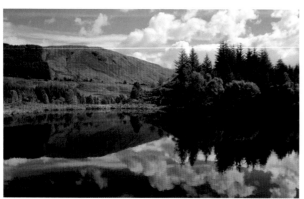

The Lochan of the Lost Sword, near Tyndrum. Legend has it that after they were beaten at the Battle of Dalrigh in 1306 by Clan MacDougall of Argyll, Robert the Bruce and his army pitched their weapons into the lochan, including Bruce's claymore.

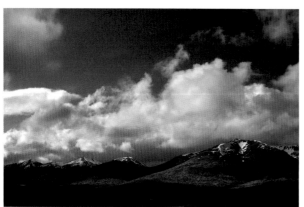

The mountains of Glen Etive from Mam Carraigh.

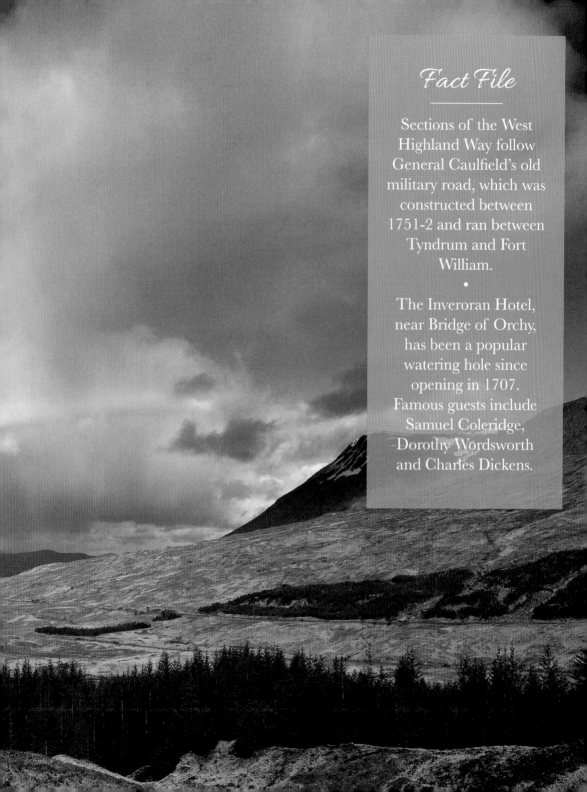

Fact File

Sections of the West Highland Way follow General Caulfield's old military road, which was constructed between 1751-2 and ran between Tyndrum and Fort William.

•

The Inveroran Hotel, near Bridge of Orchy, has been a popular watering hole since opening in 1707. Famous guests include Samuel Coleridge, Dorothy Wordsworth and Charles Dickens.

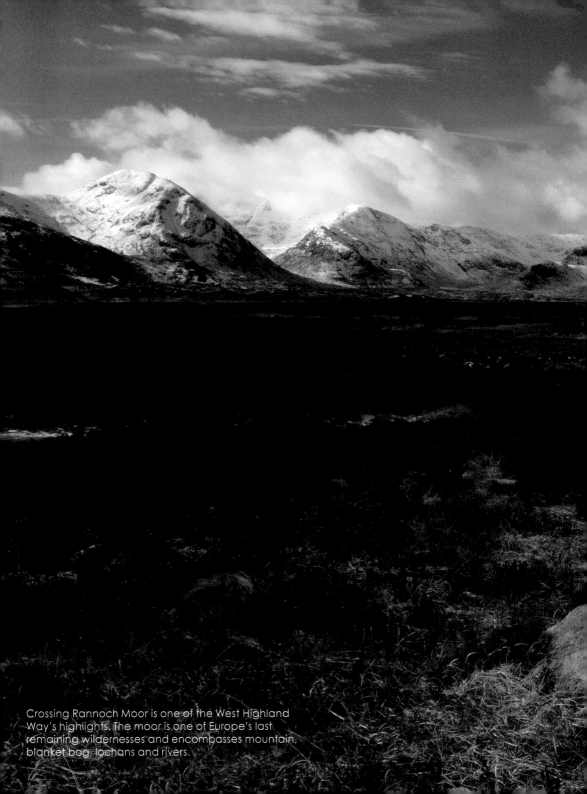

Crossing Rannoch Moor is one of the West Highland Way's highlights. The moor is one of Europe's last remaining wildernesses and encompasses mountain, blanket bog, lochans and rivers.

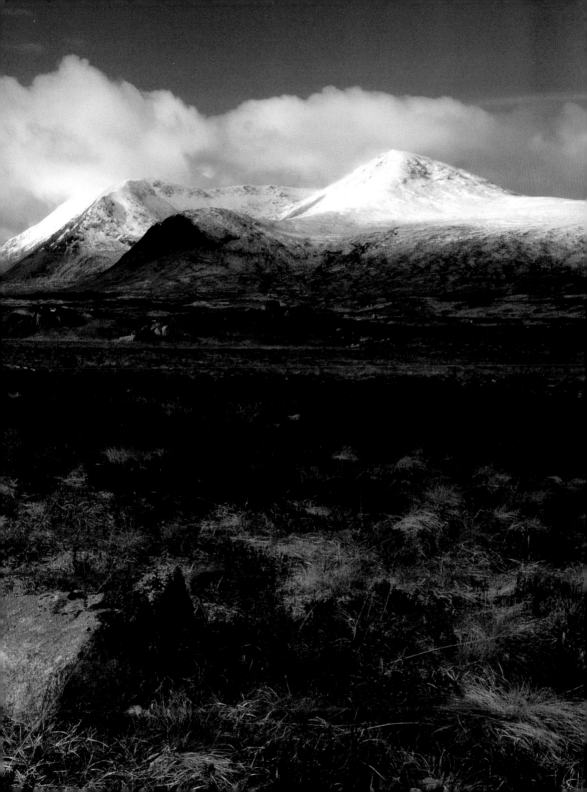

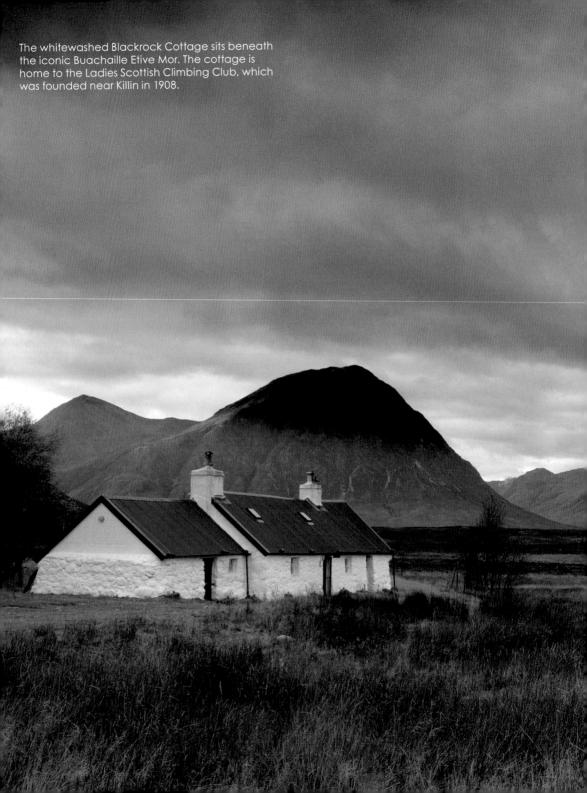

The whitewashed Blackrock Cottage sits beneath the iconic Buachaille Etive Mor. The cottage is home to the Ladies Scottish Climbing Club, which was founded near Killin in 1908.

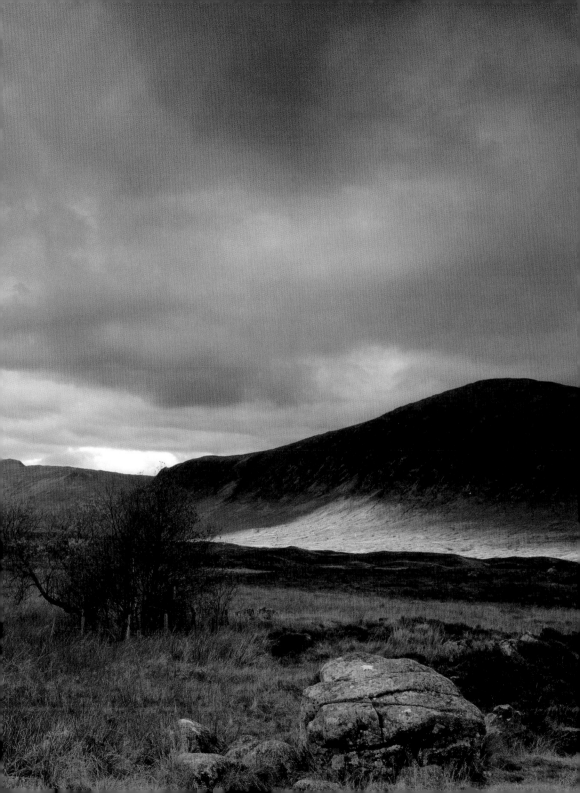

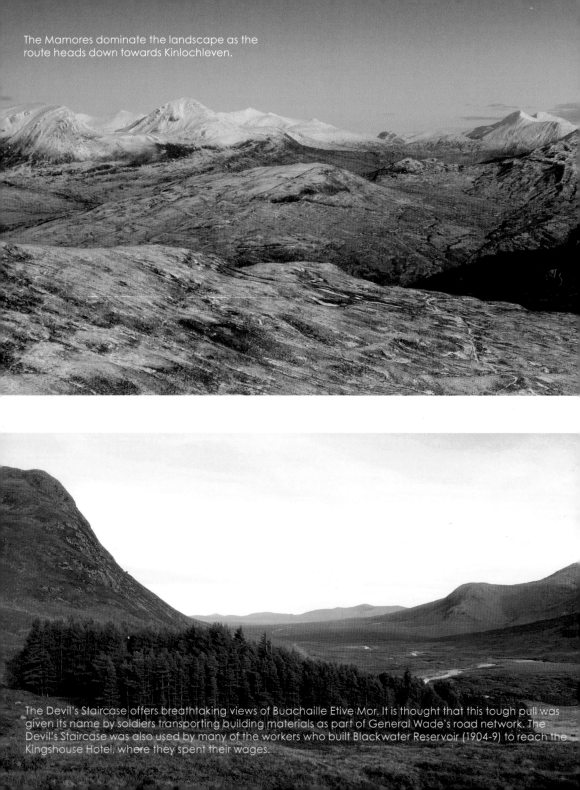

The Mamores dominate the landscape as the route heads down towards Kinlochleven.

The Devil's Staircase offers breathtaking views of Buachaille Etive Mor. It is thought that this tough pull was given its name by soldiers transporting building materials as part of General Wade's road network. The Devil's Staircase was also used by many of the workers who built Blackwater Reservoir (1904-9) to reach the Kingshouse Hotel, where they spent their wages.

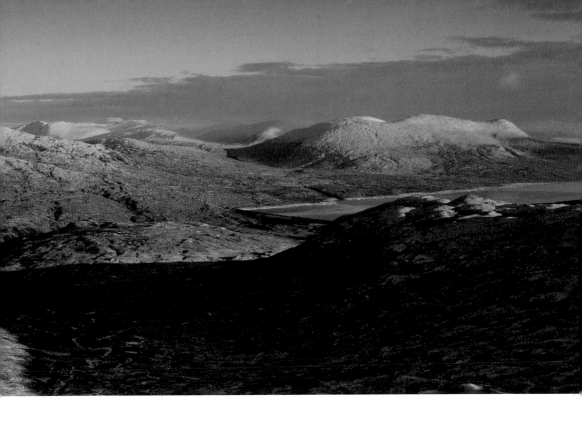

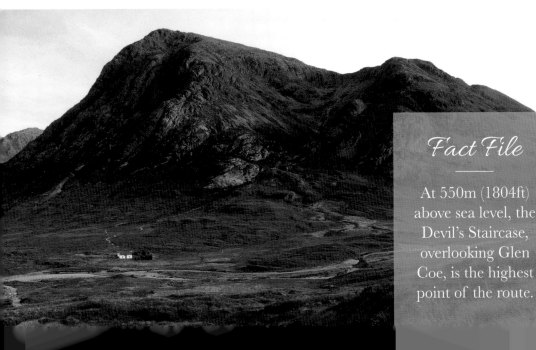

Fact File

At 550m (1804ft) above sea level, the Devil's Staircase, overlooking Glen Coe, is the highest point of the route.

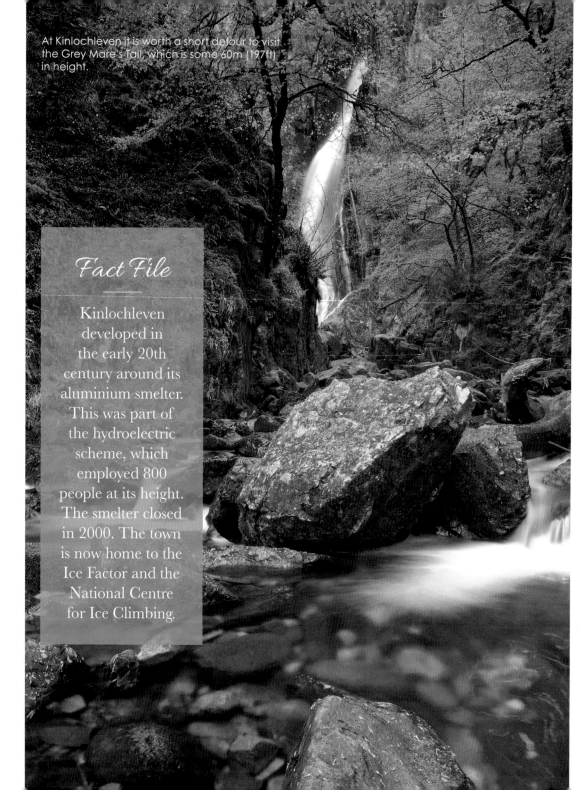

At Kinlochleven it is worth a short detour to visit the Grey Mare's Tail, which is some 60m (197ft) in height.

Fact File

Kinlochleven developed in the early 20th century around its aluminium smelter. This was part of the hydroelectric scheme, which employed 800 people at its height. The smelter closed in 2000. The town is now home to the Ice Factor and the National Centre for Ice Climbing.

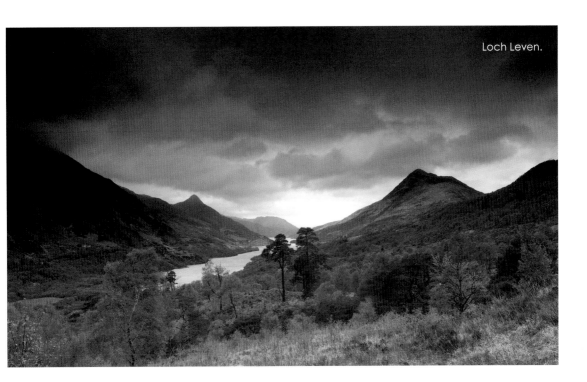

Loch Leven.

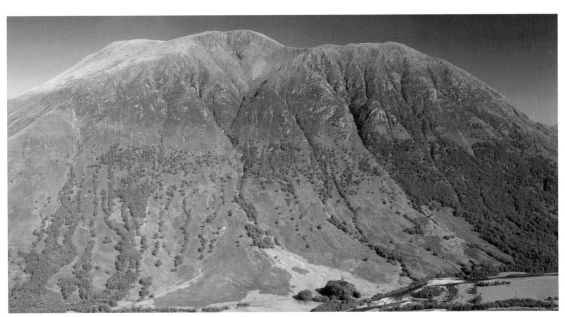

Dun Deardail provides a stunning view of Ben Nevis's massive bulk as it rises above Glen Nevis. Dun Deardail holds visible remains of a fort that was built around 2000 years ago and then rebuilt as a Celtic fort and Pictish citadel. At 1345m (4411ft) above sea level, Ben Nevis is Britain's highest mountain.

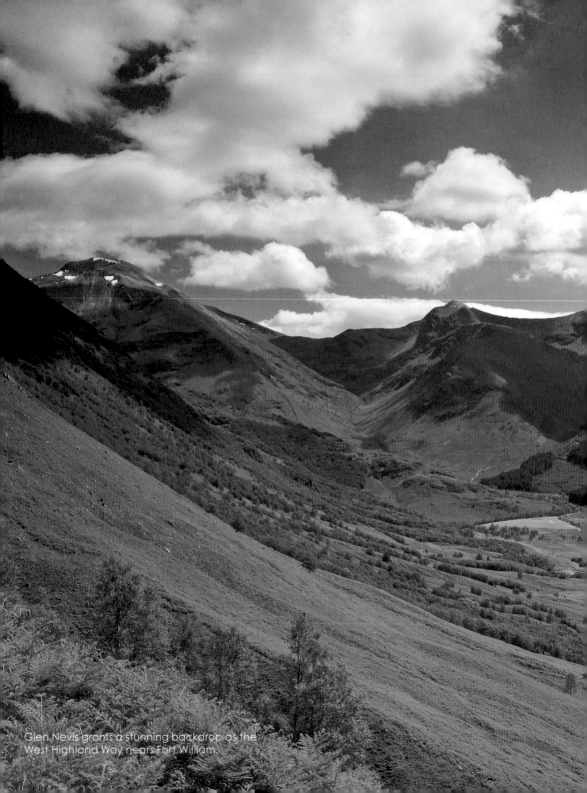

Glen Nevis grants a stunning backdrop as the West Highland Way nears Fort William.

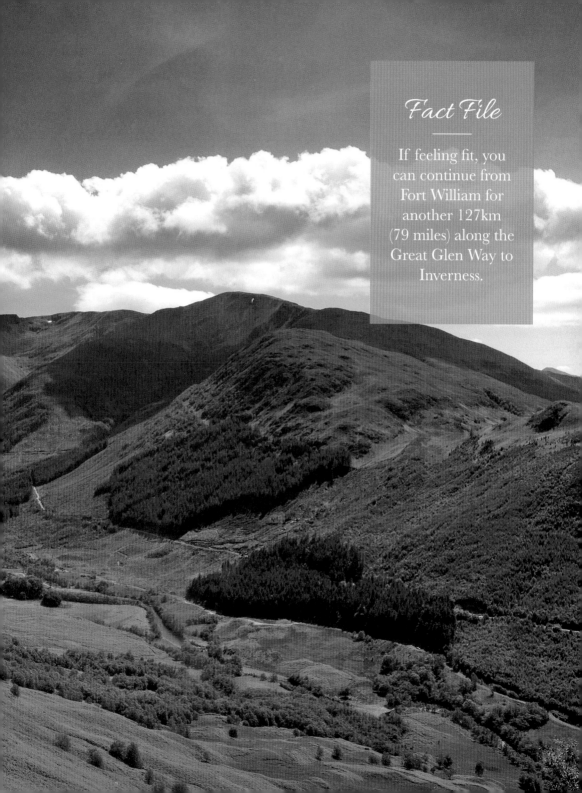

CHAPTER EIGHT

Fort William to Mallaig

The Road to the Isles

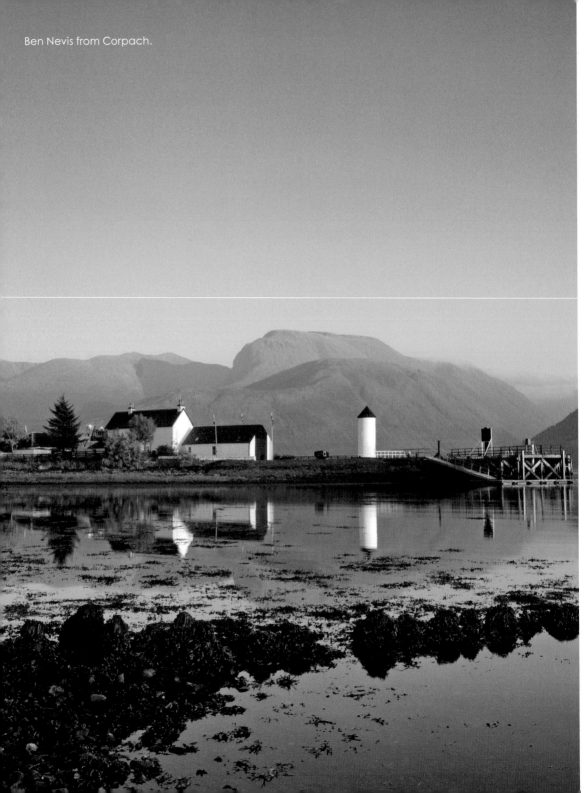

Ben Nevis from Corpach.

The Road *to the* Isles

The Road to the Isles. It is a name that instills a sense of travel or adventure and for those who have taken the trip along the A830, between Fort William and Mallaig, it is one that will live long in the memory. This 69km (43 mile) excursion travels through a slice of Scotland's finest scenery, with breathtaking views around almost every corner.

Stunning views of Ben Nevis, Britain's highest mountain, rise from Fort William, while Loch Morar is Britain's deepest freshwater loch. Gorgeous Loch Eil is framed by some of Scotland's craggiest peaks, while the shimmering necklace of beaches along the coast at Arisaig are just waiting to be explored.

Fassfern, the Glenfinnan Monument and, of course, the magnificent 21-arch Glenfinnan Viaduct can all be visited en route.

And this most magnificent of journeys need not conclude at Mallaig, although several fabulous seafood restaurants may hold your attention when in town. A number of ferries set sail from Mallaig to the likes of Knoydart, Skye, Canna, Muck, Eigg and Rum, meaning many more of Scotland's most scenic destinations begin from the end of the A830.

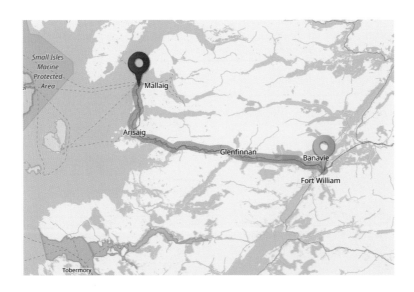

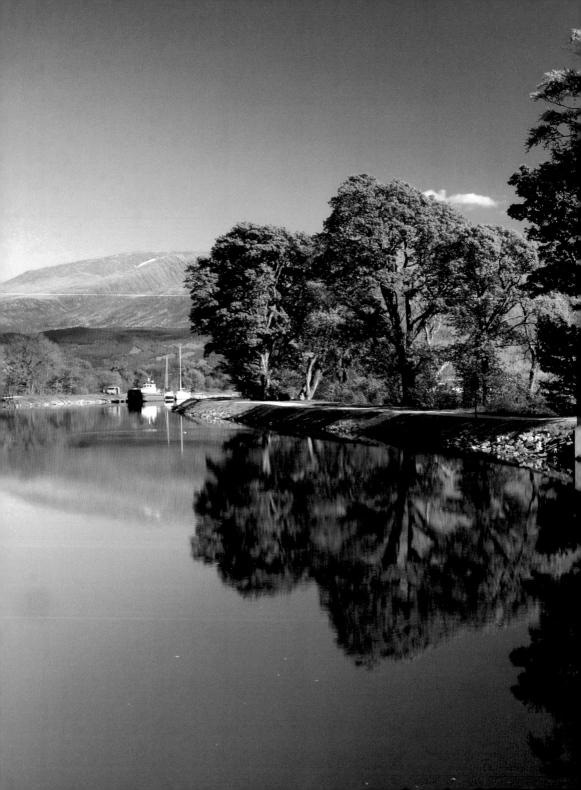

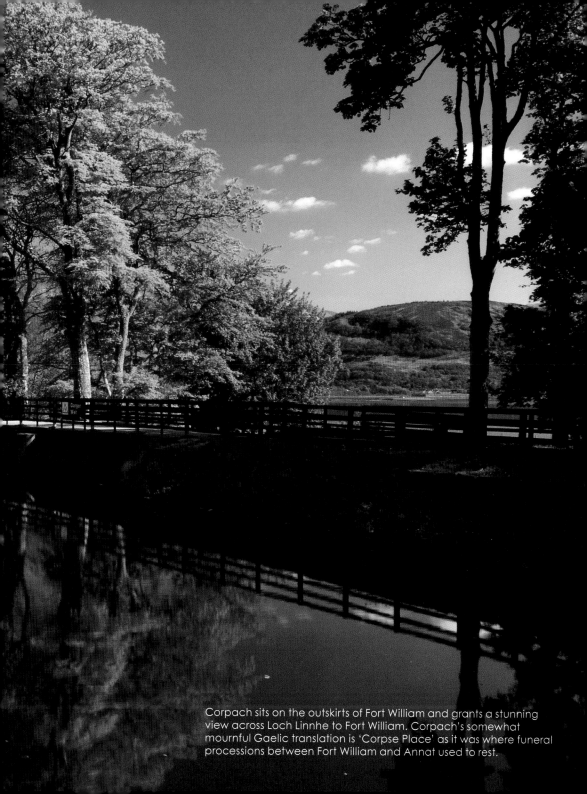

Corpach sits on the outskirts of Fort William and grants a stunning view across Loch Linnhe to Fort William. Corpach's somewhat mournful Gaelic translation is 'Corpse Place' as it was where funeral processions between Fort William and Annat used to rest.

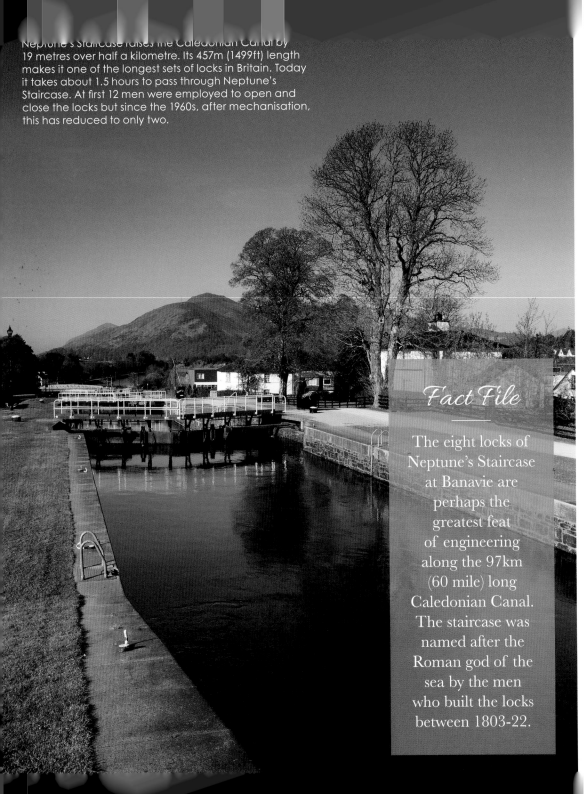

Neptune's Staircase raises the Caledonian Canal by 19 metres over half a kilometre. Its 457m (1499ft) length makes it one of the longest sets of locks in Britain. Today it takes about 1.5 hours to pass through Neptune's Staircase. At first 12 men were employed to open and close the locks but since the 1960s, after mechanisation, this has reduced to only two.

Fact File

The eight locks of Neptune's Staircase at Banavie are perhaps the greatest feat of engineering along the 97km (60 mile) long Caledonian Canal. The staircase was named after the Roman god of the sea by the men who built the locks between 1803-22.

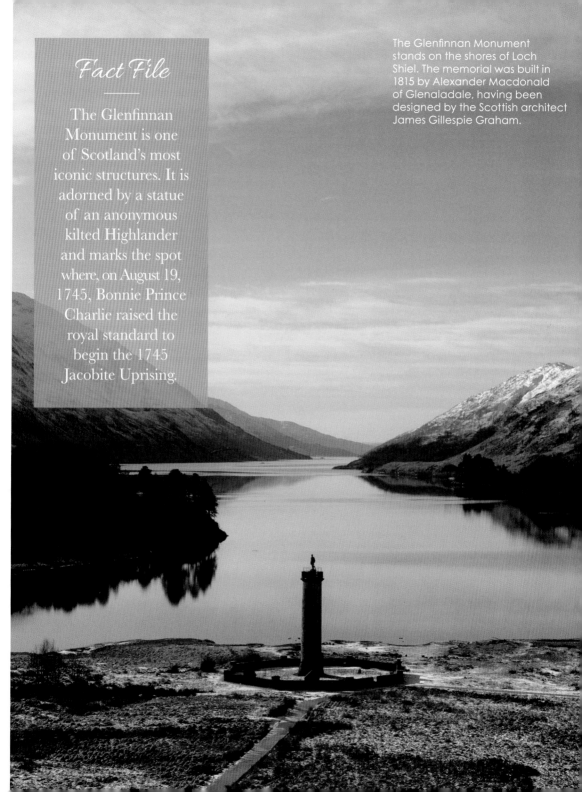

Fact File

The Glenfinnan Monument is one of Scotland's most iconic structures. It is adorned by a statue of an anonymous kilted Highlander and marks the spot where, on August 19, 1745, Bonnie Prince Charlie raised the royal standard to begin the 1745 Jacobite Uprising.

The Glenfinnan Monument stands on the shores of Loch Shiel. The memorial was built in 1815 by Alexander Macdonald of Glenaladale, having been designed by the Scottish architect James Gillespie Graham.

Fact File

The Glenfinnan Viaduct is 380m (1248ft) in length. It was completed in 1901 as part of the extension of the West Highland Railway from Fort William to Mallaig, known as the Iron Road to the Isles. The Glenfinnan Viaduct has 21 arches, with the tallest being around 31m (100ft) in height. It appeared in the 2001 movie, *Harry Potter and the Philosopher's Stone.*

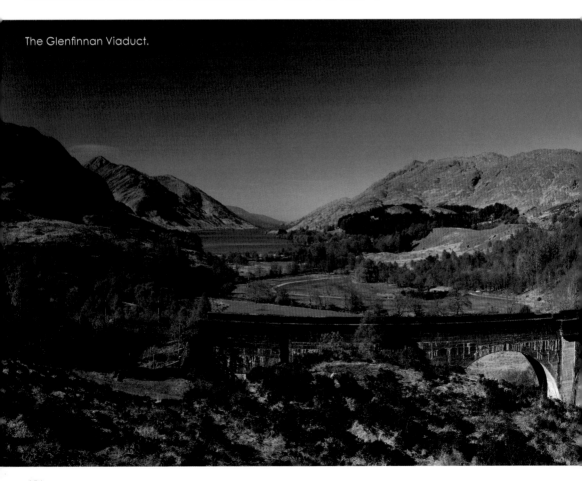

The Glenfinnan Viaduct.

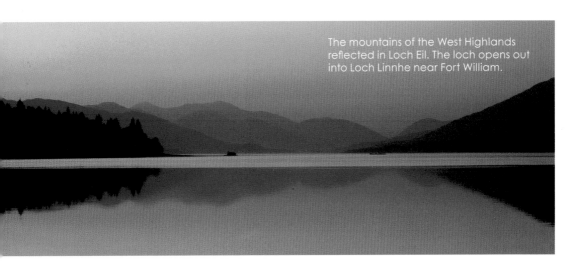

The mountains of the West Highlands reflected in Loch Eil. The loch opens out into Loch Linnhe near Fort William.

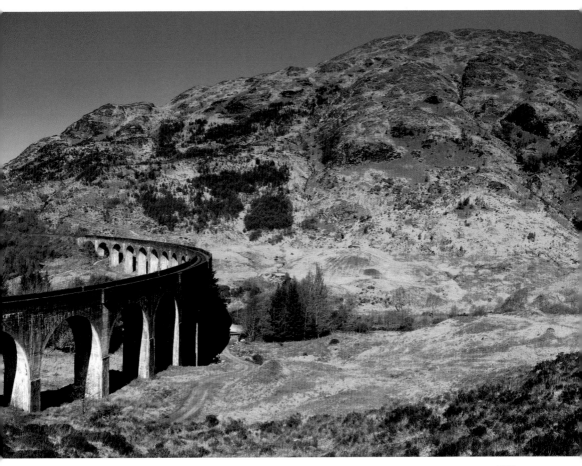

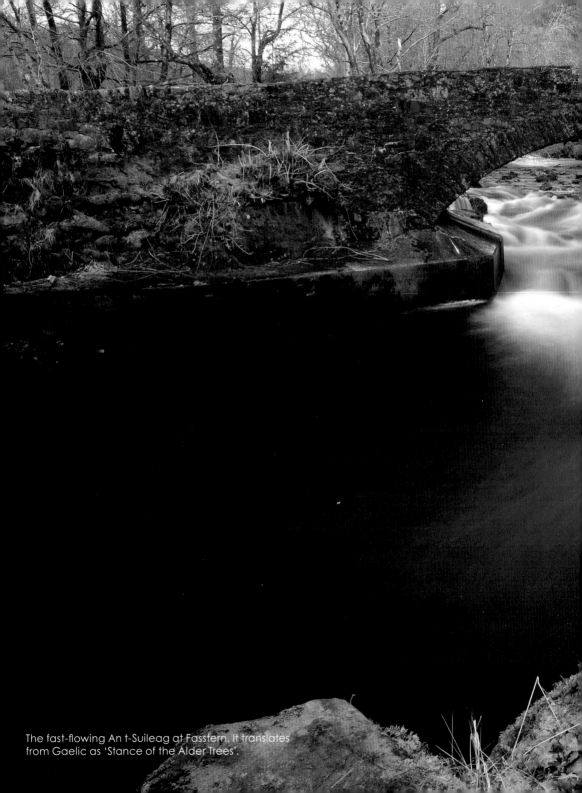

The fast-flowing An t-Suileag at Fassfern. It translates from Gaelic as 'Stance of the Alder Trees'.

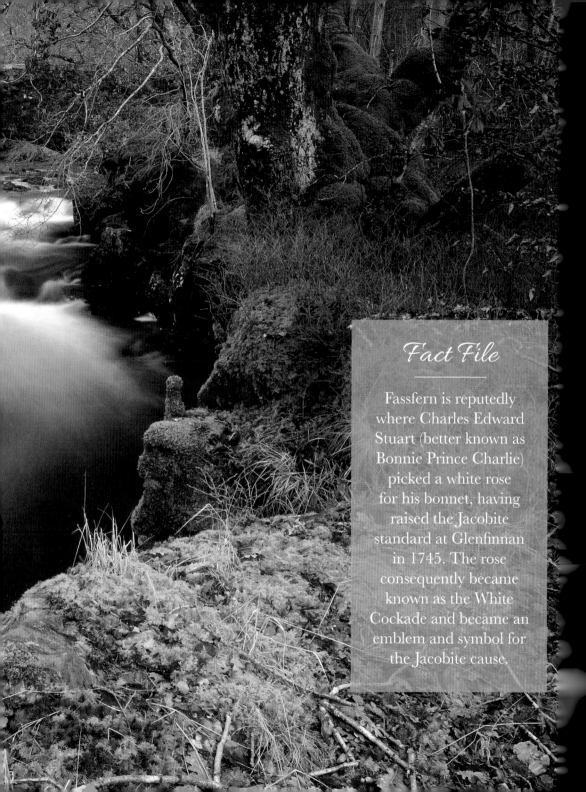

Fact File

Fassfern is reputedly
where Charles Edward
Stuart (better known as
Bonnie Prince Charlie)
picked a white rose
for his bonnet, having
raised the Jacobite
standard at Glenfinnan
in 1745. The rose
consequently became
known as the White
Cockade and became an
emblem and symbol for
the Jacobite cause.

The A830 runs past Polnish Chapel. This distinctive building was built in 1872 to serve the now deserted townships of Ardnish and Polnish.

Arisaig stands on the banks of Loch na Ceall where, in 1746, the Royal Navy captured two French ships sent to help the Jacobites after the Battle of Culloden. However, the French escaped with their bounty of gold and apparently hid it near Loch Arkaig.

A string of gorgeous beaches awaits those visiting Arisaig. In the early 19th century Arisaig was home to a thriving fishing and crofting community. However, like much of the Scottish Highlands, the Highland Clearances decimated the communities here. It is thought that over 1000 Arisaig crofters were forced from their homes and land, with sheep deemed more economically viable than people. Many of the crofters left for Nova Scotia.

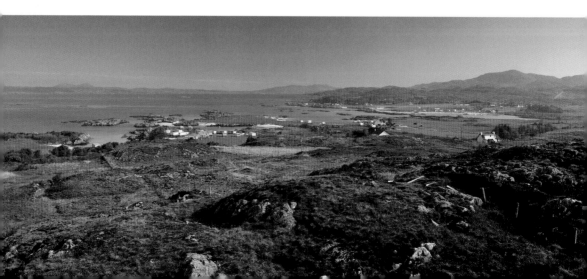

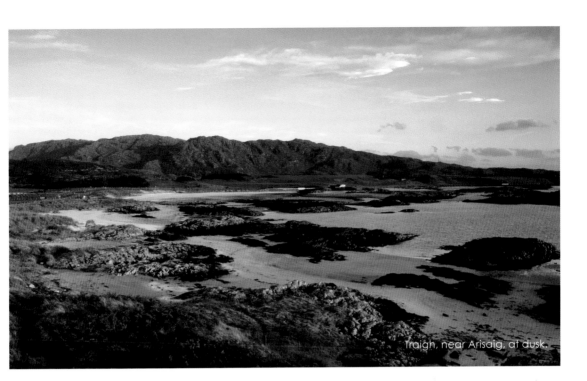

Traigh, near Arisaig, at dusk.

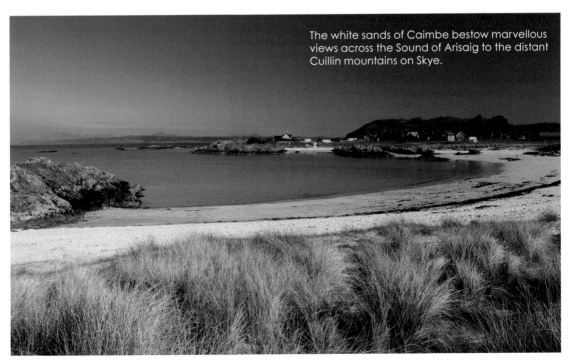

The white sands of Caimbe bestow marvellous views across the Sound of Arisaig to the distant Cuillin mountains on Skye.

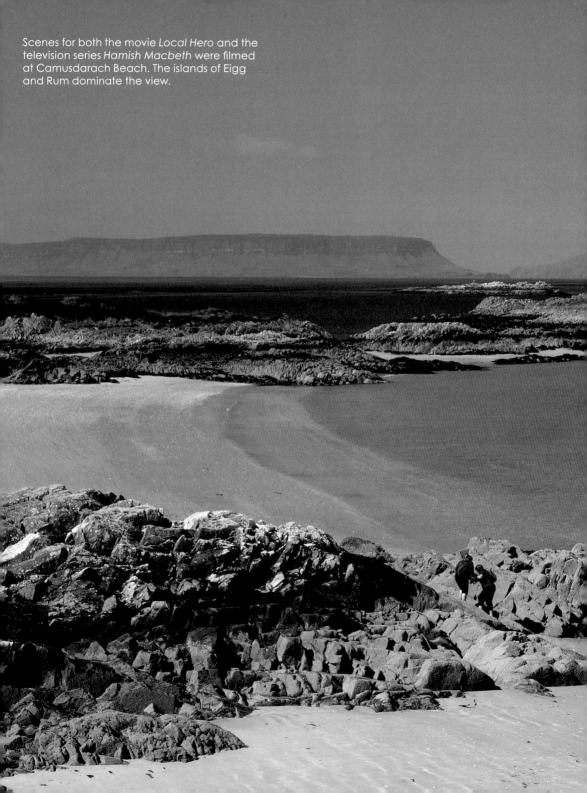

Scenes for both the movie *Local Hero* and the television series *Hamish Macbeth* were filmed at Camusdarach Beach. The islands of Eigg and Rum dominate the view.

Fact File

The classic Scottish
movie *Local Hero*
was filmed at
Camusdarach,
near Arisaig. It was
the setting for the
ramshackle home
of Ben Knox, the
character played
by the marvellous
Scottish actor
Fulton Mackay.

Mallaig has been a hugely popular tourist destination since the railway arrived in 1901. Its name may well translate from the Old Norse *muli*, meaning 'headland bay'. The view from here extends across the Sound of Sleat to Rum, Eigg and the jagged outline of Skye. Mallaig developed through its fishing fleet after Lord Lovat, the owner of North Morar Estate, parcelled up the farmstead of Mallaigvaig in 1841 into a series of plots to attract settlers. Today a number of ferries set sail daily to the Small Isles of Eigg, Muck, Rum and Canna.

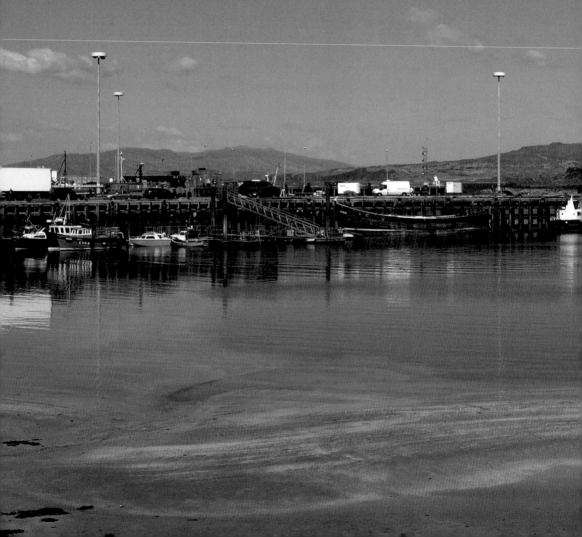

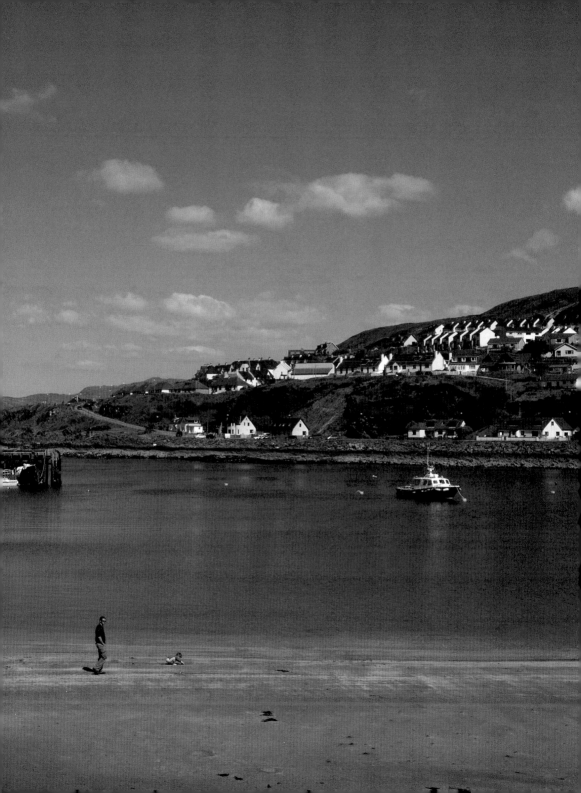

CHAPTER NINE

Lochs, Glens and Mountains

Loch Lomond *to* Inverness

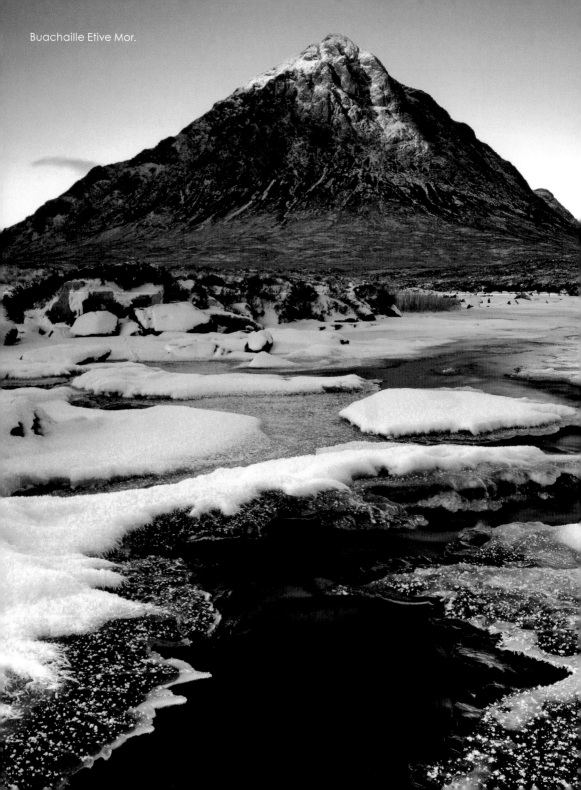

Buachaille Etive Mor.

Loch Lomond *to* Inverness

For centuries the A82 has taken many a traveller from the Lowlands into the celebrated landscape of the Scottish Highlands, and the 240km (150 miles) between Loch Lomond and Inverness continue to inspire.

From Balloch – which sits at the entrance to the Loch Lomond & the Trossachs National Park – Loch Lomond is a constant for over 39km (24 miles), with Ben Lomond providing a stunning backdrop.

The road then climbs through Crianlarich and Tyndrum and out onto the wild expanse of Rannoch Moor. A spectacular mountainous backdrop sets the scene for what lies ahead, as the A82 reaches the entrance of Glencoe. Here one of Scotland's most celebrated mountains, the iconic Buachaille Etive Mor, rises from the floor of Rannoch Moor. The view is simply breathtaking.

The road then descends through Scotland's most famous glen before crossing the Ballachulish Bridge, after which it runs alongside Loch Linnhe to Fort William.

Beyond Spean Bridge the evocative Commando Memorial offers a moment of reflection, with the A82 then hugging the banks of Loch Lochy and Loch Oich. The final stage of the journey runs alongside Loch Ness and through Drumnadrochit, before ending at the beautiful city of Inverness, the capital of the Highlands.

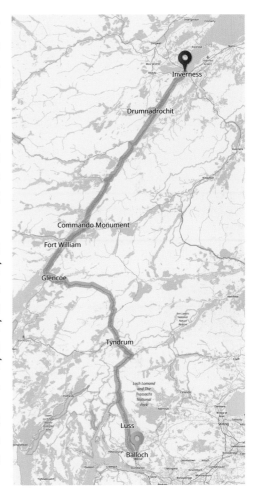

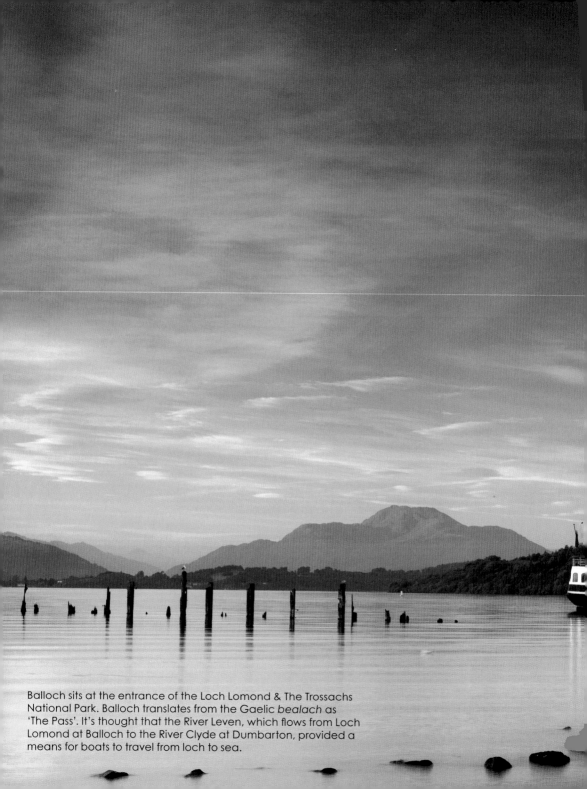

Balloch sits at the entrance of the Loch Lomond & The Trossachs National Park. Balloch translates from the Gaelic *bealach* as 'The Pass'. It's thought that the River Leven, which flows from Loch Lomond at Balloch to the River Clyde at Dumbarton, provided a means for boats to travel from loch to sea.

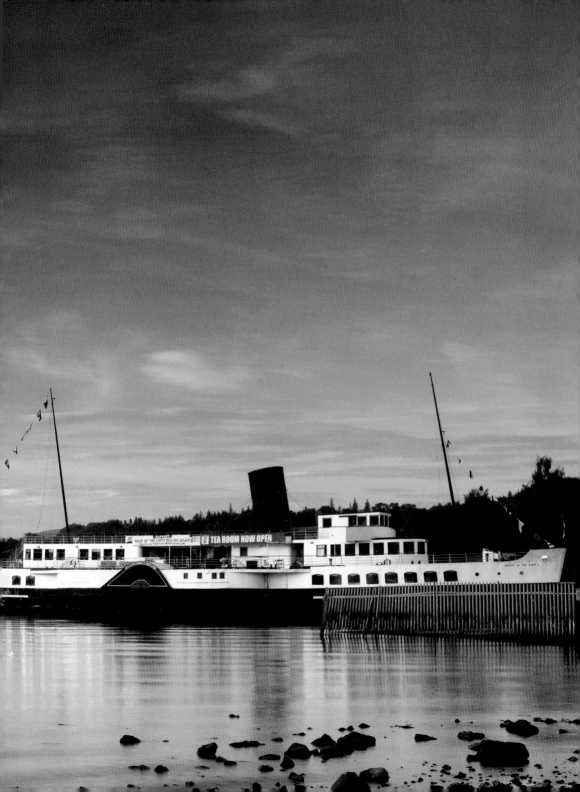

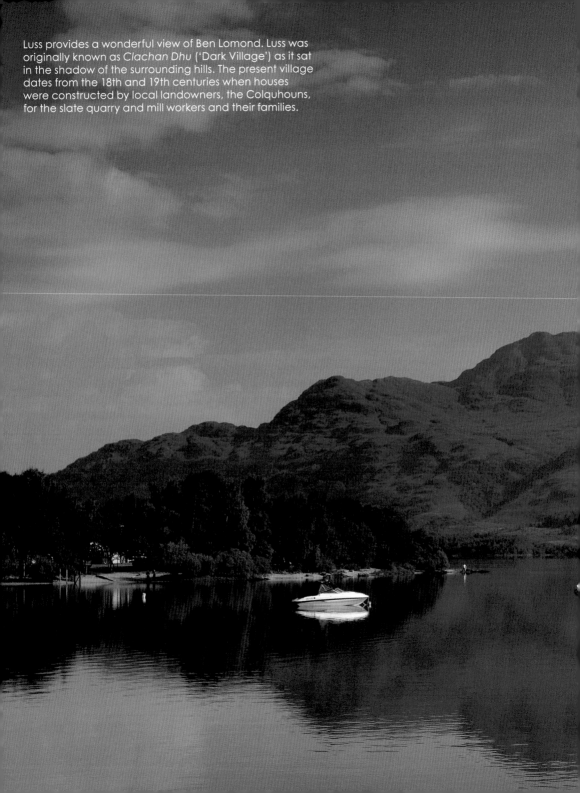

Luss provides a wonderful view of Ben Lomond. Luss was originally known as *Clachan Dhu* ('Dark Village') as it sat in the shadow of the surrounding hills. The present village dates from the 18th and 19th centuries when houses were constructed by local landowners, the Colquhouns, for the slate quarry and mill workers and their families.

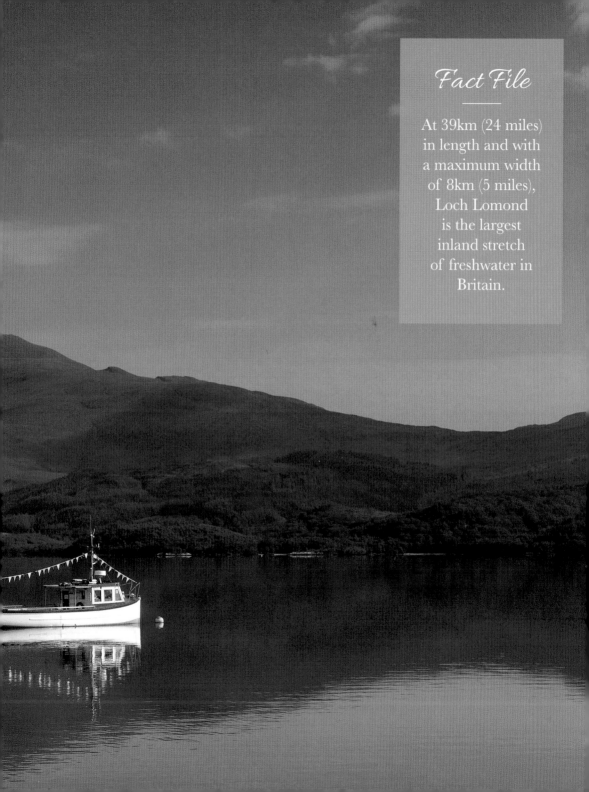

As the A82 runs towards Crianlarich, ancient oak woodland flanks the road, where bluebells are in abundance during May.

Fact File

The original route of the A82 between Tarbet and Crianlarich was built as a military road in the 1750s and today forms part of the West Highland Way.

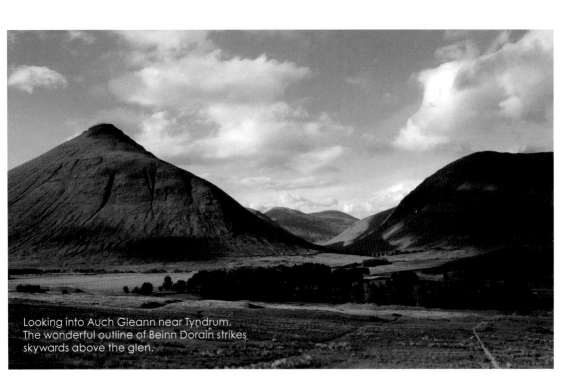

Looking into Auch Gleann near Tyndrum. The wonderful outline of Beinn Dorain strikes skywards above the glen.

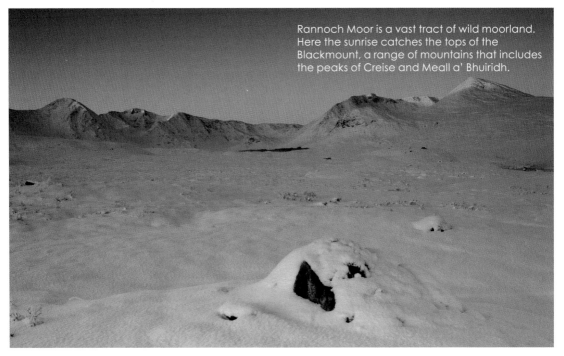

Rannoch Moor is a vast tract of wild moorland. Here the sunrise catches the tops of the Blackmount, a range of mountains that includes the peaks of Creise and Meall a' Bhuiridh.

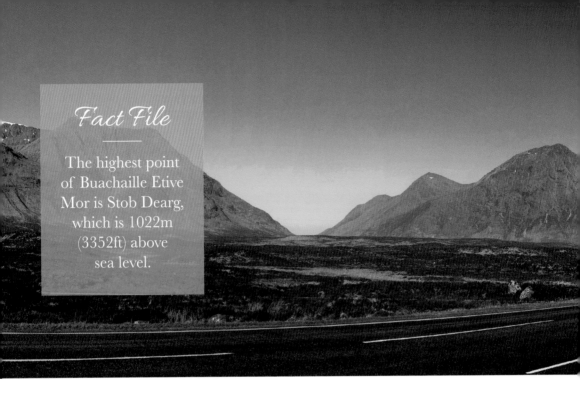

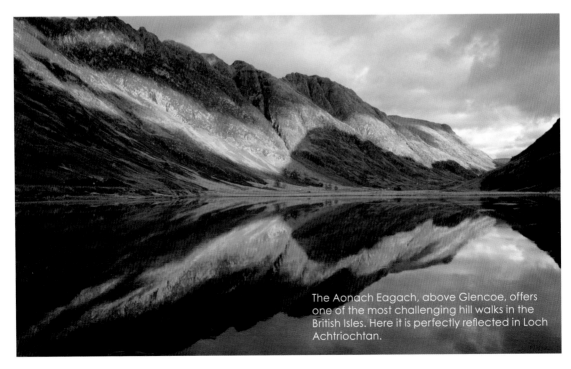

The Aonach Eagach, above Glencoe, offers one of the most challenging hill walks in the British Isles. Here it is perfectly reflected in Loch Achtriochtan.

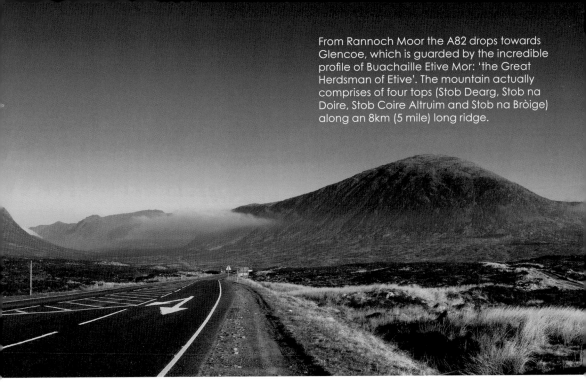

From Rannoch Moor the A82 drops towards Glencoe, which is guarded by the incredible profile of Buachaille Etive Mor: 'the Great Herdsman of Etive'. The mountain actually comprises of four tops (Stob Dearg, Stob na Doire, Stob Coire Altruim and Stob na Bròige) along an 8km (5 mile) long ridge.

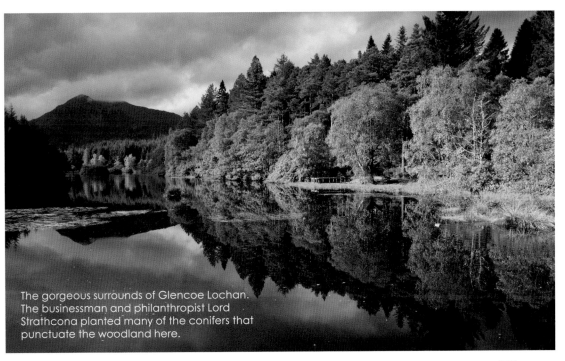

The gorgeous surrounds of Glencoe Lochan. The businessman and philanthropist Lord Strathcona planted many of the conifers that punctuate the woodland here.

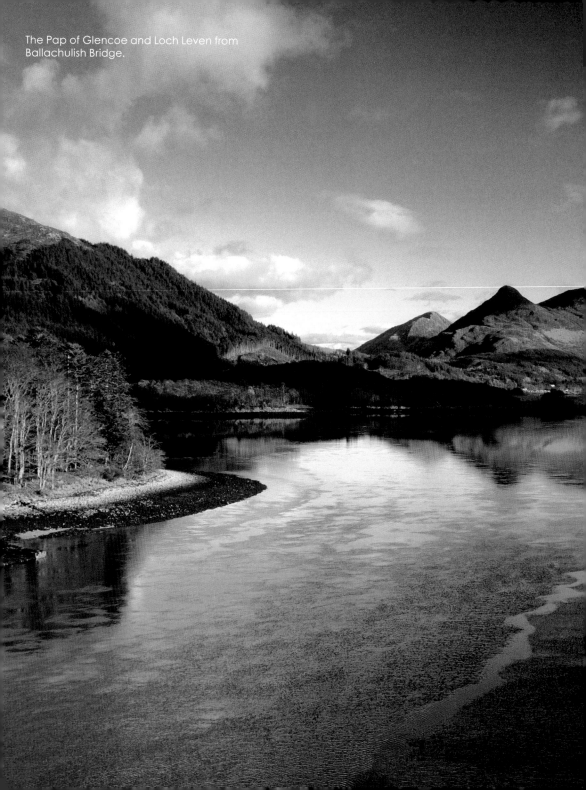
The Pap of Glencoe and Loch Leven from Ballachulish Bridge.

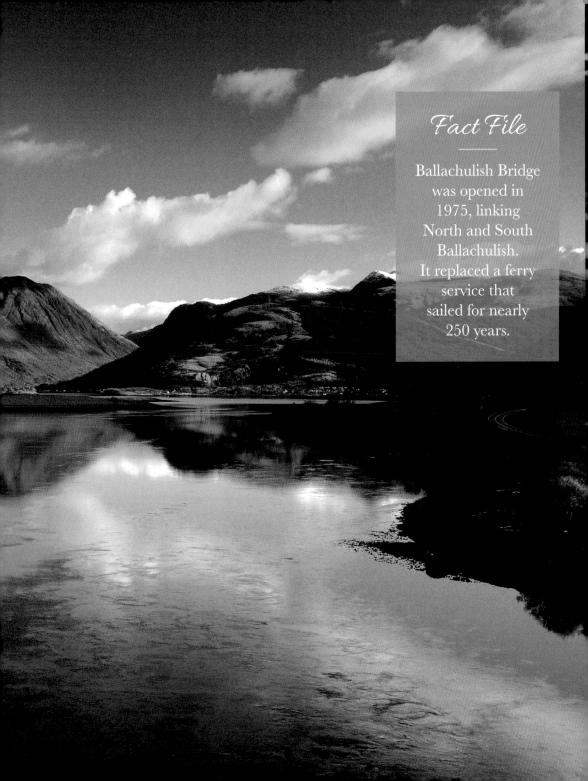

Fact File

Ballachulish Bridge
was opened in
1975, linking
North and South
Ballachulish.
It replaced a ferry
service that
sailed for nearly
250 years.

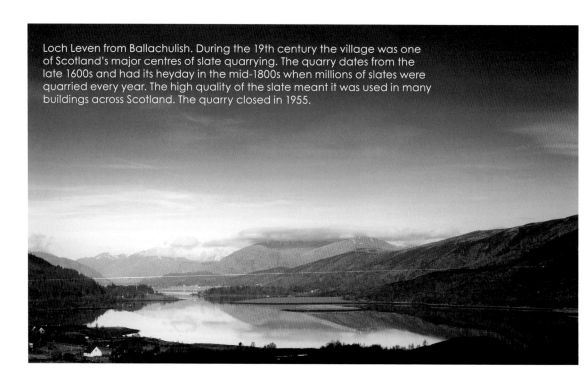

Loch Leven from Ballachulish. During the 19th century the village was one of Scotland's major centres of slate quarrying. The quarry dates from the late 1600s and had its heyday in the mid-1800s when millions of slates were quarried every year. The high quality of the slate meant it was used in many buildings across Scotland. The quarry closed in 1955.

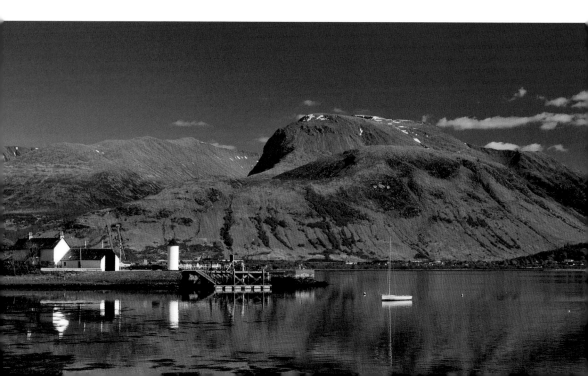

The Commando Monument above Spean Bridge grants a spectacular view of Ben Nevis and the Aonachs.

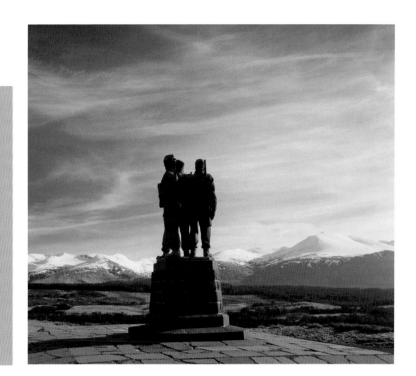

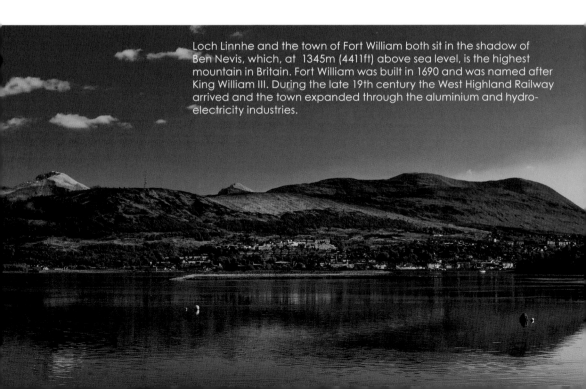

Loch Linnhe and the town of Fort William both sit in the shadow of Ben Nevis, which, at 1345m (4411ft) above sea level, is the highest mountain in Britain. Fort William was built in 1690 and was named after King William III. During the late 19th century the West Highland Railway arrived and the town expanded through the aluminium and hydro-electricity industries.

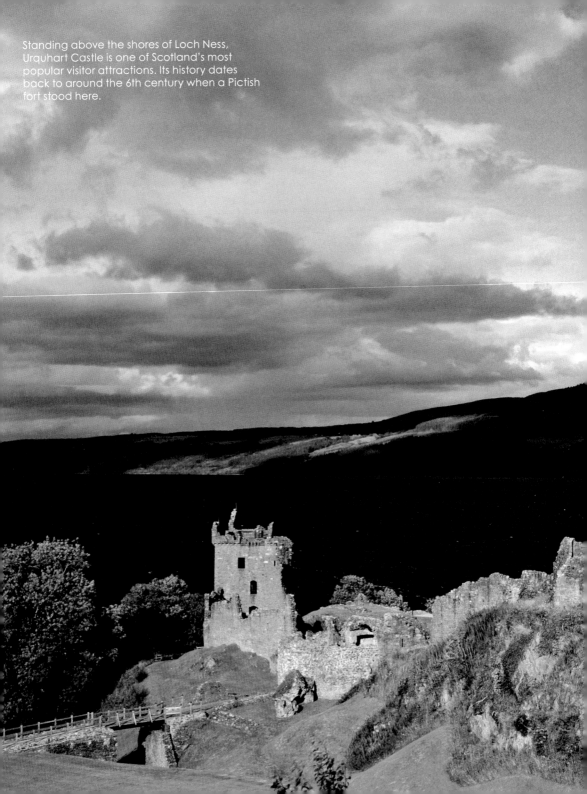

Standing above the shores of Loch Ness, Urquhart Castle is one of Scotland's most popular visitor attractions. Its history dates back to around the 6th century when a Pictish fort stood here.

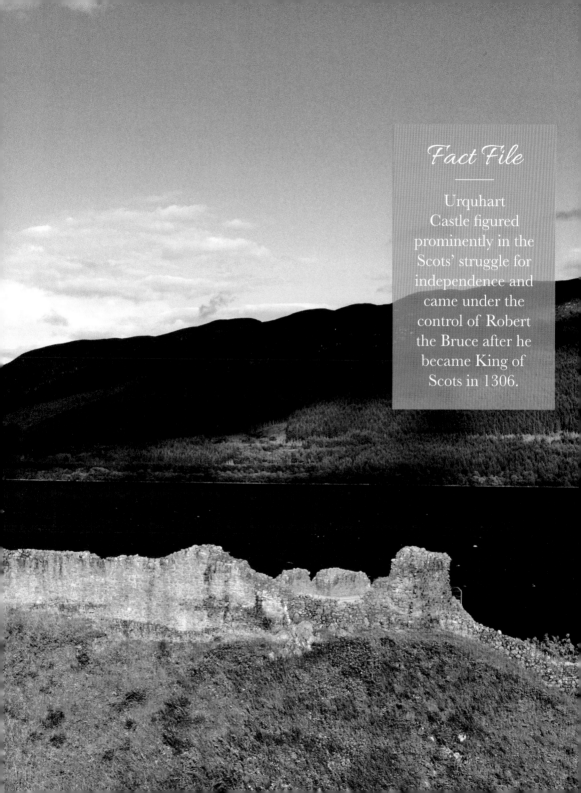

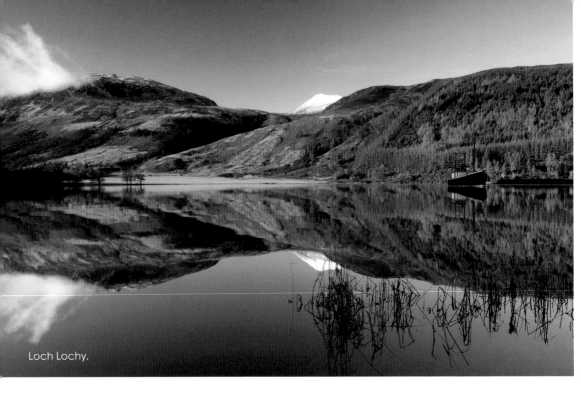

Loch Lochy.

Fact File

The Caledonian Canal runs for 96.5km (60 miles) from near Fort William to Inverness. It was opened in 1822, having been designed by the great Scottish engineer Thomas Telford. The canal was constructed to provide safe passage for ships travelling between the North Sea and the Atlantic coast, negating the need for the arduous journey through the Pentland Firth and around Cape Wrath.

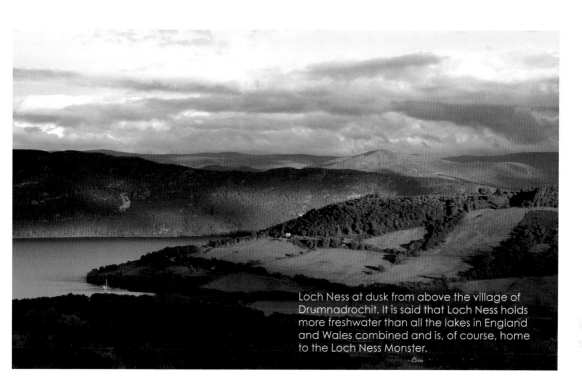

Loch Ness at dusk from above the village of Drumnadrochit. It is said that Loch Ness holds more freshwater than all the lakes in England and Wales combined and is, of course, home to the Loch Ness Monster.

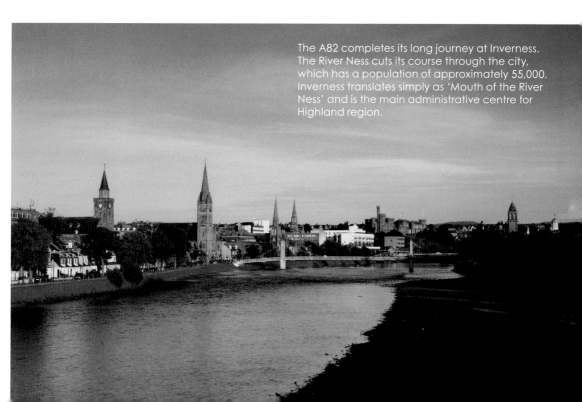

The A82 completes its long journey at Inverness. The River Ness cuts its course through the city, which has a population of approximately 55,000. Inverness translates simply as 'Mouth of the River Ness' and is the main administrative centre for Highland region.

CHAPTER TEN

Way Out West

Inverness *to* Applecross

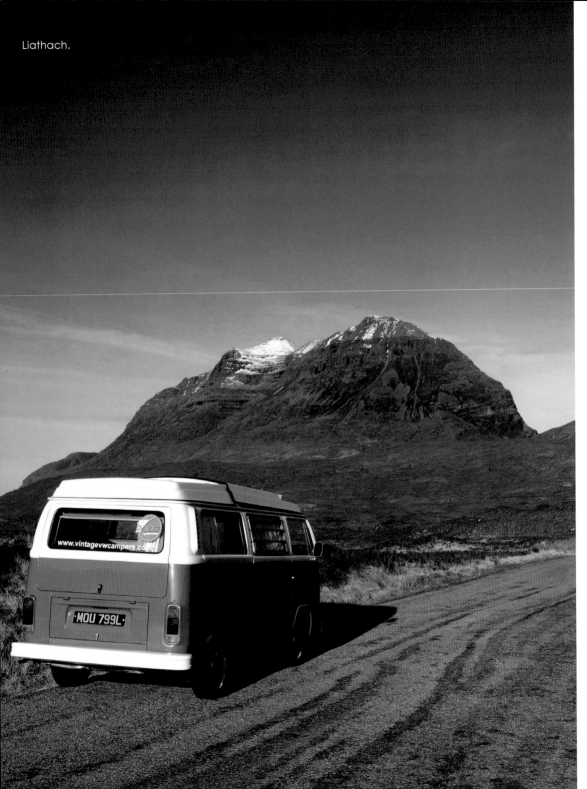

Liathach.

Inverness *to* Applecross

The 148km (92 miles) between Inverness and Applecross is one of Scotland's most spectacular routes, with scenery of breathtaking beauty around almost every corner.

Heading west from Inverness, the initial stage of the journey really whets the appetite for what lies ahead. Wild moorland, gorgeous lochs and colossal mountains are all on show, perfectly illustrating this wonderful country.

This scenery is perhaps best exemplified by the 27km (17 mile) stretch between Kinlochewe and the coastal splendour of Shieldaig. En route, iconic peaks such as Beinn Eighe, Liathach and Beinn Alligin strike skywards above Upper Loch Torridon.

The final 40km (25 miles) across the remote peninsula of Applecross travel along single-track road, with the exceptional views extending to Raasay and the sawtooth outline of Skye's Cuillin Ridge.

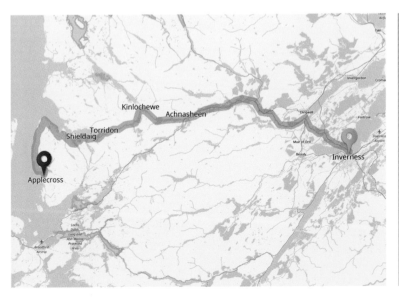

Fact File

Inverness is one of the fastest growing cities in Europe and has a population of approximately 55,000.

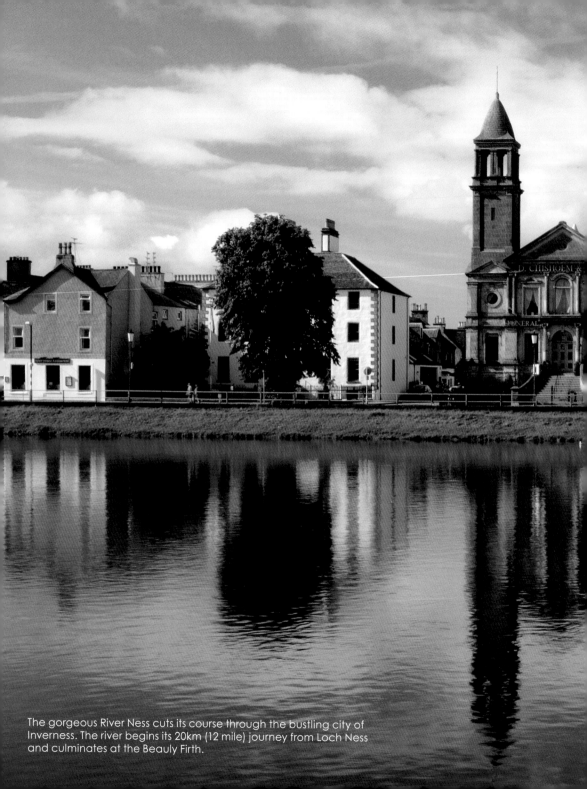

The gorgeous River Ness cuts its course through the bustling city of Inverness. The river begins its 20km (12 mile) journey from Loch Ness and culminates at the Beauly Firth.

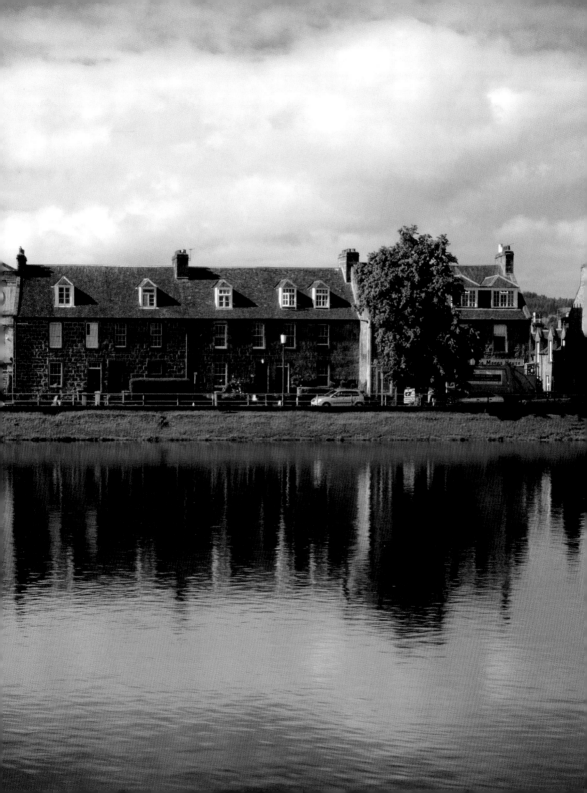

Sgurr a'Ghlas Leathaid is one of the shapely mountains along the early stages of the route.

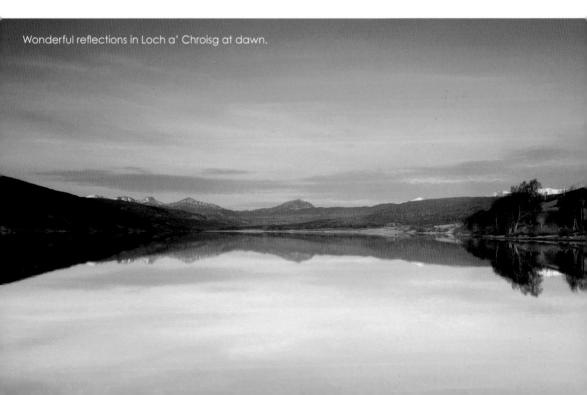

Wonderful reflections in Loch a' Chroisg at dawn.

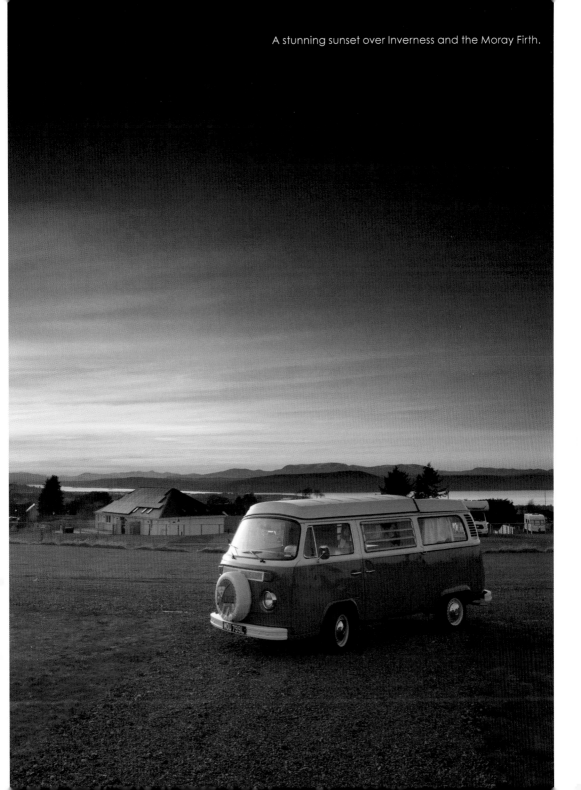

A stunning sunset over Inverness and the Moray Firth.

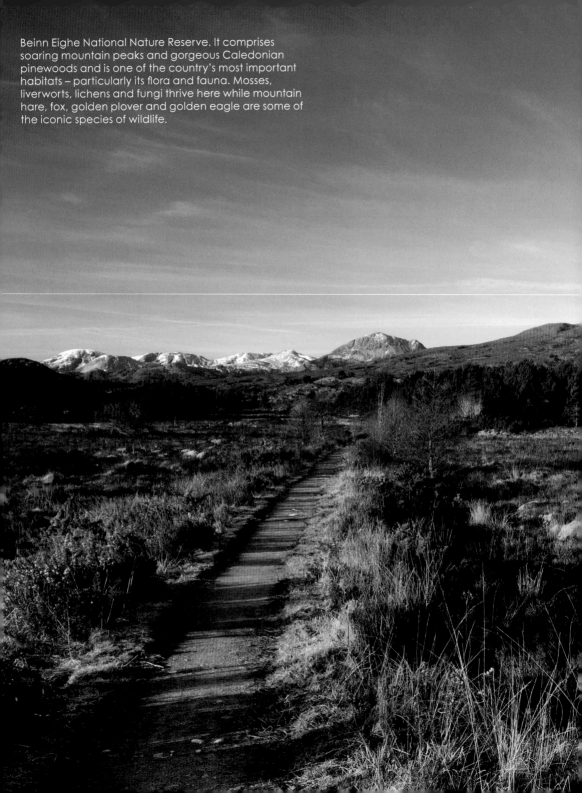

Beinn Eighe National Nature Reserve. It comprises soaring mountain peaks and gorgeous Caledonian pinewoods and is one of the country's most important habitats – particularly its flora and fauna. Mosses, liverworts, lichens and fungi thrive here while mountain hare, fox, golden plover and golden eagle are some of the iconic species of wildlife.

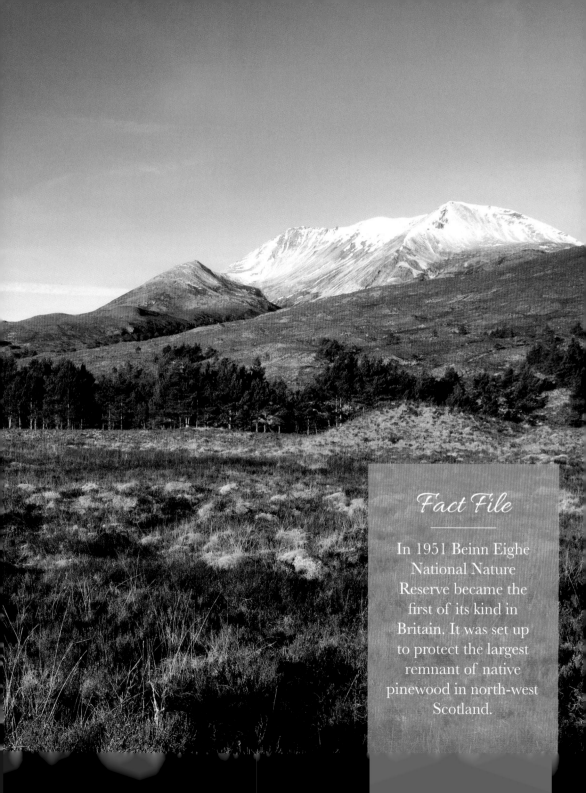

Fact File

In 1951 Beinn Eighe National Nature Reserve became the first of its kind in Britain. It was set up to protect the largest remnant of native pinewood in north-west Scotland.

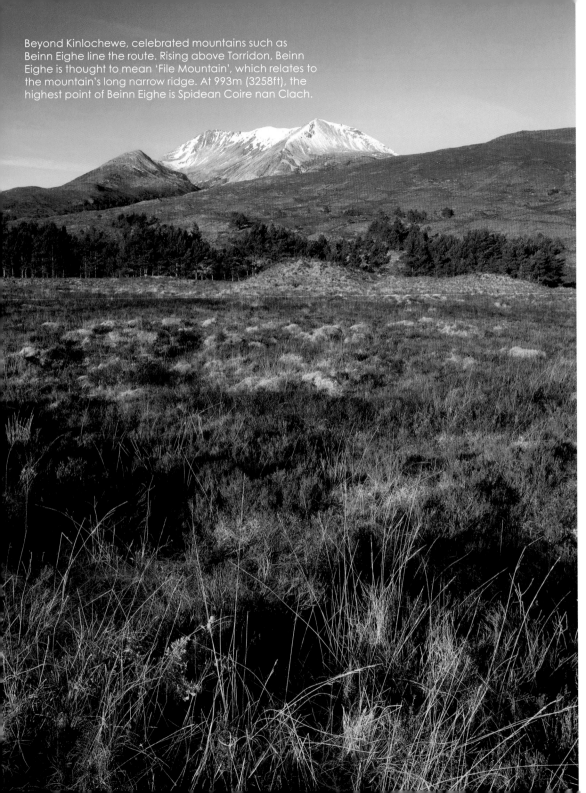

Beyond Kinlochewe, celebrated mountains such as Beinn Eighe line the route. Rising above Torridon, Beinn Eighe is thought to mean 'File Mountain', which relates to the mountain's long narrow ridge. At 993m (3258ft), the highest point of Beinn Eighe is Spidean Coire nan Clach.

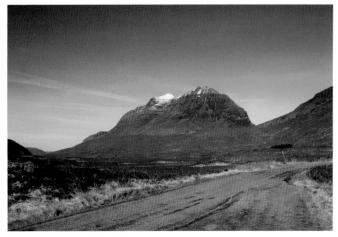

Liathach dominates the view above the A896. Its translation is simply 'the Greyish One' but it is a complex mountain in every other respect. The main ridge has four other peaks over 914m (3000ft) in height. Much of Liathach is composed of Torridonian sandstone, thought to be over 500 million years old.

The village of Torridon is dwarfed by the surrounding landscape.

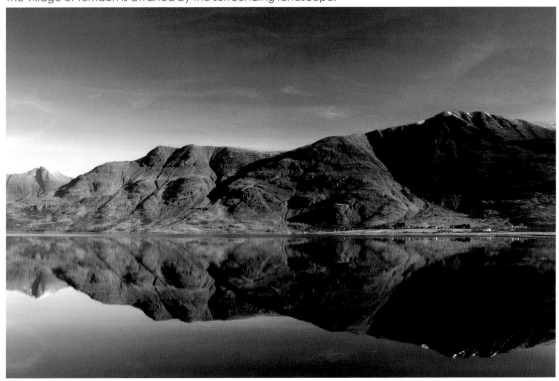

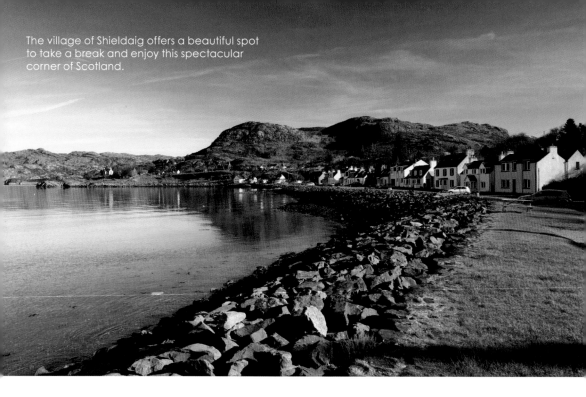

The village of Shieldaig offers a beautiful spot to take a break and enjoy this spectacular corner of Scotland.

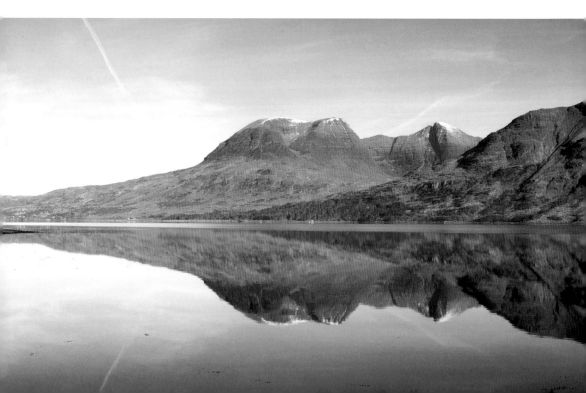

Fishing trawlers plying their trade on the waters of Loch Shieldaig.

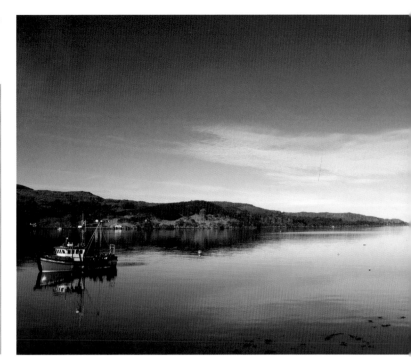

Fact File

Shieldaig was established in 1800 as a small fishing village but also as a training base for the Royal Navy. Its name means 'Herring Bay'.

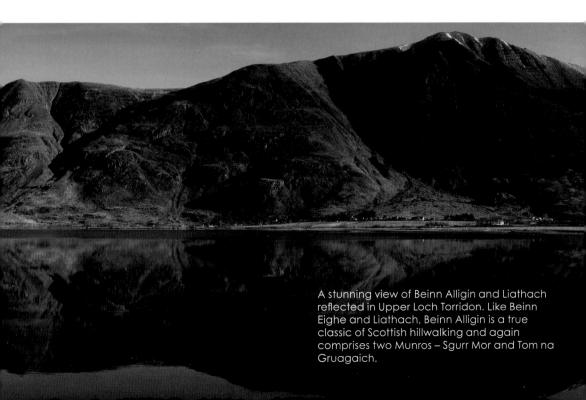

A stunning view of Beinn Alligin and Liathach reflected in Upper Loch Torridon. Like Beinn Eighe and Liathach, Beinn Alligin is a true classic of Scottish hillwalking and again comprises two Munros – Sgurr Mor and Tom na Gruagaich.

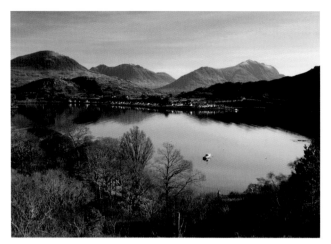

The road to Applecross bestows a sensational view across Loch Shieldaig and Shieldaig to the great mountains of Torridon. Out on Loch Shieldaig sits Shieldaig Island. It is densely covered in mature Scots pine, which are thought to have been planted in the 1870s to provide timber for poles for drying fishing nets. The island has been under the care of the National Trust for Scotland since 1970.

The inlet of Loch Beag opens out into Loch Torridon.

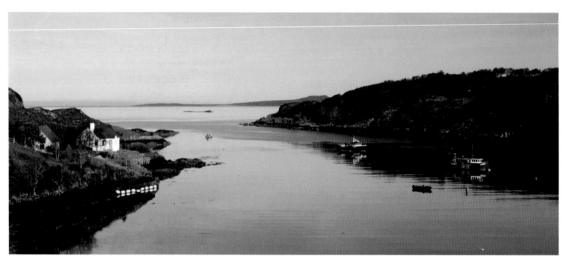

The road to Applecross snaking its way across the wild moorland of this remote headland. The name Applecross probably translates as 'Mouth of the Crosan River'. However, its history may be associated with a nearby monastery that was founded by St Maelrubha in AD673. The Applecross Inn has been situated at its present site since the early 1800s.

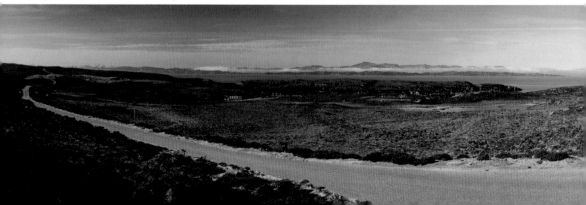

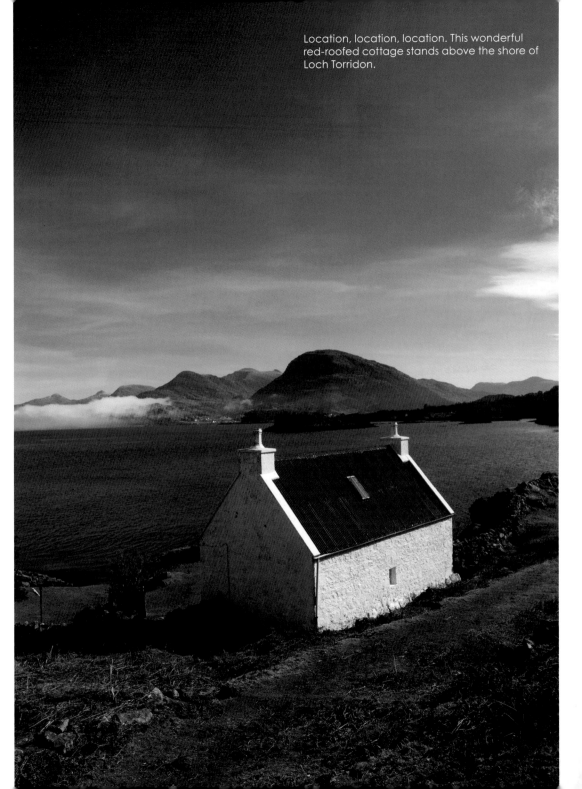

Location, location, location. This wonderful red-roofed cottage stands above the shore of Loch Torridon.

Fact File

Rising above
Applecross is
Bealach na Ba, the
'Pass of the Cattle'.
Reaching
626m (2053ft)
above sea level, it is
one of the highest
roads in Scotland.

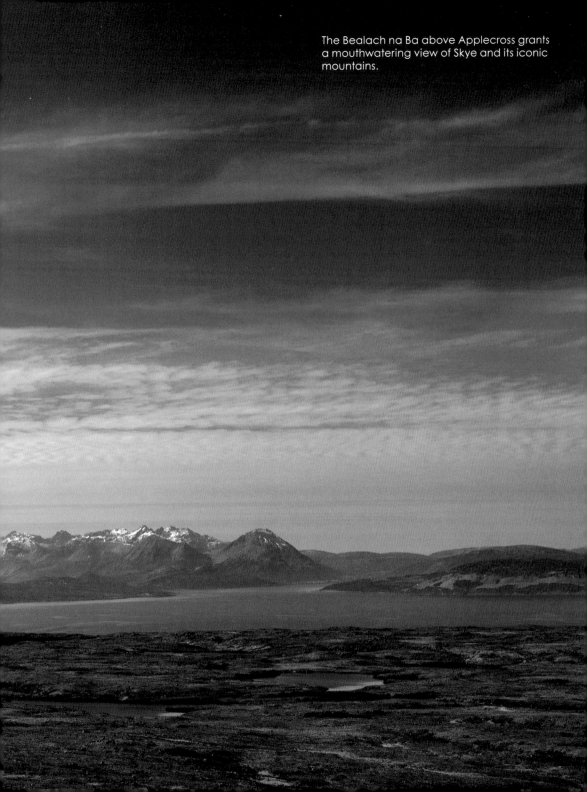

The Bealach na Ba above Applecross grants a mouthwatering view of Skye and its iconic mountains.

CHAPTER ELEVEN

The North Coast 500

Kinlochewe *to* Durness

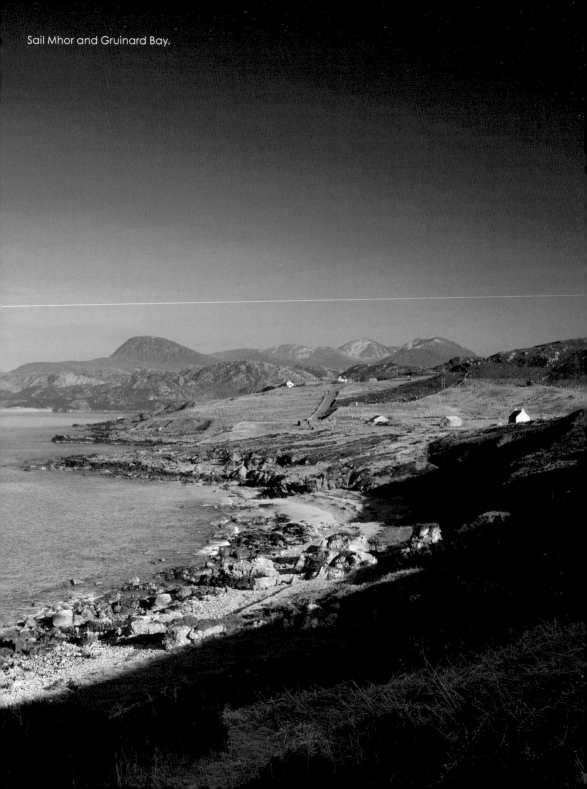

Sail Mhor and Gruinard Bay.

Kinlochewe *to* Durness

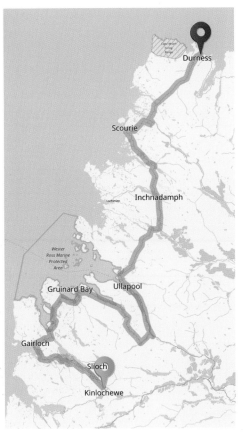

The North Coast 500, which travels around mainland Scotland's northern fringes, is recognised as one of the world's most spectacular routes due to the breathtaking scenery along its length.

The section from Kinlochewe, a small village 80km (50 miles) west of Inverness, to Durness, which sits near the northwest tip of the Scottish mainland, encapsulates much of what the route has to offer.

The magnificent mountain of Slioch, rising to 981m (3218ft) above the steely blue waters of Loch Maree, dominates the view along the early stages, before the route tapers its way around a wonderfully rugged coastline, in the shadow of An Teallach and Sail Mhor, to Ullapool.

The diversity of the NC500 is then highlighted as it runs north through Sutherland's incredibly dramatic landscape, where the rocks are some of the oldest in the world. Mountains such as Quinag, Stac Pollaidh and Cul Mor hold your attention until the road eventually reaches Durness and the dramatic Smoo Cave.

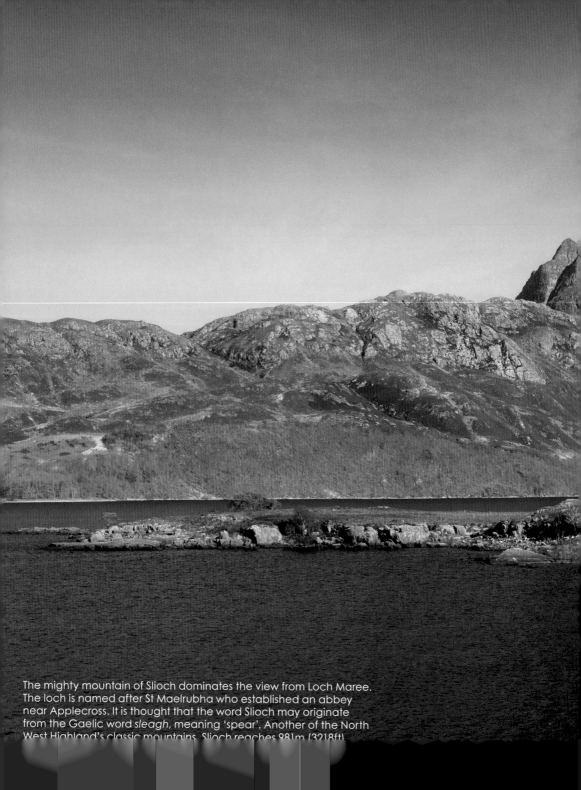

The mighty mountain of Slioch dominates the view from Loch Maree. The loch is named after St Maelrubha who established an abbey near Applecross. It is thought that the word Slioch may originate from the Gaelic word *sleagh*, meaning 'spear'. Another of the North West Highland's classic mountains, Slioch reaches 981m (3218ft)

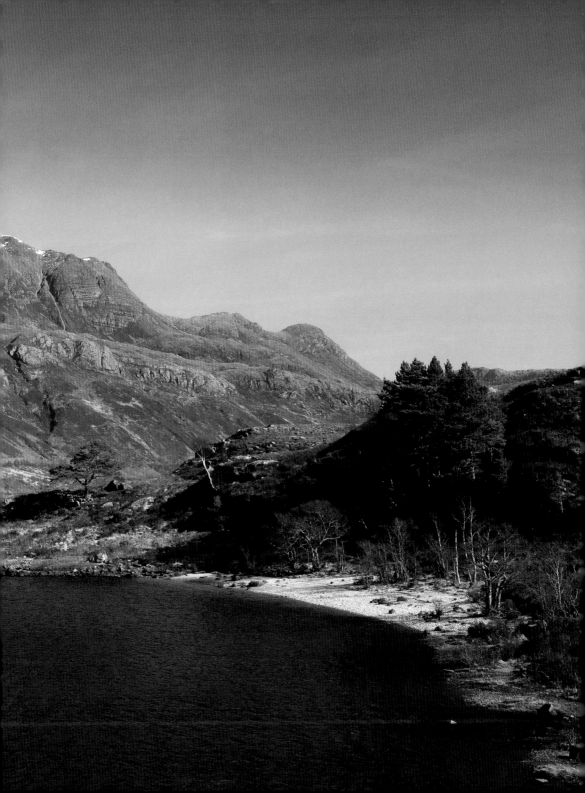

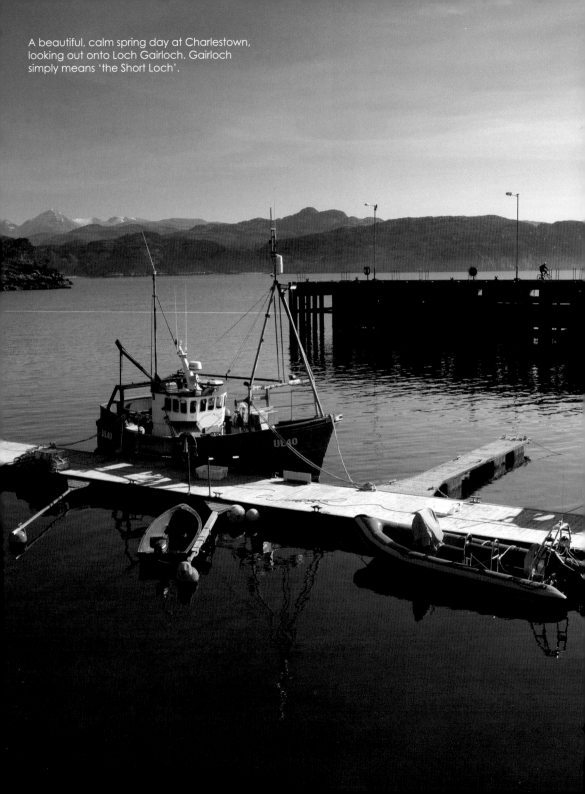

A beautiful, calm spring day at Charlestown, looking out onto Loch Gairloch. Gairloch simply means 'the Short Loch'.

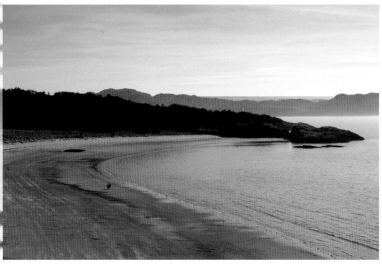

Fact File

The North Coast 500 is actually 830km (516 miles) in length and has been described as Scotland's Route 66.

A gorgeous arc of golden sand at Gairloch.

The North Coast 500 proceeds along the A832 past the First Coast towards Gruinard Bay, in the shadow of huge mountains such as An Teallach and Sail Mhor.

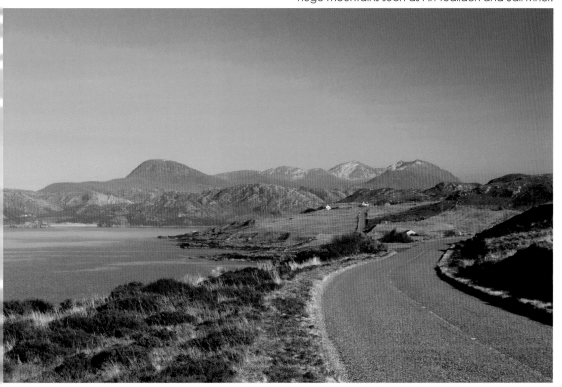

The spectacular Gruinard Bay. Sitting a
little out in Gruinard Bay is Gruinard Island,
which became infamous as the site of a
biological warfare test in the 1940s by British
military scientists. The island remained out
of bounds for nearly 50 years until it was
decontaminated. Gruinard Island has been
uninhabited since the 1920s.

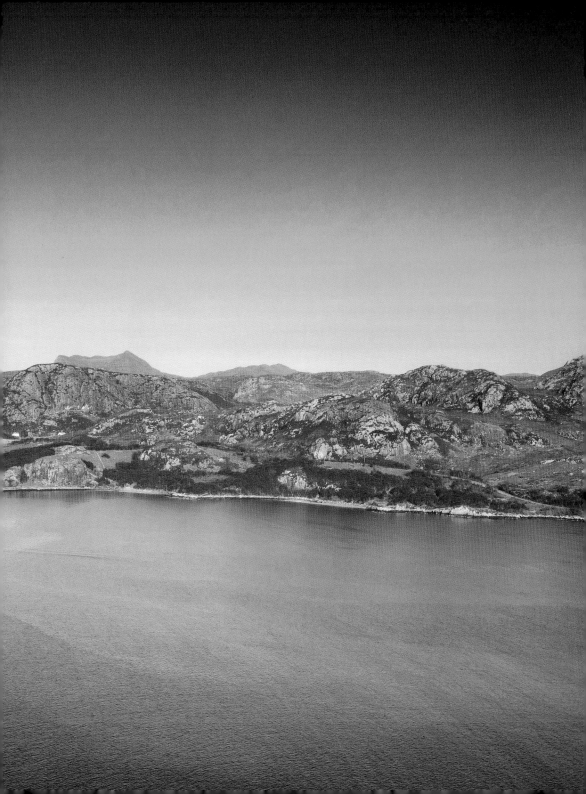

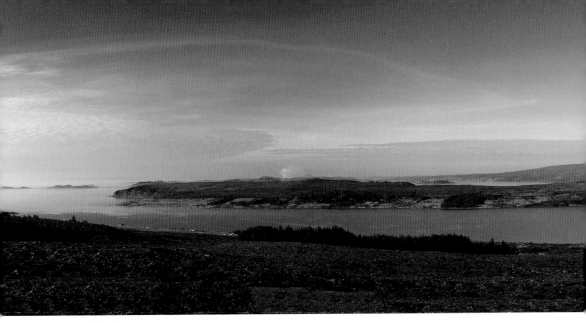

High above Little Loch Broom.

Late evening light, Gruinard Bay.

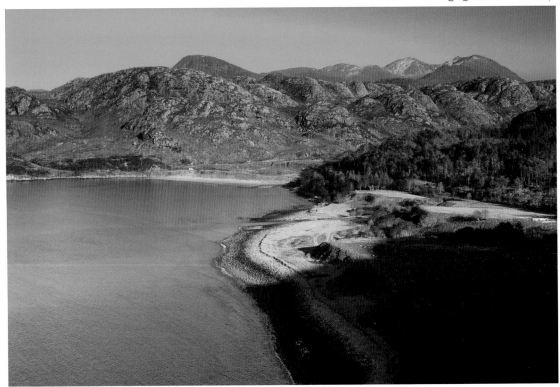

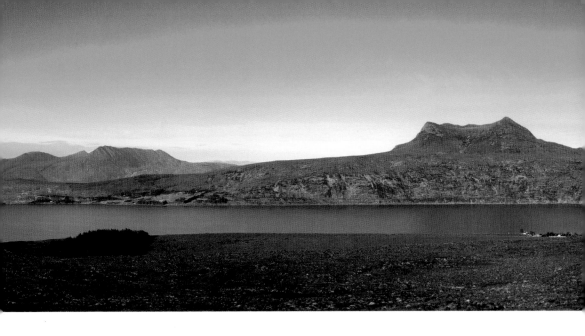

Fact File

Ullapool was built in 1788 by the British Fisheries Society to exploit the herring boom of the time. Today the village is the main ferry terminus for Stornoway on Lewis.

•

Inverewe Gardens, a little north of Poolewe, was created by Osgood Mackenzie in 1862. It is home to exotic plants from across the world.

The route passes through Ullapool, one of the main settlements along the North Coast 500. It has been a major fishing port since 1788, an industry that still thrives today. A ferry began linking Ullapool with Stornoway, on the Isle of Lewis, in 1870 although it ceased in 1885, only starting up again in 1973. The name Ullapool comes from the Norse for 'Olaf's Settlement' or 'farmstead'.

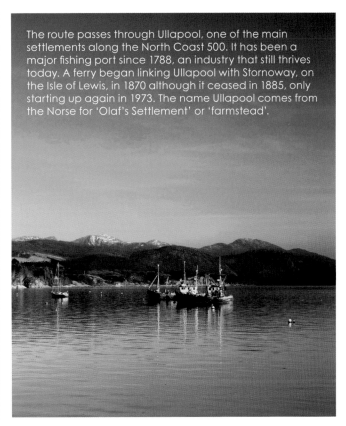

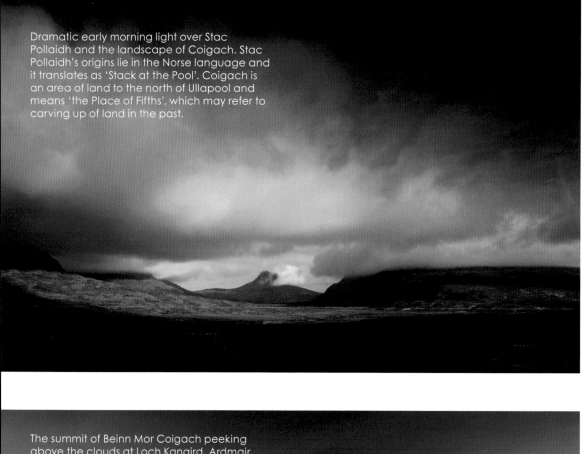

Dramatic early morning light over Stac Pollaidh and the landscape of Coigach. Stac Pollaidh's origins lie in the Norse language and it translates as 'Stack at the Pool'. Coigach is an area of land to the north of Ullapool and means 'the Place of Fifths', which may refer to carving up of land in the past.

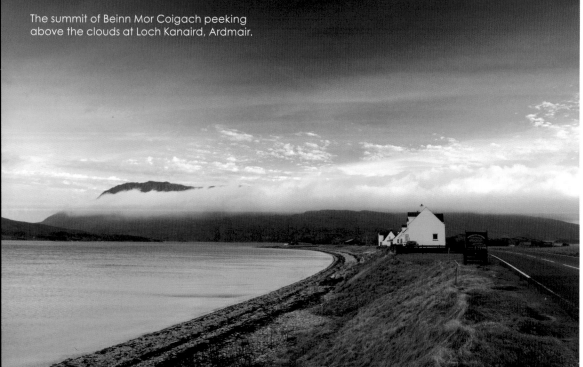

The summit of Beinn Mor Coigach peeking above the clouds at Loch Kanaird, Ardmair.

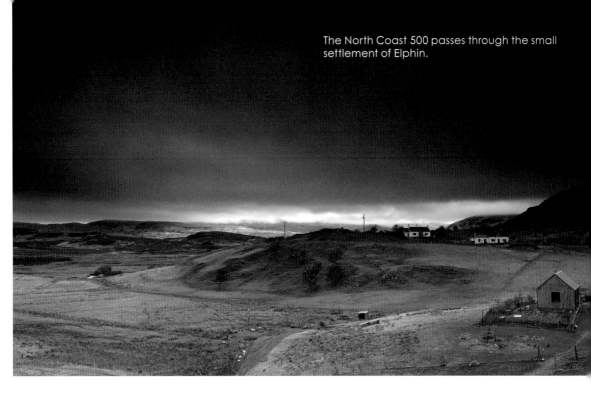

The North Coast 500 passes through the small settlement of Elphin.

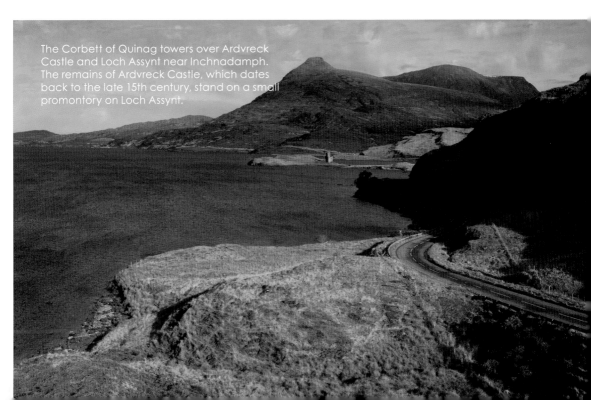

The Corbett of Quinag towers over Ardvreck Castle and Loch Assynt near Inchnadamph. The remains of Ardvreck Castle, which dates back to the late 15th century, stand on a small promontory on Loch Assynt.

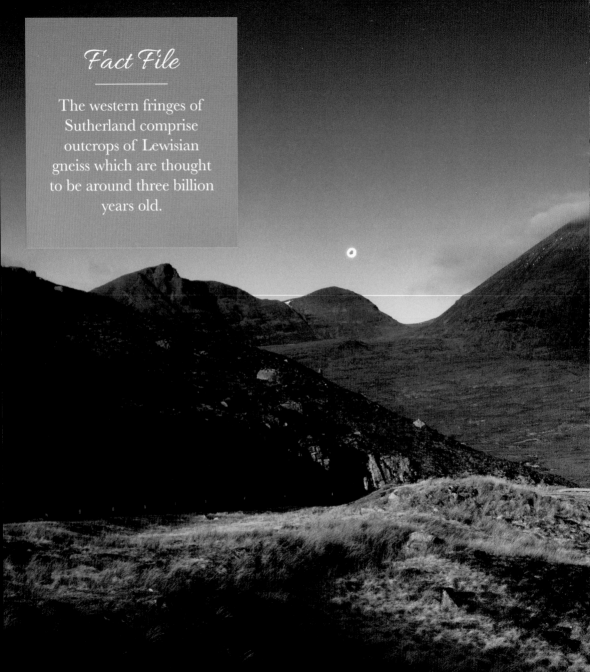

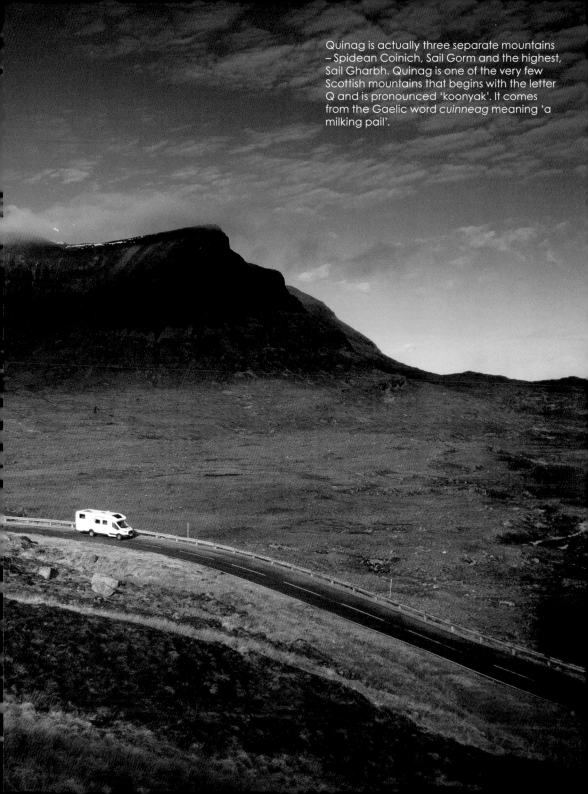

Quinag is actually three separate mountains – Spidean Coinich, Sail Gorm and the highest, Sail Gharbh. Quinag is one of the very few Scottish mountains that begins with the letter Q and is pronounced 'koonyak'. It comes from the Gaelic word *cuinneag* meaning 'a milking pail'.

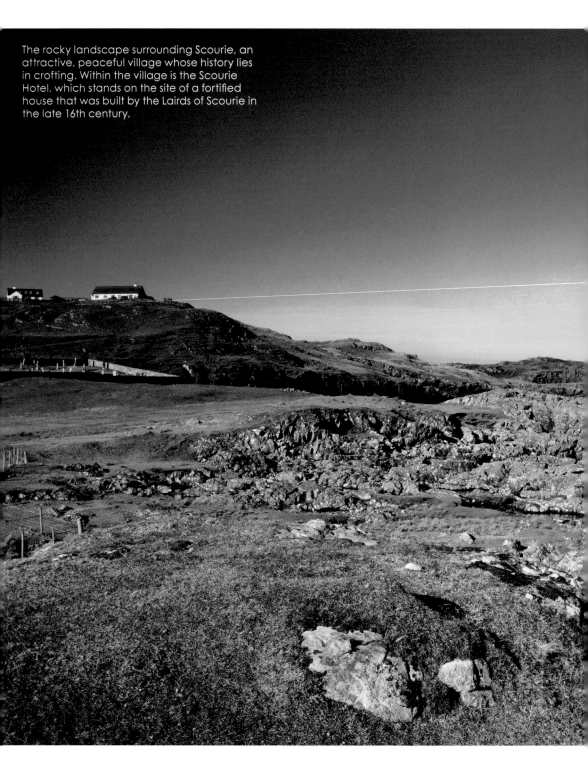

The rocky landscape surrounding Scourie, an attractive, peaceful village whose history lies in crofting. Within the village is the Scourie Hotel, which stands on the site of a fortified house that was built by the Lairds of Scourie in the late 16th century.

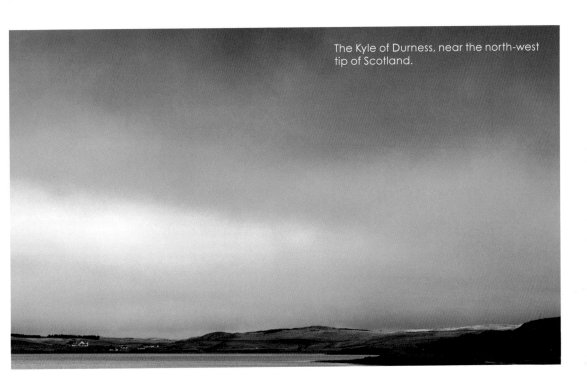

The Kyle of Durness, near the north-west tip of Scotland.

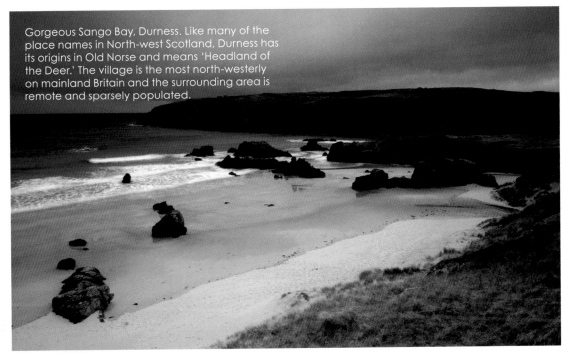

Gorgeous Sango Bay, Durness. Like many of the place names in North-west Scotland, Durness has its origins in Old Norse and means 'Headland of the Deer.' The village is the most north-westerly on mainland Britain and the surrounding area is remote and sparsely populated.

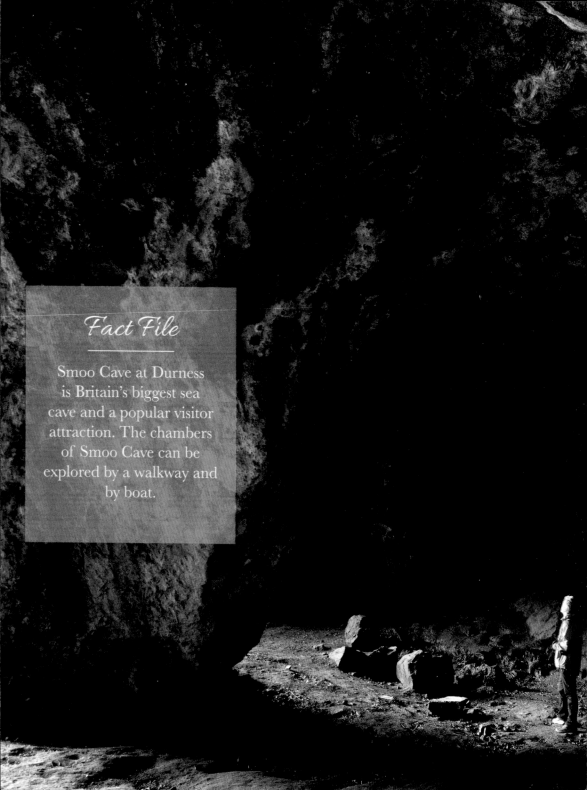

Fact File

Smoo Cave at Durness
is Britain's biggest sea
cave and a popular visitor
attraction. The chambers
of Smoo Cave can be
explored by a walkway and
by boat.

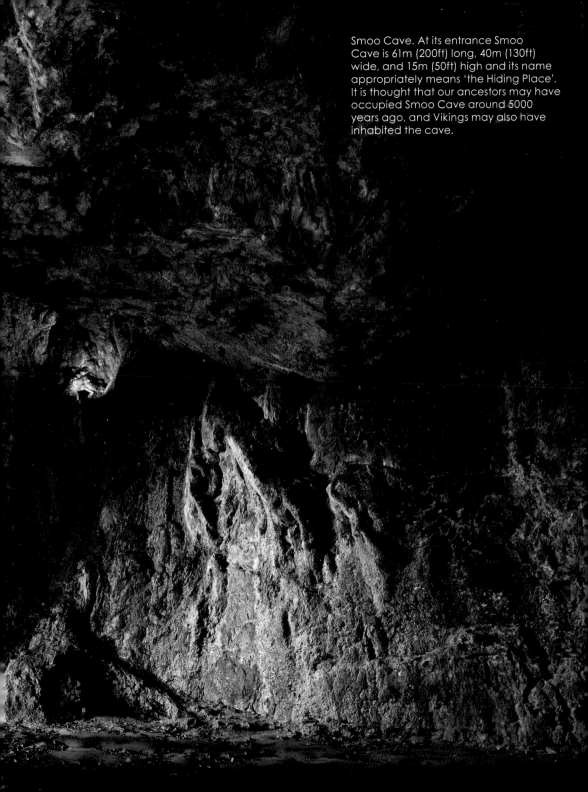

Smoo Cave. At its entrance Smoo Cave is 61m (200ft) long, 40m (130ft) wide, and 15m (50ft) high and its name appropriately means 'the Hiding Place'. It is thought that our ancestors may have occupied Smoo Cave around 5000 years ago, and Vikings may also have inhabited the cave.

CHAPTER TWELVE

An Iconic Landscape

Invergarry *to the* Storr

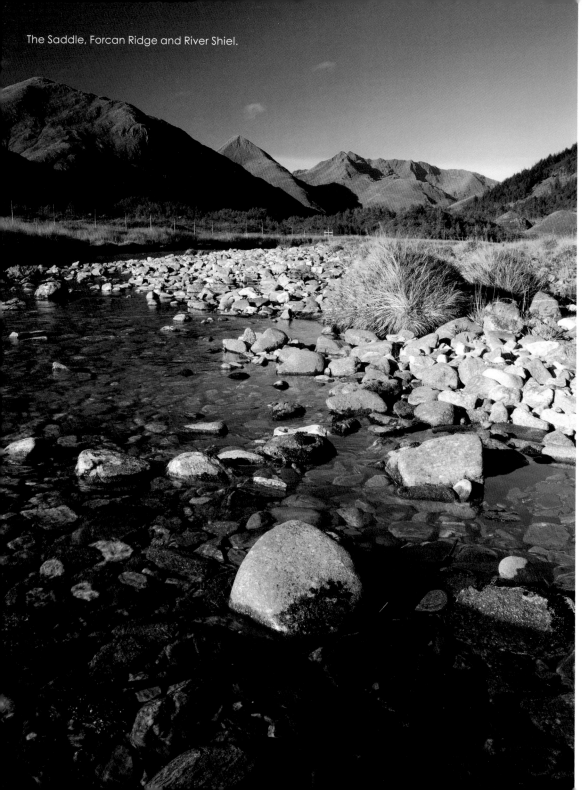

The Saddle, Forcan Ridge and River Shiel.

Invergarry *to the* Storr

By following the A87 from Invergarry onto the Isle of Skye you quickly gain a sense of why the surrounding landscape is so remarkable.

Climbing out of Invergarry, the view stretches across Loch Garry to an impressive array of West Highland peaks. The road then snakes its way through Glen Shiel, where the jagged contours of the South Glen Shiel Ridge and the imposing Five Sisters of Kintail leave you breathless in their scale and grandeur.

Once by Eilean Donan Castle, the landscape opens out as the road crosses the Skye Bridge onto the Misty Isle. Initially the domed summits of the Red Cuillin dominate the view, before the formidable contours of the Black Cuillin, breathtaking in its savage beauty, rise from Glen Sligachan.

Beyond Portree, the astonishing scenery continues as the A855 runs beneath the unique Trotternish Ridge to reach the astonishing landscape of the Storr.

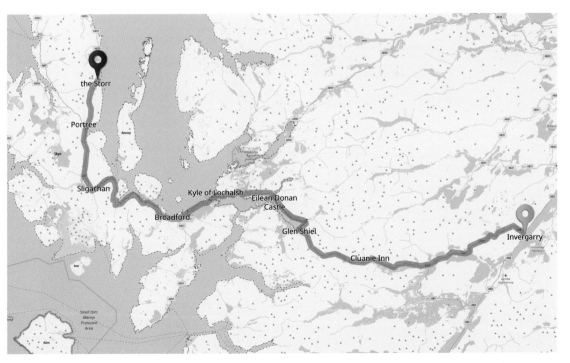

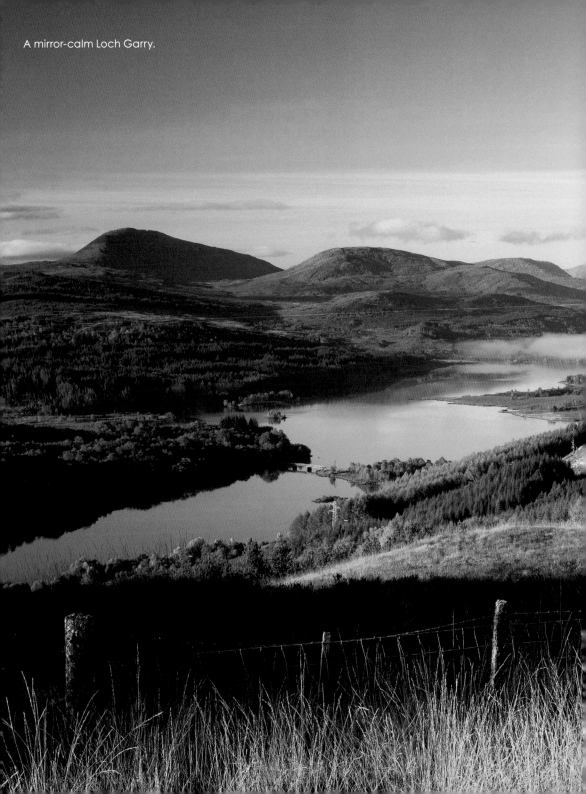

A mirror-calm Loch Garry.

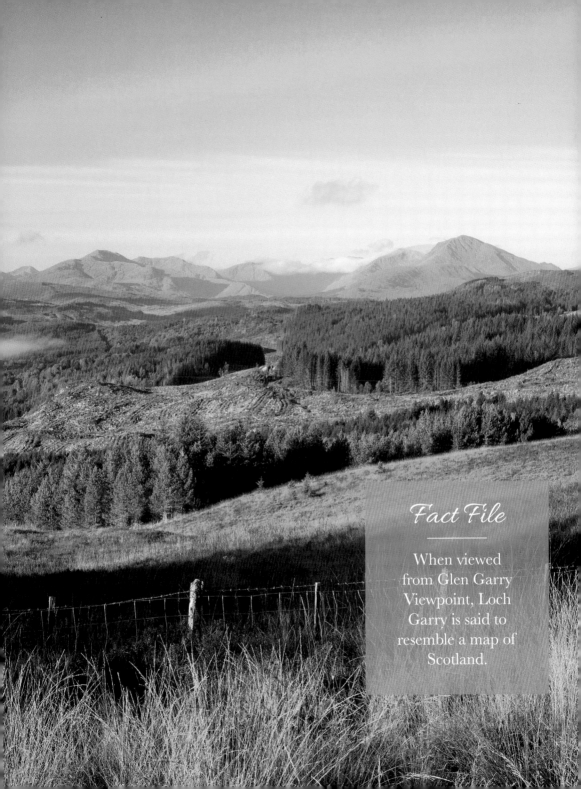

Fact File

When viewed
from Glen Garry
Viewpoint, Loch
Garry is said to
resemble a map of
Scotland.

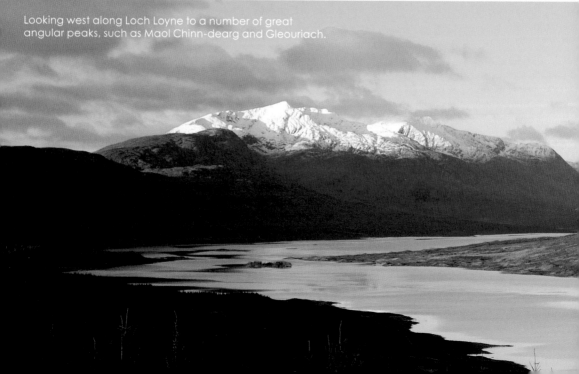

Looking west along Loch Loyne to a number of great angular peaks, such as Maol Chinn-dearg and Gleouriach.

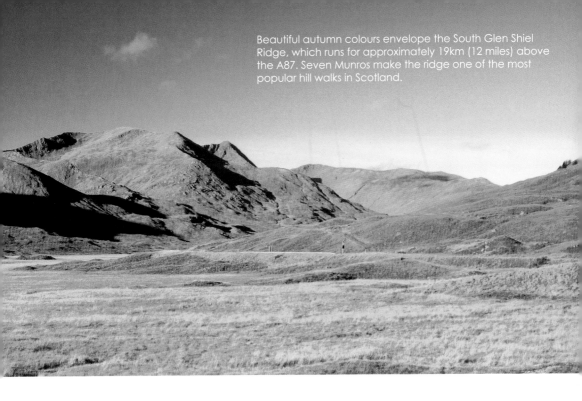

Beautiful autumn colours envelope the South Glen Shiel Ridge, which runs for approximately 19km (12 miles) above the A87. Seven Munros make the ridge one of the most popular hill walks in Scotland.

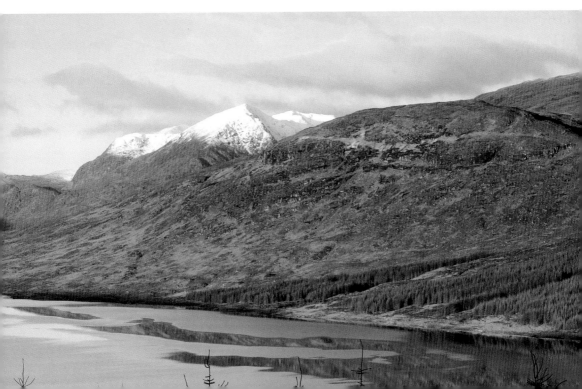

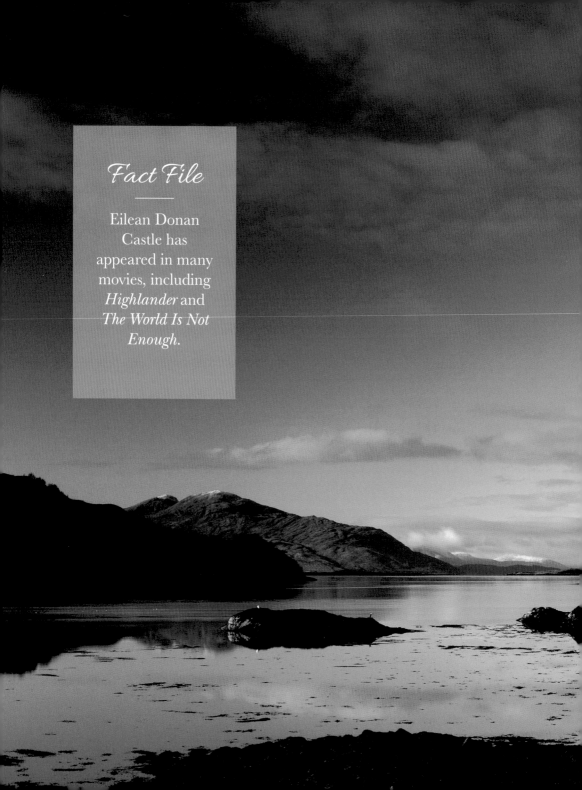

Fact File

Eilean Donan
Castle has
appeared in many
movies, including
Highlander and
*The World Is Not
Enough.*

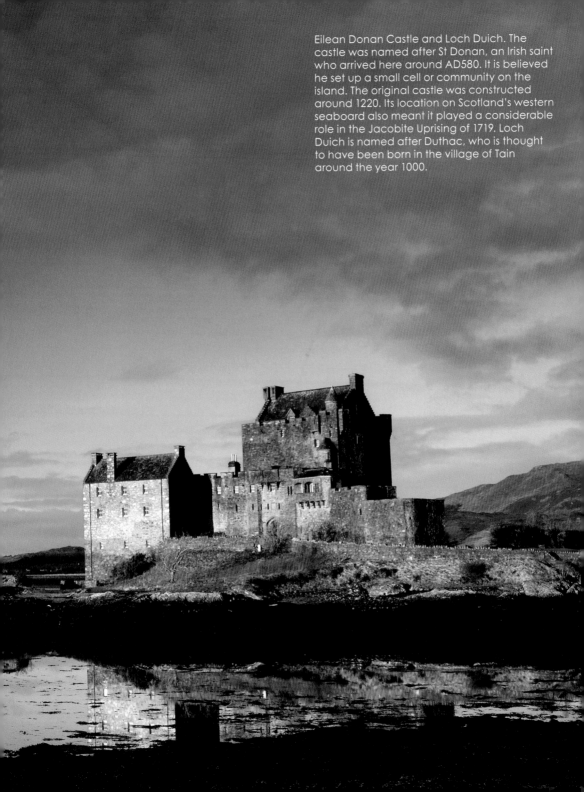

Eilean Donan Castle and Loch Duich. The castle was named after St Donan, an Irish saint who arrived here around AD580. It is believed he set up a small cell or community on the island. The original castle was constructed around 1220. Its location on Scotland's western seaboard also meant it played a considerable role in the Jacobite Uprising of 1719. Loch Duich is named after Duthac, who is thought to have been born in the village of Tain around the year 1000.

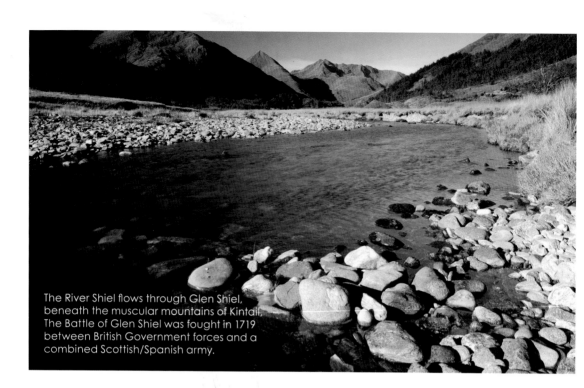

The River Shiel flows through Glen Shiel, beneath the muscular mountains of Kintail. The Battle of Glen Shiel was fought in 1719 between British Government forces and a combined Scottish/Spanish army.

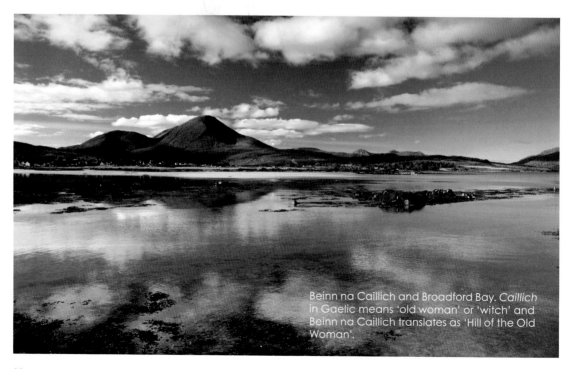

Beinn na Caillich and Broadford Bay. *Caillich* in Gaelic means 'old woman' or 'witch' and Beinn na Caillich translates as 'Hill of the Old Woman'.

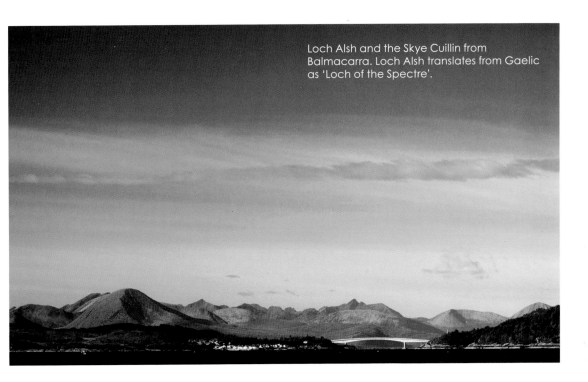

Loch Alsh and the Skye Cuillin from Balmacarra. Loch Alsh translates from Gaelic as 'Loch of the Spectre'.

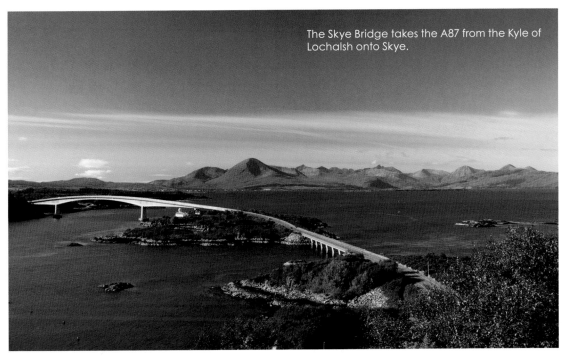

The Skye Bridge takes the A87 from the Kyle of Lochalsh onto Skye.

Storm clouds over the Red Cuillin from Lower Breakish. The rounded nature of the Red Cuillin is much less dramatic than that of the neighbouring Black Cuillin. The highest point of the Red Cuillin is Glamaig, which rises to 775m (2543ft) above sea level.

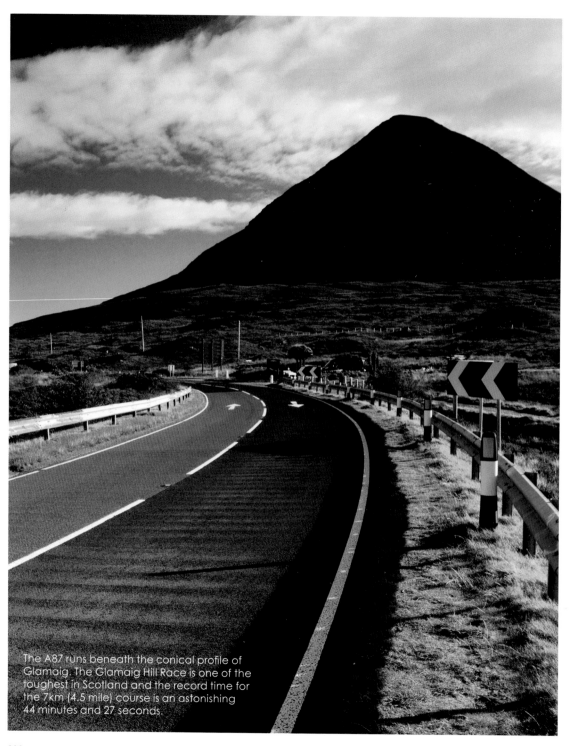

The A87 runs beneath the conical profile of Glamaig. The Glamaig Hill Race is one of the toughest in Scotland and the record time for the 7km (4.5 mile) course is an astonishing 44 minutes and 27 seconds.

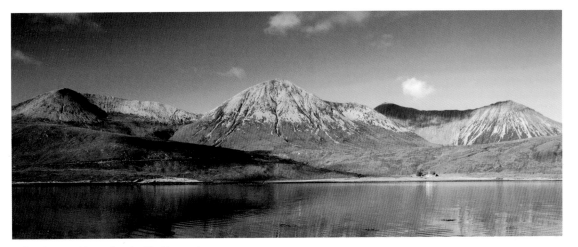

Beinn Dearg Mor reflected in the waters of Loch Ainort.

The savage beauty of the Black Cuillin from Sligachan. The Black Cuillin is a chain of 12 Munros. Its highest point, at 992m (3255ft), is Sgurr Alasdair, which was named after Alexander Nicholson (Alasdair MacNeacail in Gaelic), who made the first recorded ascent in 1873. The ridge also includes Sgurr Dearg, a mountain that requires a rock climb to reach its infamous 986m (3235ft) summit – the Inaccessible Pinnacle – and an abseil back down.

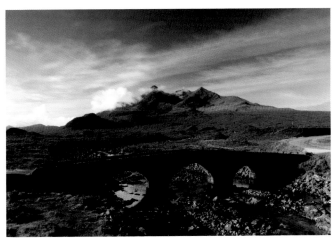

Loch Portree.

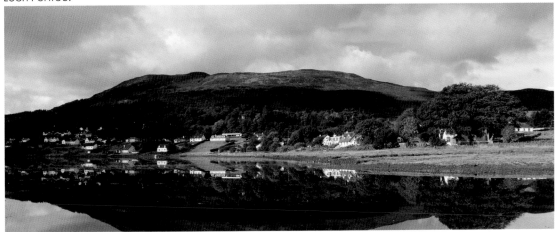

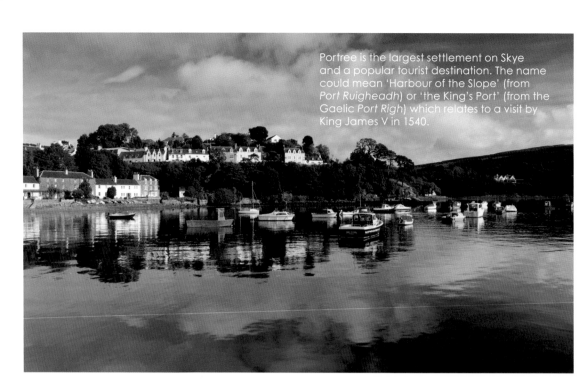

Portree is the largest settlement on Skye and a popular tourist destination. The name could mean 'Harbour of the Slope' (from *Port Ruigheadh*) or 'the King's Port' (from the Gaelic *Port Righ*) which relates to a visit by King James V in 1540.

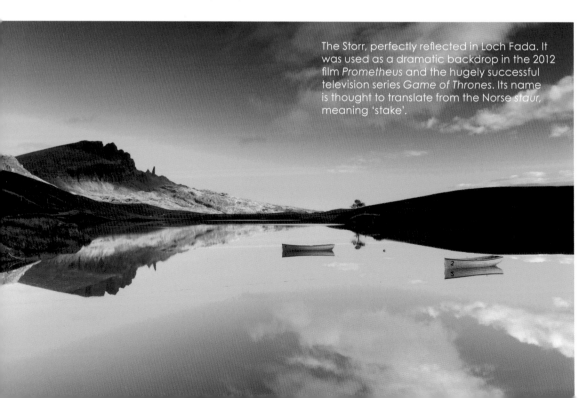

The Storr, perfectly reflected in Loch Fada. It was used as a dramatic backdrop in the 2012 film *Prometheus* and the hugely successful television series *Game of Thrones*. Its name is thought to translate from the Norse *staur*, meaning 'stake'.

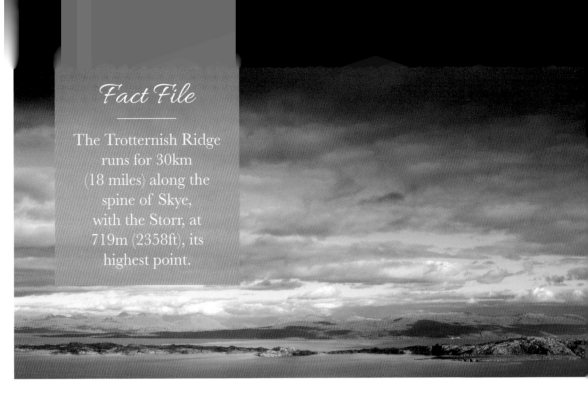

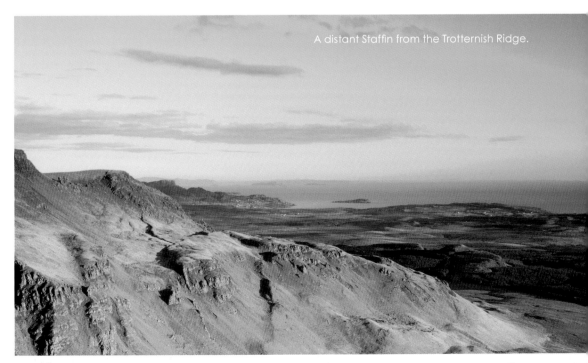

A distant Staffin from the Trotternish Ridge.

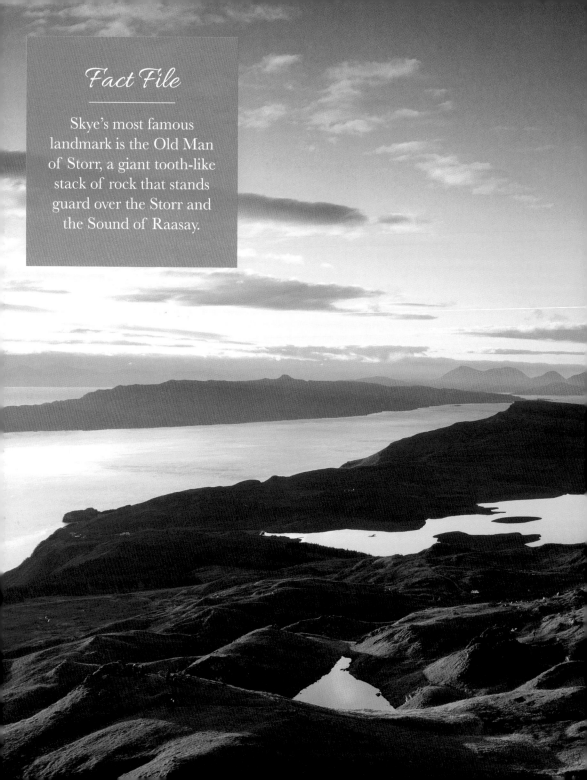

Fact File

Skye's most famous
landmark is the Old Man
of Storr, a giant tooth-like
stack of rock that stands
guard over the Storr and
the Sound of Raasay.

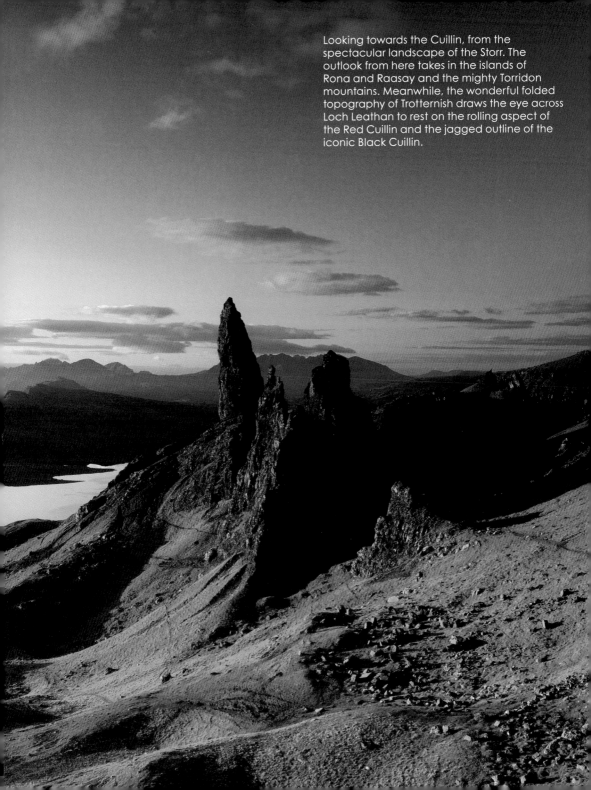

Looking towards the Cuillin, from the spectacular landscape of the Storr. The outlook from here takes in the islands of Rona and Raasay and the mighty Torridon mountains. Meanwhile, the wonderful folded topography of Trotternish draws the eye across Loch Leathan to rest on the rolling aspect of the Red Cuillin and the jagged outline of the iconic Black Cuillin.

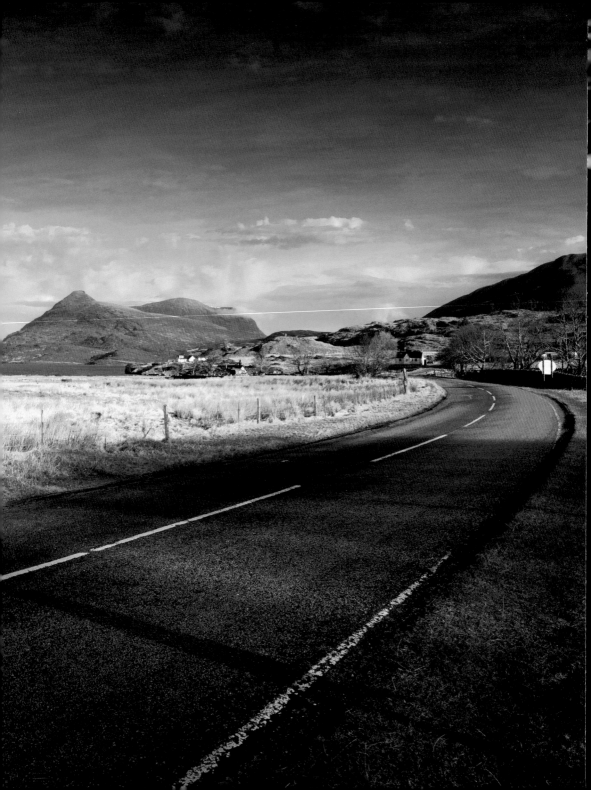

Acknowledgements

*Thank you to all at The Scots Magazine,
for their support with my work,
particularly editor Robert Wight who
came to me with the idea of Great Scottish
Journeys, and to all at Black & White
Publishing for their dedication and vision.*

www.scotsmagazine.com